I N C H I N A

Also by Eve Arnold
The Unretouched Woman
Flashback! The 50's

Hutchinson
London / Melbourne / Sydney / Auckland / Johannesburg

IN CHINA
EVE ARNOLD

HUTCHINSON & CO. (PUBLISHERS) LTD
An imprint of the Hutchinson Publishing Group
3 Fitzroy Square, London W1P 6JD
Hutchinson Group (Australia) Pty Ltd
30–32 Cremorne Street, Richmond South, Victoria 3121
PO Box 151, Broadway, New South Wales 2007
Hutchinson Group (NZ) Ltd
32–34 View Road, PO Box 40–086, Glenfield, Auckland 10
Hutchinson Group (SA) Pty Ltd
PO Box 337, Bergvlei 2012, South Africa
First published in Great Britain 1980
© Eve Arnold 1980
Printed and bound in the United States of America
ISBN 0 09 143550 1

FOR ROBERT GOTTLIEB/*With love*

CONTENTS

INTRODUCTION

Picture journalism has always been for me a combination of high adventure and low comedy, of meticulous planning and absolute chance, of infinite patience and quick reflexes. The only certainty is that nothing is certain; everything is in constant flux, from the subject to the ever-changing light. This makes for peak moments and it makes for despair; and it also keeps seducing the photographer into seeking new excitements in new situations, into endlessly trying to top the last assignment.

For fifteen years the tantalizing "ultimate assignment" for me was China. I had escalated my jobs from America to England, from Europe to the Middle East, from Afghanistan and India to Africa and Russia, but China for an American photojournalist remained impossible of attainment. First there was the political stalemate between the United States and the People's Republic of China; then there was the Cultural Revolution; and even after diplomatic relations were resumed between the two countries, it was difficult to get permission for more than a twenty-one-day visa on a guided tour with other tourists.

I didn't want to photograph China under those conditions. I wanted to make a book about the lives of the people, a book that would go beyond the ubiquitous blue suits and bicycles we had been seeing pictures of for so many years. I wanted to penetrate to their humanity, to get a sense of the sustaining character beneath the surface. I wanted to see as many particulars of China as possible, and for this I needed both time and the opportunity to work alone.

For a decade I had been making annual visa applications to the Chinese embassy in London, and the *Sunday Times* of London, for which I worked, sponsored them, but we always drew a blank. However, through Sirin Horn, a beloved Thai friend who was brought up in China and had a keen understanding of the Chinese people and the country, I came to know certain Chinese embassy people and Chinese correspondents on tours of duty in London. They were familiar with my picture stories in British journals and with my books. I spoke to them often about the possibility of working in China.

I said I hoped to show the tripod on which China had built her revolution — the peasant, the worker, and the soldier; to focus on the everyday aspects of their lives, which we in the West knew so little about and were trying to understand. I said that since I was a non-Communist journalist with no political ax to grind, who would be traveling on my own and paying my own way, there would be a good chance that my work would be believed outside China.

In the end, when the Chinese finally agreed to a visa, they did it with style and generosity (although, as I have grown to expect in my gypsying around the world, after waiting ten years for the visa, I was given exactly five days in which to present myself in Peking). I made two trips to China in 1979. The first, lasting two months, was to the more familiar places: Peking, Canton, Shanghai, Soochow, Hangchow, Wuhan, Kweilin, and Chungking, with a week's trip on the Yangtze thrown in. The second trip, of three months, was more complicated because it took me primarily to far-flung areas not normally visited by foreigners: Sinkiang in the northwest, not far from the Russian border; Hsishuang Panna in the deep south, on the Burmese border; Inner Mongolia; Tsingtao on the east coast; and Tibet. In all, I covered about forty thousand miles.

Throughout my total of five months in China, I traveled on my own, with only one interpreter, and I was given access that went beyond expectation, even to photographing the eminent: the highly respected Vice Chairman Liao Cheng Zhi, who had gone on the Long March; a representative to the People's Congress; the mayor of a city and his deputies; and Mr. Liu, a Shanghai millionaire (yes, they still exist).

Now was the moment, now was the time to be in China. In my work, timing is of the essence — and for me these trips were reminiscent of a four-month working trip through Russia I had made in 1966 for the purpose of documenting daily life there. It was the period (now known by Kremlin watchers as the Silver Years) following Khrushchev's fall, during which the new regime was finding its way. The Russians were amenable to having their story told in the capitalist press, and the London *Sunday Times* was for them a good choice, especially since Magnum Photos, of which I am a member, would syndicate my material worldwide. Russia was an assignment that took all the ingenuity I could muster. Because there was no common political ground on which to make contact, an effort was made on both sides to meet on the basis of shared human experience. The questions and answers, in words and pictures, were about people, not about dialectics.

In China, 1979 marked a period of easing toward the West. For the first time after almost a generation of secrecy, the Chinese government was taking its own people (and the outside world) into its confidence. The official organ, the Xinhua News Agency, was reporting basic information and statistics on employment, the national income, the budget, the harvest, industrial quotas, consumer goods, and much else that had been a mystery before. At the same time, Chairman Hua Kuo-feng upended Chairman Mao's strict ideology by declaring that "class struggle is no longer the principal contradiction in Chinese society." To get people moving, economic incentives were to replace ideology. The Chinese had embarked on a New Long March (modernization of agriculture, the

military, science, and industry); they were taking a heavy gamble that they could become a world power by the year 2000. It was a time of openness that made my work a joy.

Within China I traveled by plane, by ship, by train, by car, by air-conditioned bus, by jeep, and on foot; I walked on the "Roof of the World" in the rarefied air of the 13,000-foot Tibetan plateau, hand held by a Tibetan lama who steadied me as we climbed to the top of the gold-covered Potala Palace. In Sinkiang, I descended to the Turfan depression — 426 feet below sea level — the lowest spot in China. I roasted in the Gobi in July and froze in the snow in Peking in February; was soaked by the monsoon in Hsishuang Panna; and was almost blown off my feet in a predawn gale on a boat on the Yangtze while waiting for sunrise over the Three Gorges. A water buffalo I was photographing tried to charge me because he did not like the smell of my perfume, and a yak that was being milked by a Tibetan maiden grew restless because she did not like the click of my camera.

In the beginning I was dazzled with the newness of it all, my eyes reveling in the exoticism that surrounded me. Then my training as a photojournalist took over and I began to question, to interview, to try to understand. Inevitably, comparison with the U.S.S.R. came to mind. It seemed to me that in China there was none of the monotonous gray conformity I had seen in Russia. Instead, there is uniformity, yet within it a startling diversity. I had expected every commune to be like every other commune, and every factory to be set up according to directives from a central plan. This is not so. Each unit tries to solve its own problems in its own way and according to its own needs — although, granted, within the framework set up by the Communist Party. But everything is based on a system in which the individual peasants and workers are involved in the daily running of their own commune or factory.

No, it isn't all blue Sun Yat-sen – suited country. There are cowboys, bathing beaches, modern cityscapes, practicing Muslims, legal abortions, once-a-month birth-control injections, and very close family ties, which we in the West believed had been destroyed by the communes. There are food rationing and twenty-four-sheet billboards advertising everything from Lucky Cola to medicine for heart disease sold over the counter. There are humor and laughter, early television, political-romance-melodrama films in full color, six-year-old girls having their beautiful straight black hair ruined by permanent waves, and Pierre Cardin models displaying his fashions on the Great Wall.

When I returned to London from the first trip, the most frequent question asked me was "What are the Chinese like?" How does one answer such a question about more than 800,000,000 people? Just consider the differences in the basics.

First, food. In the south the staple is rice, in the north wheat and maize; further to confuse the observer, the Tibetans eat barley, the Mongolians millet. To subdivide — there is steamed bread, there is *naan,* there are endless types of noodles made by machine and by hand (and those made by hand are extruded in long strands that look like the game of cat's cradle in the fingers of the maker). As for meat — when the average Chinese speaks of meat he means pork; in Inner Mongolia camel is the great delicacy; but in Muslim areas like Turfan or Sian, where pork is forbidden by religion, meat means lamb or occasionally beef.

As for religion — I photographed a Buddhist monastery in Soochow where one hundred people come daily to worship; a lamasery in Tibet where people still come to pray, bringing yak butter to burn before the Buddha; a temple in Kunming where the young come to burn incense to entreat the deity to send the right (and wonderful) bride or bridegroom. There is a functioning Catholic church in Peking, complete with Chinese priest. The official information says that the church is intended for foreign guests, but I saw a score of local worshippers. In Sian there is a community of ninety thousand Muslims, and Sinkiang is predominantly Muslim.

Even customs for disposal of the dead vary. The Han — the Chinese majority — cremate their dead. Cremation has been encouraged for the following reasons: to ease the stranglehold of ancestor worship, to cut down on the crippling cost of burial and its attendant ceremonies, and to conserve the land for growing food for the living. The Muslims, however, still bury their dead, the Tibetans put their dead out on the mountaintops to be consumed by vultures, and the Hui minority encases its dead in hollowed-out tree trunks packed deep into the earth.

For the non-Chinese-speaking foreigner, the insurmountable obstacle is language. In European and Latin American countries, sounds are familiar even if meaning isn't; in Russia one can learn the Cyrillic alphabet comparatively easily and soon manage to order a meal or read a street sign; but in the East one is baffled by sounds for which there is no Western equivalent, and this intensifies one's sense of being an alien in an alien land. In my case, this feeling was exacerbated by my interpreter's frequent need of her own interpreter. In Tibet, Hsishuang Panna, Inner Mongolia, and Sinkiang, we had a second interpreter, and even in some large cities there were dialects my interpreter did not understand, or plays that had to be interpreted for her to interpret for me.

I tried to learn a few ideograms – at least to be able to recognize a public toilet. The sign for women was easy — a horizontal line to represent the *kong* (the earthen bed) and two crossed vertical lines to represent the crossed legs of the woman (sitting on the bed) . This worked in the cities, but usually in the provinces the language changed, and with it the calligraphy.

As I traveled (at top speed), I would become so disoriented that on several occasions I felt the way I imagine a severely dyslexic child must

feel. To offset this sense of otherness and to compensate for it there were my interpreters (a different one for each trip), who were charming and informative. Ms. Chou, who was attached to the Tourist Board as a full-time interpreter, spoke very good idiomatic English. Ms. Liu, a picture editor who wrote captions for Xinhua, spoke lovely, almost poetic English. For her everything became a parable, a fairy tale, and, as befitted her job, she spoke in photo captions: boys swimming in the Grand Canal in Soochow became "frolicsome youth"; the grasslands were variously "carpets of green" and "a sea of wildflowers"; the wheat fields "surged"; embroidery was always "exquisite"; and if there was a sheep anywhere about, the landscape became a "pastoral scene." Her masterpiece came on a breathtaking fifty-hour automobile trip down the Burma Road from Kunming to the Burmese border. As we traveled through subtropical and tropical mountain country, I would stop the car as often as the driver allowed to photograph rising mist, a rainbow, a tribal group on its way to market, or a man carrying his yoke and burden of earth or vegetables on his shoulders just as his ancestors had.

After observing my "snap decisions" (pun intended), Liu started to shake her head, a sure sign of a metaphor to follow: "It is like looking at a flower from the back of a galloping horse." In its exaggeration, her phrase aptly suggests the China I saw and tried to record in my pictures. She recognized that I was working in the kaleidoscopic immediacy of shifting image, changing light, and arrested time, and that speed of recognition was the essence of my involvement with her world. There was no other way for me to record impressions as they hit like a hot wind. Heightened reactions seemed to dictate the photographs. Some days the bombardment of the senses was so intense, and the speed at which we moved so great, that by nightfall it seemed as though my mind had conjured up the images and that my will had made them real. There was no time to reason or intellectualize a situation, and to have done so, even if we had had the time, would have been like pulling the perfume stopper out of the bottle.

But the idea was not only to photograph; it was also to observe, to talk to people, to interview them. So at a commune or factory it was not enough simply to see the place and take pictures of the people. Out of discussions would come questions. These people spent their lives within the confines of commune or factory: how did they deal with birth control, retirement, old age? What about marriage, divorce, death? My questions were not prepared beforehand, and the answers very often would be to *show* me what I wanted to know.

I entered people's homes — everything from a cave built into the side of a hill below road level in Sian to an accountant's house outside Peking to a cowboy's dwelling in Tibet. In these situations nothing was made ready for me in advance, but occasionally a worker whom I stopped to talk to — in a turbine factory in Shanghai or an apartment house in Kweilin — would, in answer to my questions about her life, offer to show me her home, only asking for time to go home to make the bed.

The choices of whom to talk to were mine and made at random. There were only a few things I asked for that were not possible, and there were several things I photographed that were questioned. I was refused a law court and I was refused the navy. About the first, I was told that heretofore there had been no court of law and no legal system as we know it. There are only magistrates (and, since Liberation, party officials). The Chinese are now setting up a judicial system…perhaps next time. (It is interesting to note that recently, when the Chinese started to prepare contracts with foreign firms, they were stymied because they had no legal code to go by.) I could not get permission to photograph the navy, even though I was in Tsingtao, where there is a naval base. One of the cadres at Xinhua (my hosts) laughed and said, "We gave you the army; now if we give you the navy, you'll ask for the air corps next."

As for the very few pictures I took that were questioned, one was of six men carrying a huge stone girder on their shoulders, which looked like something from the days of the Pharaohs. The leader, pacing himself with a staff he carried, would chant to establish rhythm and the men would hoist to the beat and move the girder a few feet, put it down according to the chant, rest, chant, pick up, move, stop, put down, rest, etc. In the south, Szechwan, where the Chinese are trying to go straight from a feudal society into the twenty-first century, there are no cranes to do the work. Only people.

Although I was allowed to take this picture, there was unease and worry about it afterward. We stayed up much of one night discussing it. Was the picture taken for historic reasons? Perhaps to be published in the year 2000, when modernization had been achieved, to show the distance they had come?

No, I said. I did not expect to be around in the year 2000. I wanted to pay homage to gallant men who were giving everything to help achieve a goal; I felt they should be applauded now.

They did not agree, saying: We have problems like unemployment, with youth not wanting to work. We talk about it in the press. Yes, we write about it, but we would not, for instance, show a photograph of a loafer on the streets smoking cigarettes.

I asked why a photograph was such a threat. Oh, because it is more effective than words and yet tells only a partial truth. The reader might not grasp its meaning fully, or might completely misunderstand. It only states the problem with which we are dealing and which we are gradually solving. We agree that we must learn truth from reality, but the pictures of the men heaving the girder would not be understood in the West because the picture says only that the men work hard; it does not say that it is for themselves they work hard!

So it's not all right to show the picture, but all right to write about it? Of course.

* * *

It is considered bad manners to "grab" a photograph. The photographer is expected to ask permission of the subject. This of course makes a mockery of trying to photograph candidly on the streets. By the time the photographer has asked the interpreter to ask the subject, and the answer has come back in translation, the atmosphere will have changed, the meaning of the photograph disappeared, and the whole deteriorated into farce. In cities like Peking or Shanghai, where there are always groups of foreign tourists, people are used to cameras and pay little attention; but when I worked in places where people had never seen a foreigner *or* camera, taking a photograph could become a comedy of total absurdity. I experienced one such episode on a street in a small town on the Yangtze, where I saw my first non-blue-suited peasant. She was dressed in colorful country clothes and had just brought in from the country some herbs that she was arranging for sale. (This was an innovation. The government had recently decreed that people could engage in "free market" as a sideline to supplement their incomes, a practice banned during the Cultural Revolution.) When the herb seller saw my camera, she started to protest loudly. The interpreter stepped in to rescue me. She explained that I was an "honored" guest and a "fine" photographer. A "fine" photographer? the woman jeered. If she were any good, she'd have a studio, she wouldn't have to wander the streets!

Each day brought its own rewards and surprises. Perhaps the biggest surprise was the ethnic differences of the minorities in their traditional clothes, still living as they had for centuries — language, religion, customs, and mores virtually unchanged — but utilizing the education, medical care, and better living conditions now available to them.

What I was constantly impressed with was the spirit of the people. China has just emerged from ten years of Cultural Revolution, of purge and counterpurge, of destruction to her past and violence to her future, and possesses a whole generation of young who have been the victims of upheaval. At a dinner I gave for the people who had planned my trips, I was asked for my impressions of what I had seen during my five months in China. These were serious journalists who wanted a serious answer.

I said that I was aware that the socialist system the People's Republic of China is trying to build requires constant surveillance to make sure people do not slide back into feudal attitudes and bureaucratic practices. The problem remains of trying to build a nonelitist society where the intellectual does not feel superior to the worker, the worker to the peasant, men to women, the cadre (leader) to those led, the Han (Chinese) to the minorities, and the city dweller to the country dweller. There must also be a way for the military to fit into this plan for an egalitarian society: it isn't enough to legislate ideas; they must be enforced.

I went on to say that I was surprised on two scores: how far the Chinese have come in thirty years — the number of planes, air-conditioned trains, tractors, cars, oil wells, seagoing vessels, television sets, and the knowledge of Western medicine; and how far they still have to go to leave behind the backbreaking physical labor in which millions remain engaged.

It is the uneven development, these differences in the levels of technology, that China calls "walking on two legs." I regarded these unequal juxtapositions with awe, and questioned how China will ever succeed in finding the equivalent for one-quarter of the world's people — this intensive labor force — in machinery that will be able to lift the yoke from their backs. Will China be able to use technology so that it "serves the people," or will technological unemployment bring even greater problems?

Despite such large and difficult questions, I could affirm that in China I never saw the malnutrition and starvation I had seen in black South Africa, or the despair and apathy of India. Neither were there the vile slums of Harlem nor the grinding conformity of Russia. There are poverty, self-sacrifice, and grueling labor, but people work and people eat, and there is hope.

When, on my return from China, I began to assemble the results of my work, the pictures dictated their own formula of making simple graphic sense of what I was trying to say.

First/LANDSCAPE: To set the stage for the human drama that is being enacted

Second/PEOPLE: To introduce the people of the People's Republic of China

Third/WORK: To show the motivating force on which communism is based

Fourth/LIVING: To present something of the way of life in China today — its problems, benefits, and rewards, from birth onward

I felt from the start that color photographs would best serve my purpose of conveying information. The eye sees in color; black-and-white, beautiful though it is, is an abstraction. I wanted the reality.

For the sake of clarity, I have spelled place names according to the traditional transliteration system commonly used in the West. The Pinyin system recently adopted by the People's Republic of China is still too new; for example, most readers would be unable to recognize the Yangtze River as Chang Jiang or Canton as Guangzhou.

I regret the instances in the book where words describe situations for which I show no pictures. Alas, no book about China could be large enough to show everything.

IN CHINA

LANDSCAPE

When I first arrived in Peking, I was aware that I carried with me two totally different concepts of the country I was about to see: for me, the *People's Republic of China* conjured up an image of people – huge, undifferentiated masses of people; if I thought of *China*, however, the image was of landscape, of immense space dotted with tiny figures, demonstrating the relationship of man with overwhelming nature – the relationship one sees over and over again in classic Chinese scrolls. These preconceptions had to be either abandoned or placed in perspective before I could begin to see the reality.

Actually, both images proved to have a certain validity, though with one major qualification – the masses of people are not undifferentiated. Even in major cities one immediately notices the individuality of the people. There are single figures and large groups, but never faceless hordes – this despite the enormous population: almost four times that of the United States. Millions are packed densely into the cities, while the 12,500-mile borderland is sparsely settled; and the rest of the country is so vast that although it holds hundreds of millions of people, large parts of it appear virtually empty. The overall impression remains that of small-scaled man against the huge, dominating, ever-changing landscape, from the northern steppes of Inner Mongolia to the tropical forests of Yunnan, from snow-covered Tibetan highlands to the beaches of Tsingtao.

But although the landscape dominates man, everywhere man has settled there is a sense of intense and continuous contact with the land, a sense of the feet that have trod the soil for millennia, of the hands that have molded and fashioned it, and, to complete the cycle, of the human excrement that is constantly returned to the soil. Much of the land resists man's efforts to work it. In 1949, when the Communists came to power, only 10 percent of the land was under direct cultivation. It has taken thirty years of backbreaking work and struggle to raise this to 11 percent. But every square inch of available land near any habitation is planted for food, and this is why one sees factory spires emerging from green terraced fields all over the country.

Most amazing – to me, at any rate – was the extraordinary variety that nature has granted the Chinese. Even the colors of the earth change from place to place: black earth, brown soil, red loam, and rice paddies of all shades, from pale gold to dark tan. The Chinese refer to the myriad tones of green that make up the vegetation as "ten thousand greens." In south China, where two crops of rice are sown annually, the expression is "yellow in the morning, green in the afternoon," because the ripe yellow sheaves of grain are harvested in the morning, and in the afternoon of the same day the new green shoots for the next harvest are planted.

The woodlands also vary radically. In the northwest near the Russian border, there are shelter belts of trees, planted since Liberation to anchor the shifting sands of the Gobi, so that now a "green Great Wall" is emerging. By contrast, the tropical south near the Burmese border is a vast botanical garden, with its coniferous forests, savannahs, rubber, sisal, hemp, mango, and pineapple plantations, and its brilliant flowers.

Each kind of pasture land has a different look too, and each is adapted to a different kind of livestock breeding. The treeless steppes of Inner Mongolia, with their occasional outcropping of rock, are used mainly for horses and cattle; the broad plains of Tibet for yak, sheep, and goats; the fertile green grasslands of Sinkiang mainly for sheep.

The palette of the sky's blue ranges from pale celadon to deep cobalt. And the mountains change shape, size, color, and texture from place to place. Those in Tibet are Himalayan and under snow; those in Sinkiang are Alpine and evergreen; those in Kweilin are pinnacles of limestone.

The country is covered with lakes and streams, creeks, rivers, and canals, and life on the waterways is wonderful to watch. The two trips I took on the turbid Yangtze absorbed me completely because there was so much to see. The river is used for irrigation and navigation, for growing water chestnuts and lotus roots, for hydraulic power and disposal of industrial waste, for long-distance sightseeing, for modern seagoing vessels and ancient sailing junks.

The Grand Canal, too, excited my imagination. It starts in Peking and ends a thousand miles to the southeast in Shanghai, passing through four provinces and linking five rivers. It was built more than 2500 years ago to allow grain tribute paid in the south to be shipped north to the imperial court. Today grain is brought by barge down the Grand Canal as it has been for centuries, but now the grain is sold to the state. The domestic uses of the canal haven't changed much in two millennia, according to some fishermen I spoke with in Soochow. People still wash their clothes and bathe in it, and young swimmers still hitch rides on the barges.

Finally, always, there is the connection with the past. One senses it at the ruins of a lost city, now buried on the Silk Road in Sinkiang, as well as at the glorious Potala Palace in Lhasa in Tibet, that supreme shrine built into the side of the Red Mountain, where before 1959 the Dalai Lama was temporal and religious ruler. Before 1959 there were 174 high-ranking lamas at the Potala Palace; now there are none. Today the palace is run by a management group of twelve, in charge of archeological affairs.

Coming from the modern city of Shanghai, the bathing beaches of the east coast, and the oilfields of Shantung to the lost city and the Potala Palace, I felt as though I were moving backward through Chinese history. But neither city nor beach, monument nor ruin, left me with images as compelling as those provided by the land itself – the land on which 85 percent of the people still live and from which they are inseparable. What I will never forget is my deep sense of the people's harmony with their landscape – what the writer Lu Hsun called a "spiritual geography."

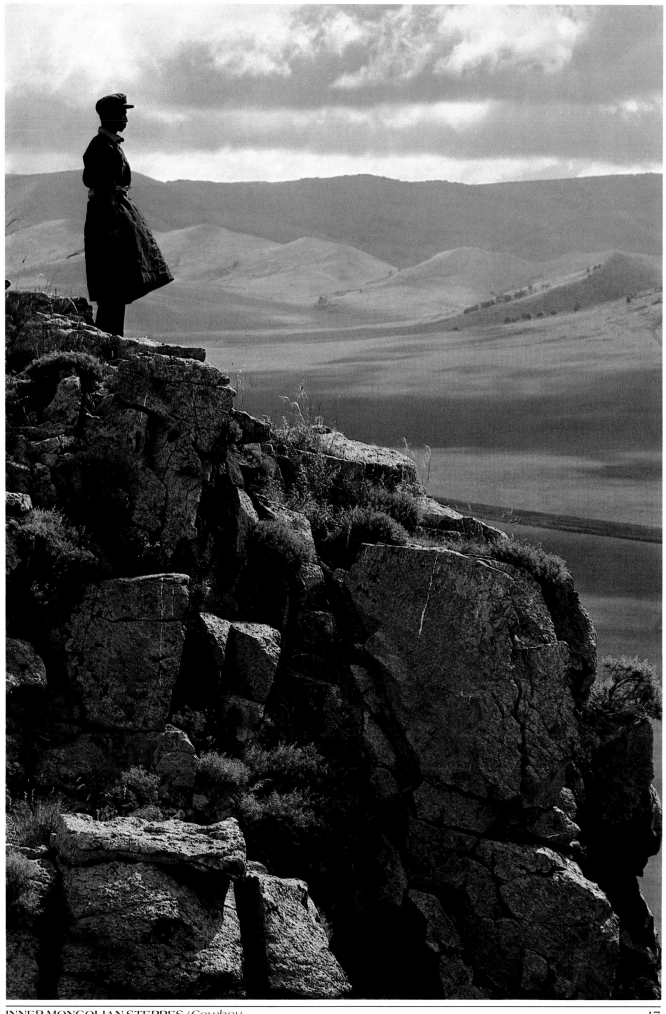

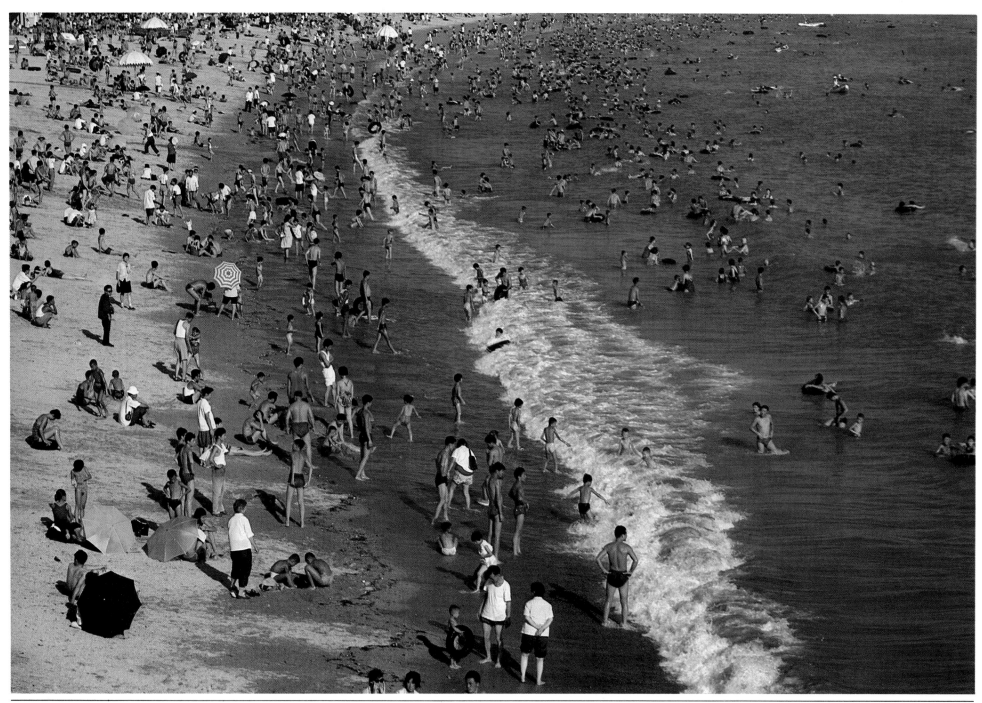

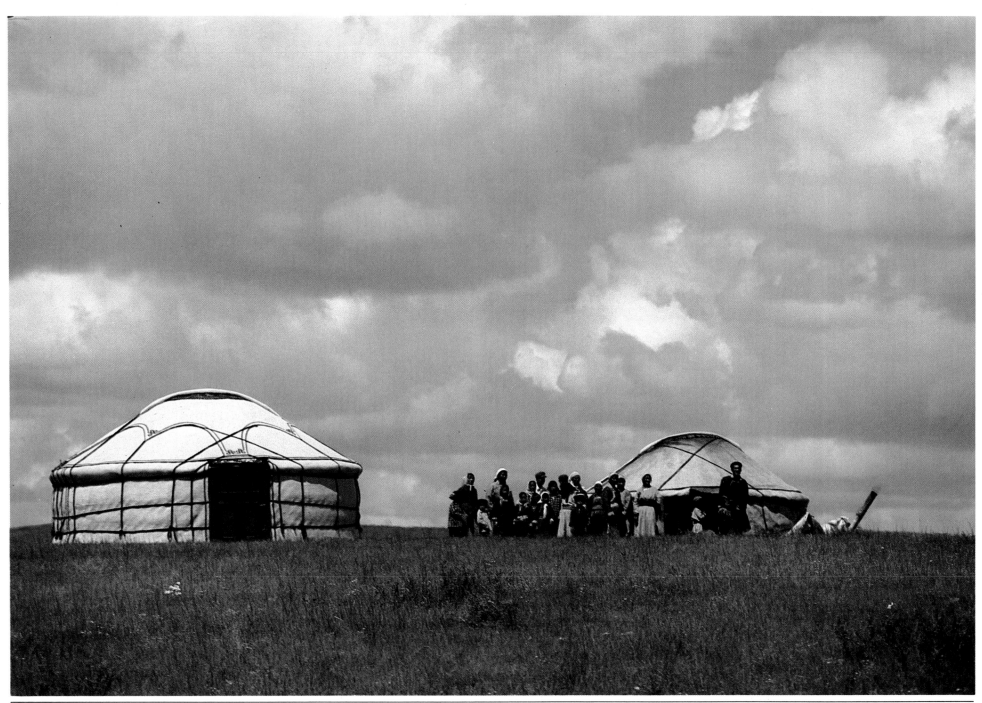

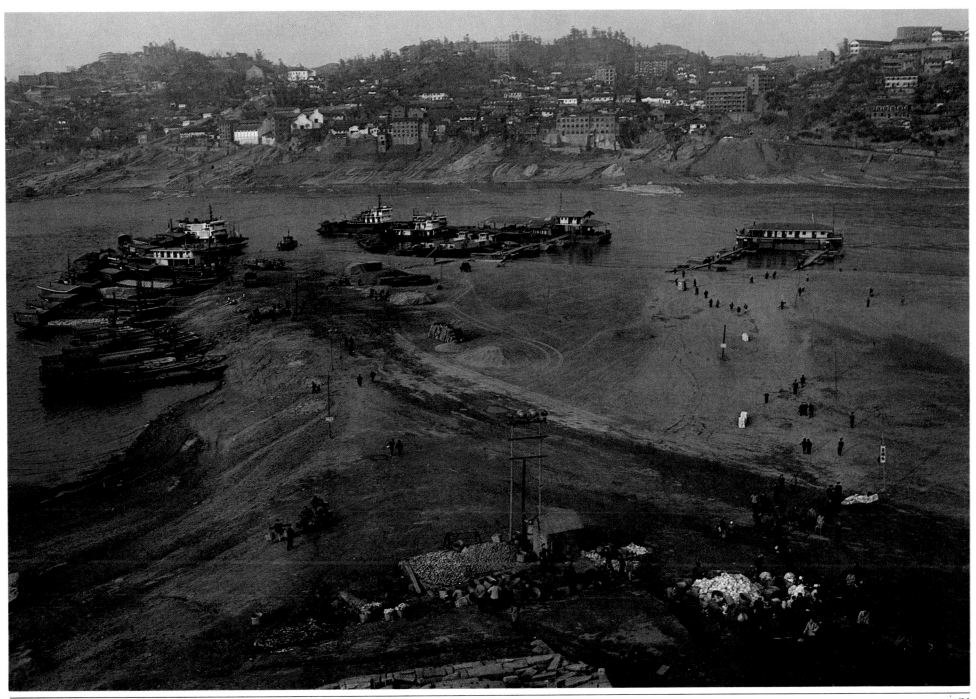

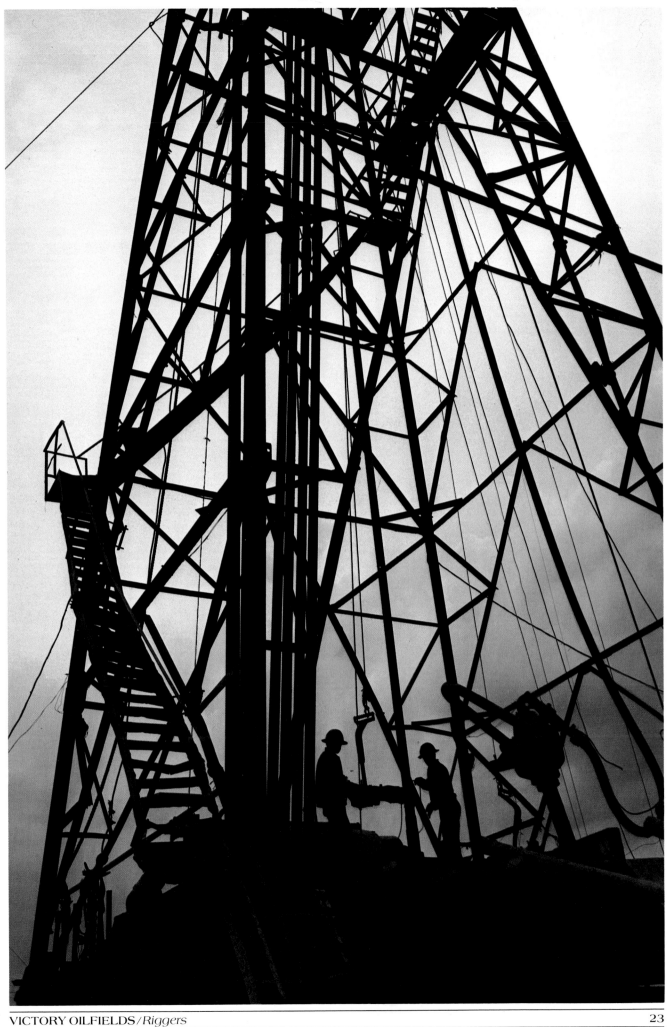

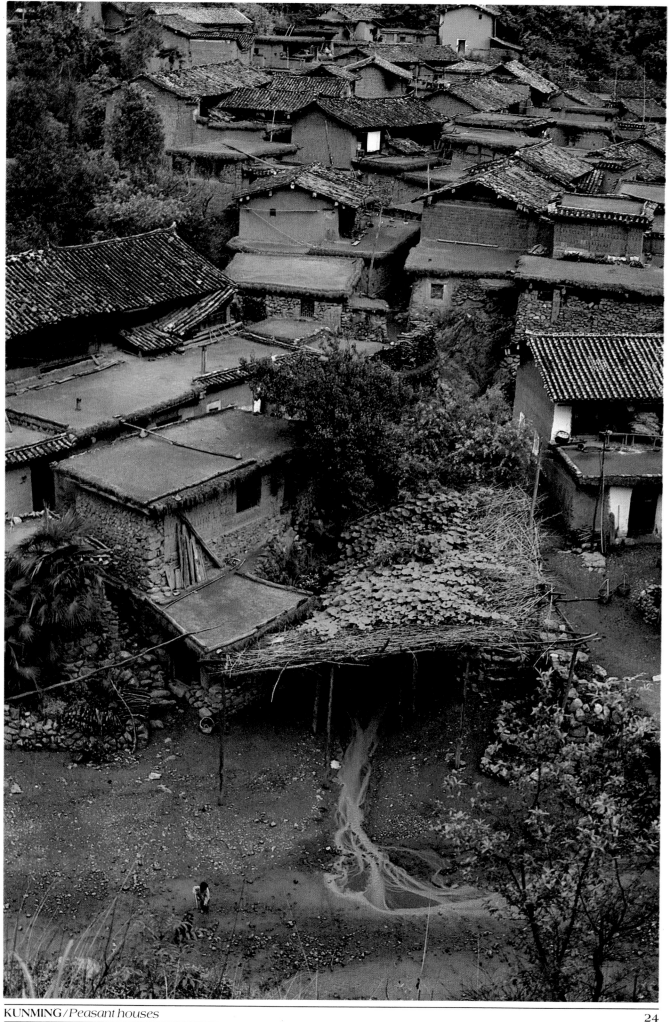

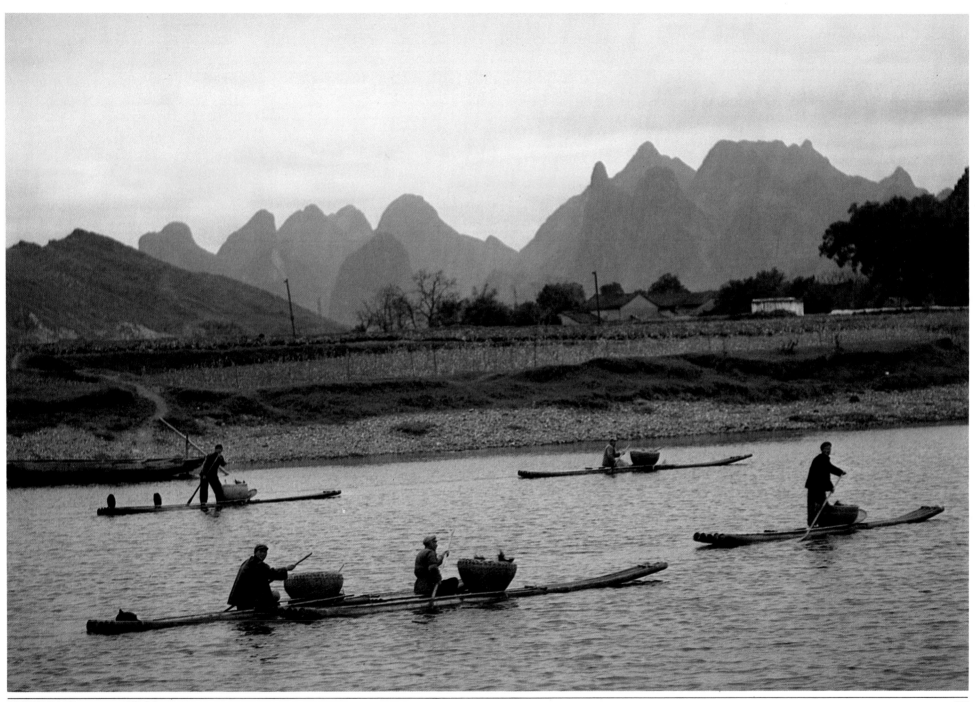

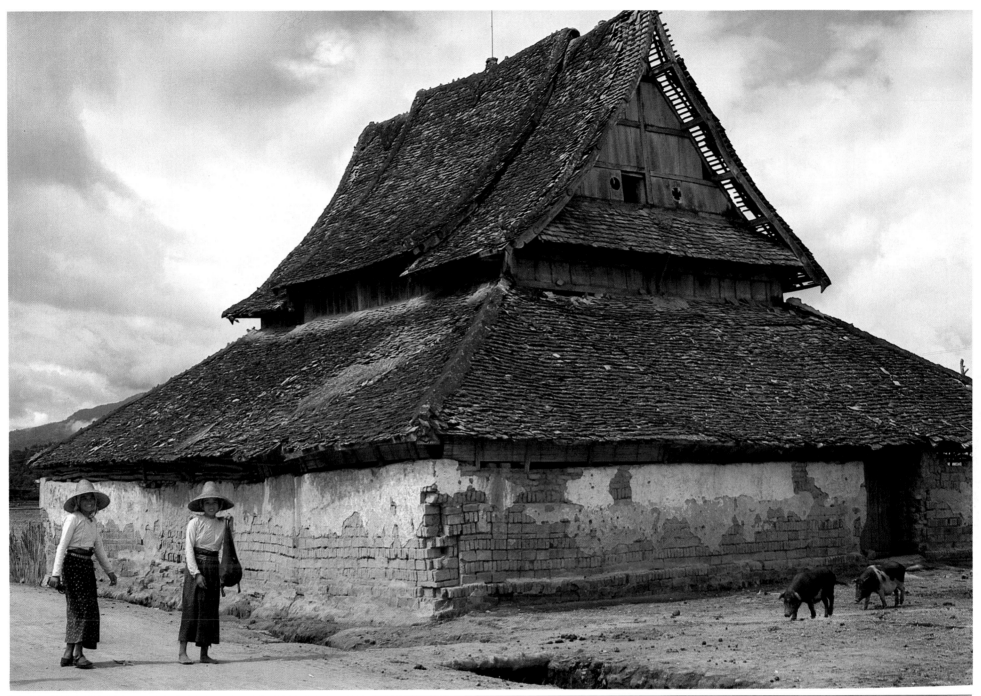

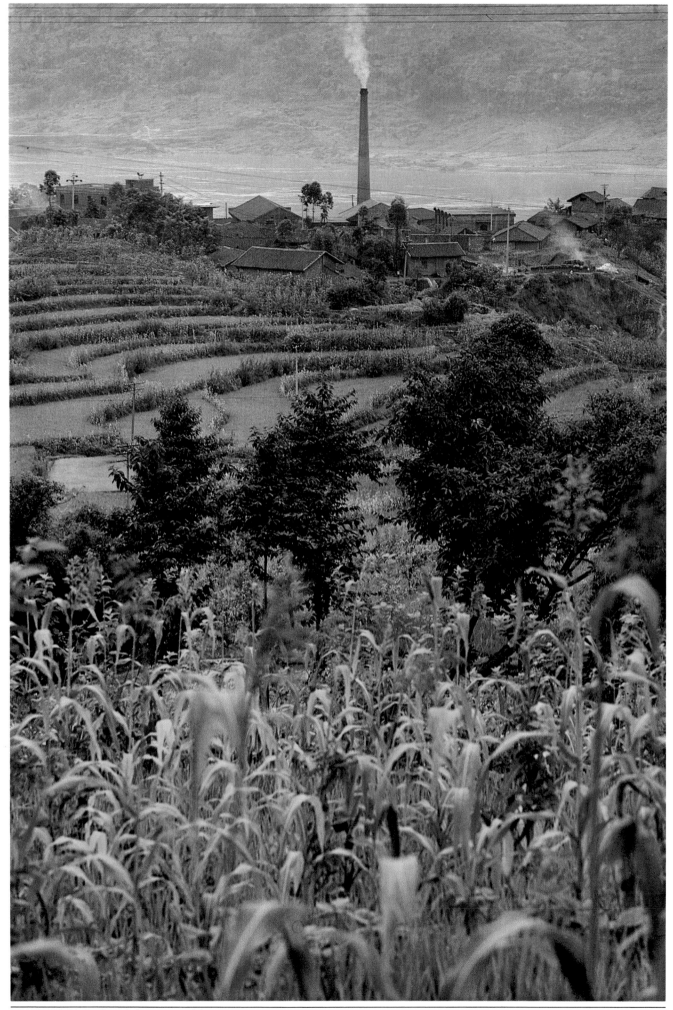

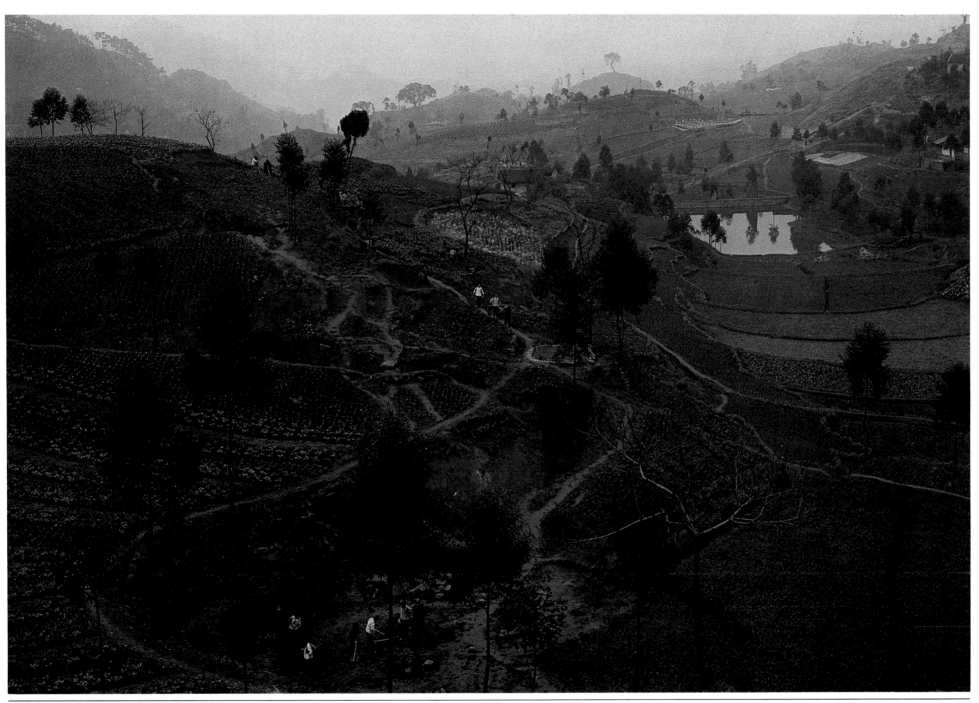

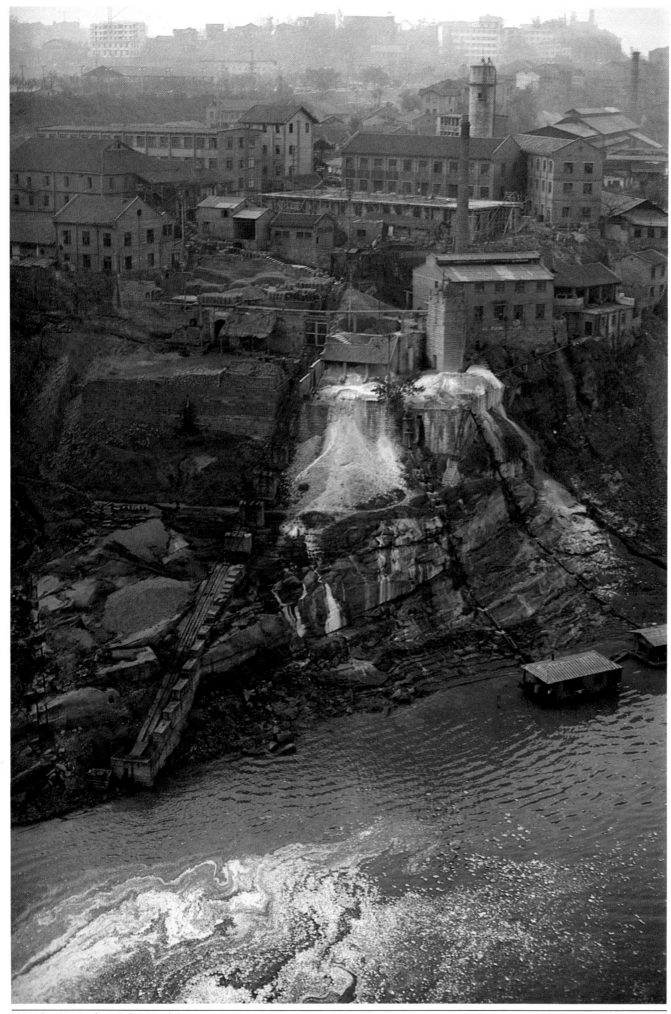

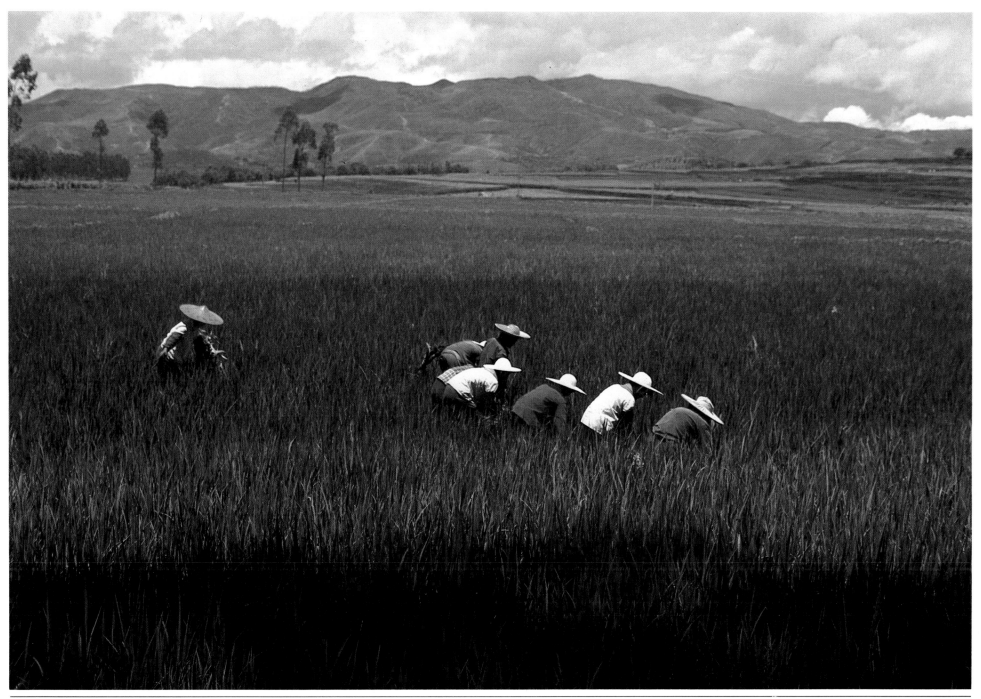

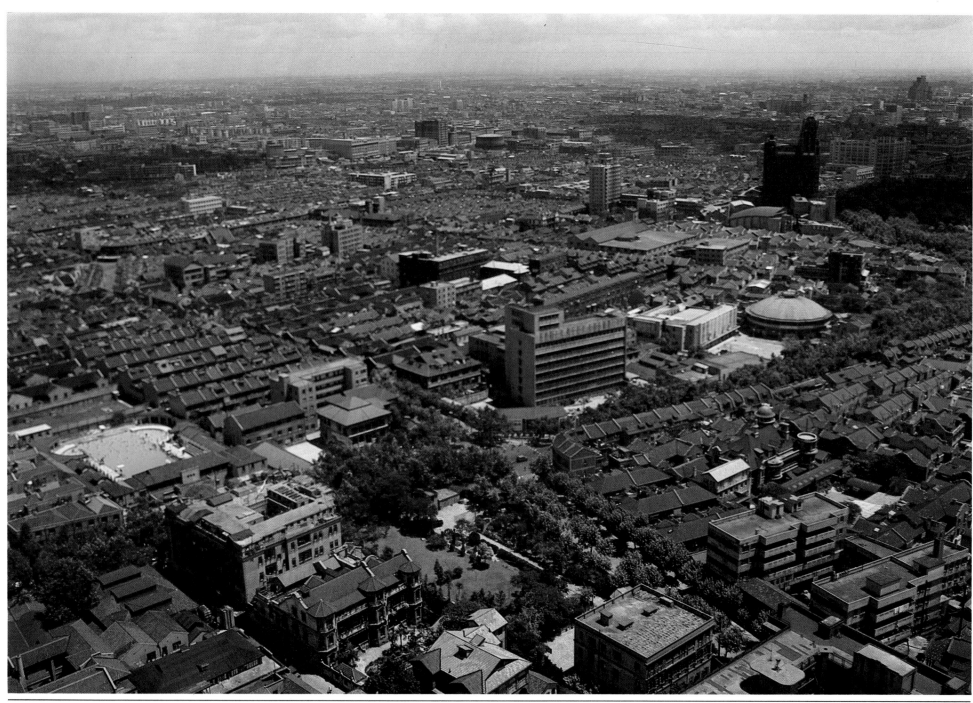

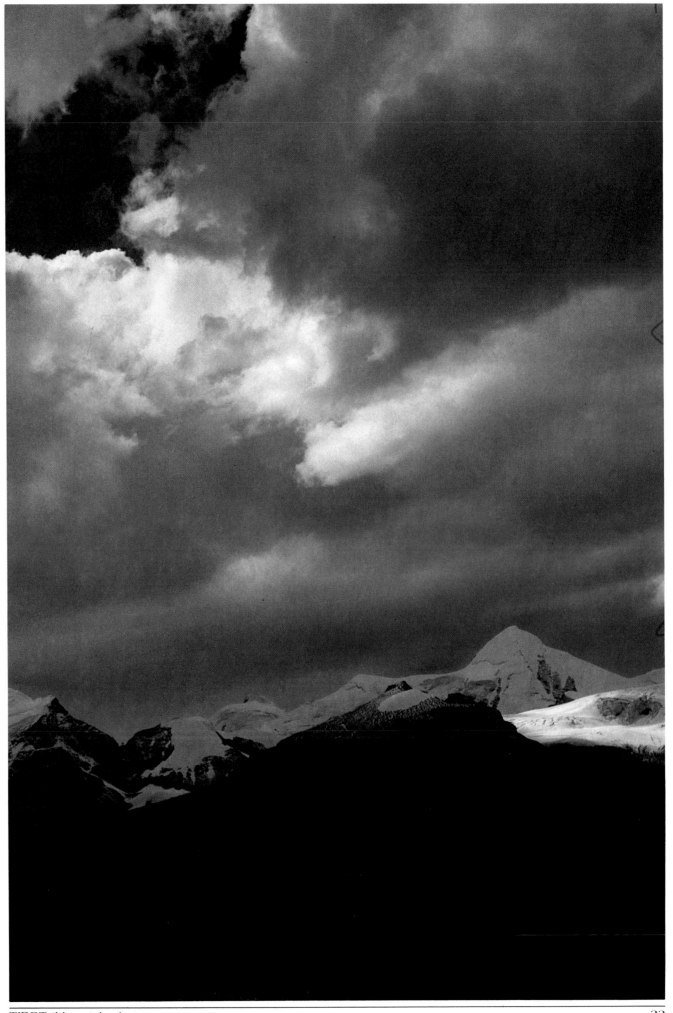

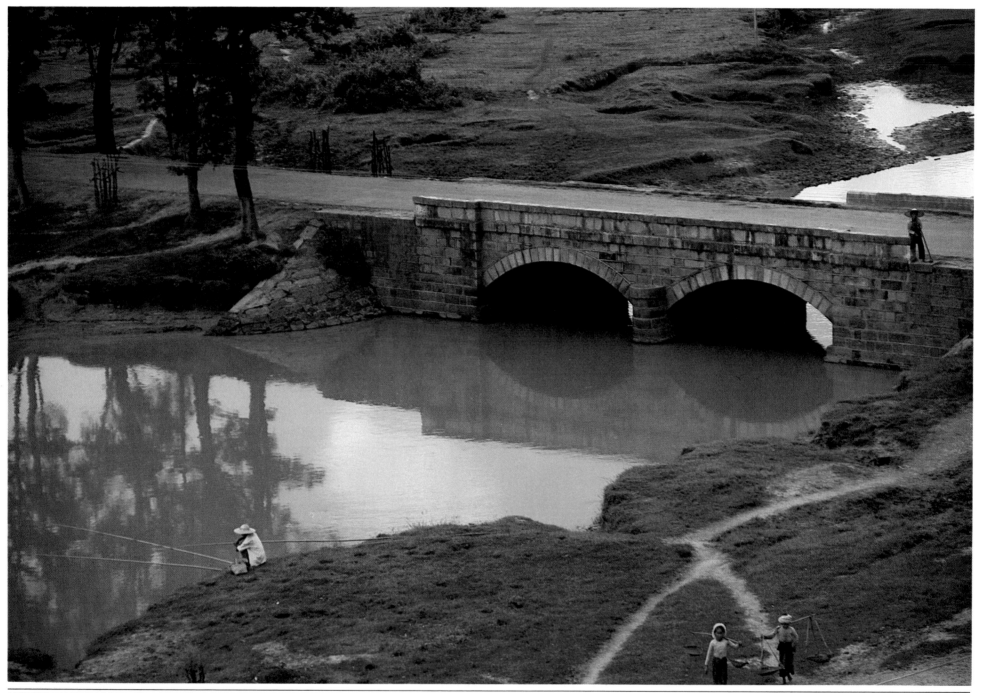

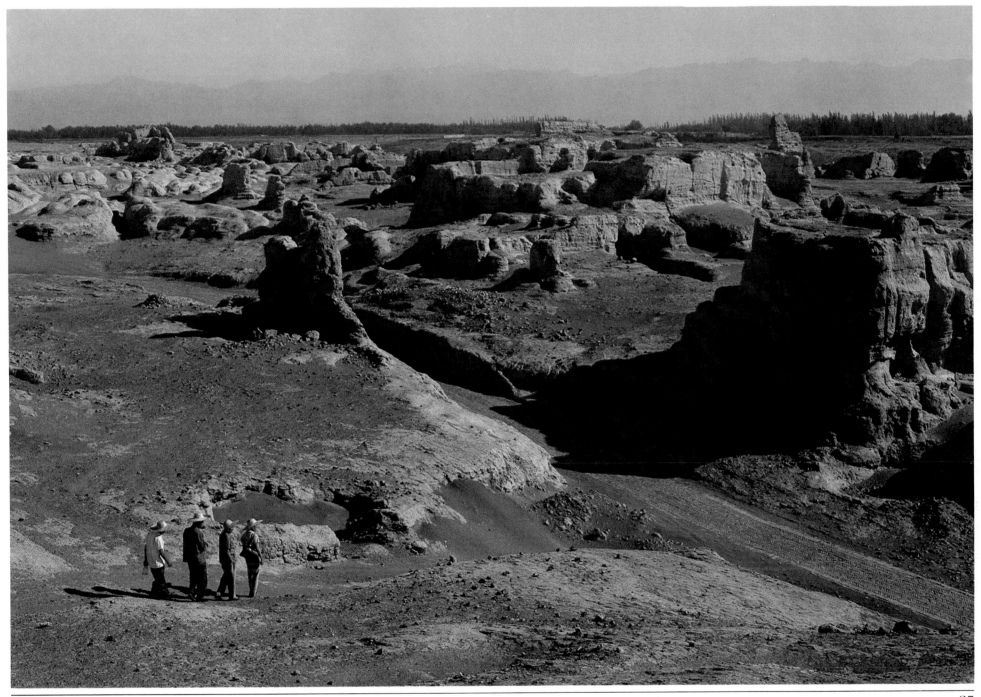

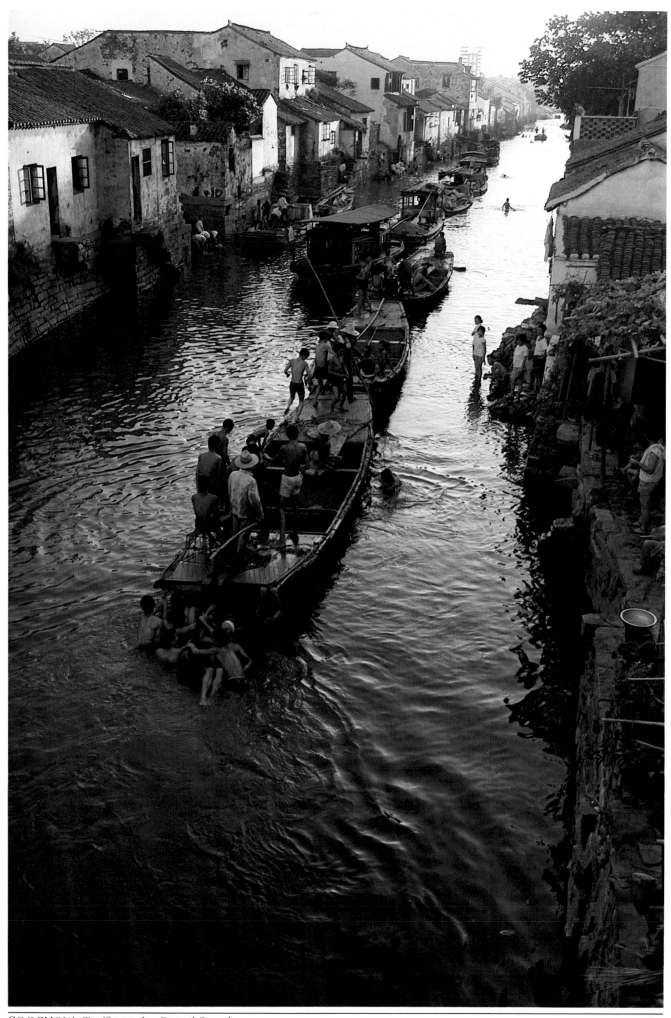

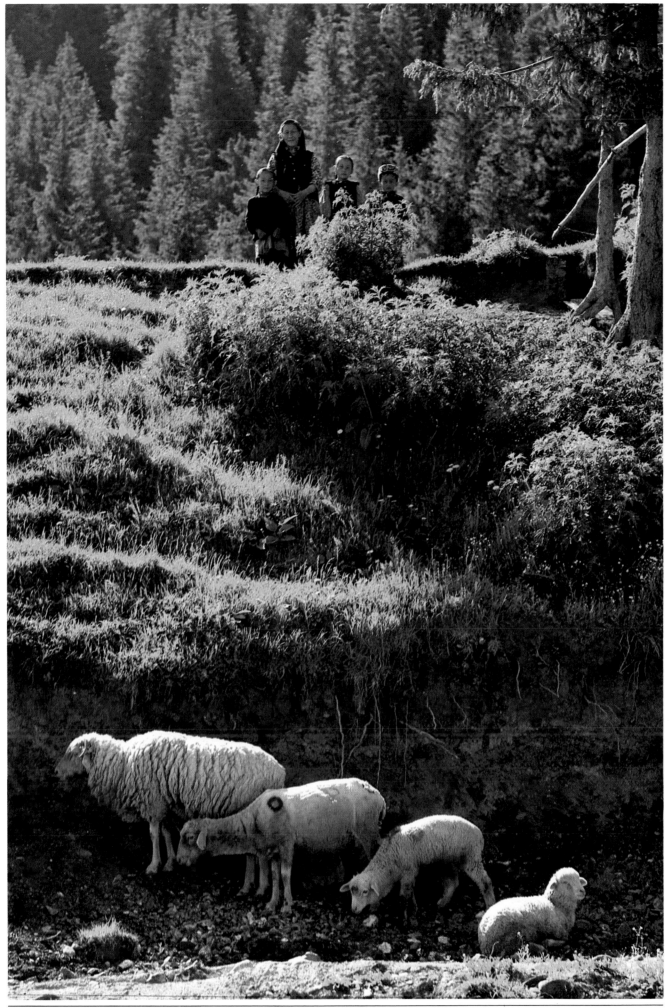

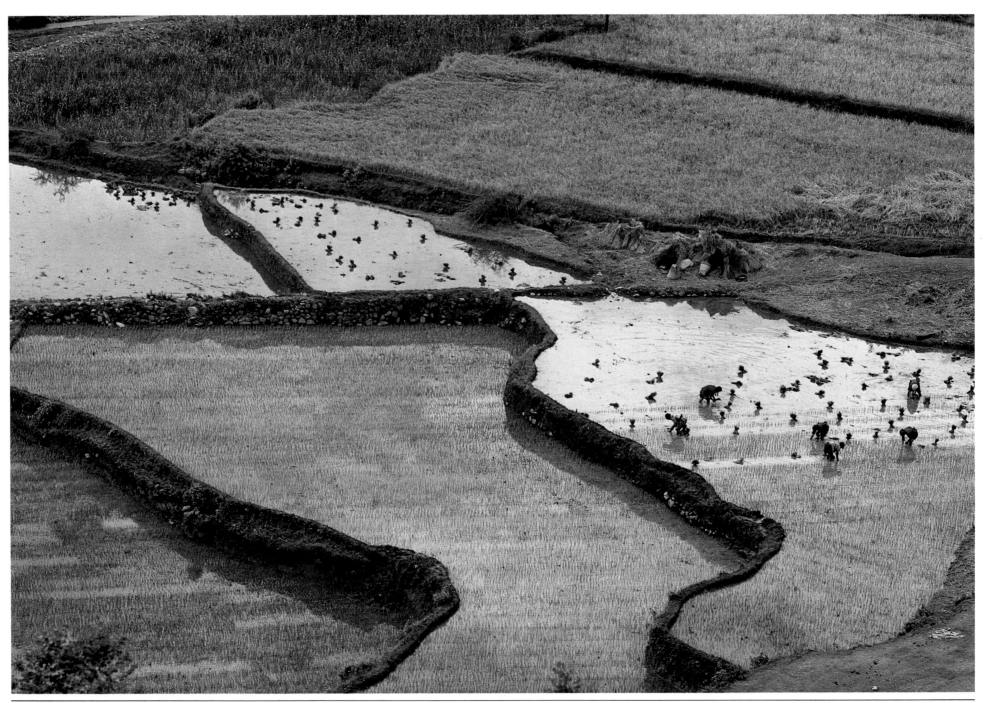

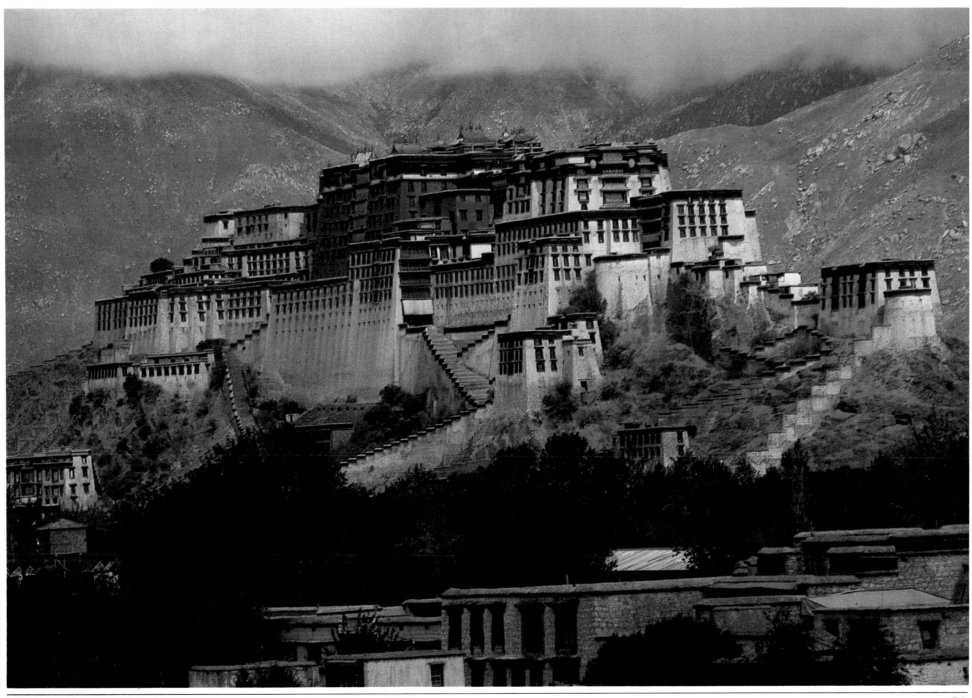

PEOPLE

As a photographer, I wanted to look into people's faces and record what I saw; as a journalist, I had many questions to ask. I had been reared on the "they all look alike" myth, as well as on the idea that socialism was a leveler that destroyed individuality and produced identical ciphers.

In China, there were no look-alikes, no stereotypes. The physical similarities among the Han (94 percent of the people) were offset by the exotic differences in the physical characteristics of the minorities (6 percent of the people). The southern minorities in tribal dress might have been Peruvians or American Indians, and the people from Inner Mongolia in their tribal dress might have been Eskimos. There were enormous variations in skin coloring, from "white" through the expected "yellow" to the "brown" of the minorities of the deep south. Features changed, from the delicate ones of a child in a classroom in the northwest to the broad flat features of two Tibetan peasant women out for a stroll in the gardens of the Summer Palace in Lhasa.

What I considered beautiful, I soon realized, was not often in agreement with the standards held by my hosts. Although they said nothing, I felt them questioning my choices. Often a local male photographer would travel short distances with us, and with him I would raise the question of the Chinese standard of beauty. Not unexpectedly, it was feminine pulchritude we would talk about. Here is a composite picture:

1. The Chinese describe a pretty girl as having a round face, but a beauty as having a face like a goose egg.
2. She must have large eyes, a straight, rather large nose, and a small mouth.
3. Her eyebrows should be like weeping willow leaves — curved.
4. High cheekbones are considered ugly. There is an expression — "a woman will kill her husband without a knife" — which reflected the superstition that a husband would die early if he married a woman with high cheekbones. It is no longer believed.
5. Women should be slender — and not too short, not too tall.
6. Big breasts are now considered healthy and strong. In the old days women with large breasts would hunch their shoulders to try to hide their size.
7. Big feet are now acceptable.
8. As for hair, currently straight black hair is considered unfashionable, and the old-fashioned Western fifties-type permanent wave is the dernier cri — perhaps both in imitation of the West and in reaction to the days of the Cultural Revolution, when the young Red Guards ran amok in the streets, arbitrarily cutting off girls' braids, which they, the Red Guards, considered symbols of bourgeois revisionism.

Having read a great deal about the young taking over the country during the Cultural Revolution, I was interested in what was happening to them now. No longer intrepid spokesmen for the glorious adventure, they seemed muted, their protests resolving themselves into dignified symbolic demonstrations against unemployment. The young may be China's most pressing problem. This seems particularly serious when one recalls the enormous amount of planning done for the very young, who are brought up to participate with their elders in the daily work, no matter how unimportant the task, in order that they emerge as youth with a sense of serving, of being needed, and of belonging.

At the top there is an aging bureaucracy of cadres and other officials, many of whom suffered during the Cultural Revolution, and between them and the young there seems to be a disillusioned generation of people aged thirty to fifty who are trying to find their bearings. The government is attempting to solve all these problems through the

medium of the New Long March – China's attempt to become a world power by the year 2000. For this, China has turned to the West for help – in everything from trade and the hard cash that comes in through tourism to technical aid and cultural exchange. To achieve its goals, China is borrowing incentive methods from the capitalists.

What is surprising is that the relentless struggle has not crushed the personality of the people. A dignity and sense of self-respect are evidenced in many ways. It's a small thing, but several among the blue-suited female Communist Party members I got to know wore feminine bits of lace or embroidery sewn onto a piece of underwear or a blouse worn under a jacket so that no one would see them.

The Chinese treatment of women is interesting. Although the constitution guarantees them equal rights with men, and everywhere people mouth the phrase "women hold up half the sky," there are still many real problems to be worked out. Here are a few examples. When women started as well drillers at the Victory Oilfields, they were not strong enough to do the tough jobs on the derricks, where the wages were highest, so they had to take the less demanding jobs of replacing pipes in smaller wells for lower pay. The same problem exists in the rice paddies in the south: the men till and level the soil with the water buffalo, a task for which the women are not strong enough. Even though they work desperately hard in the fields, planting and harvesting, the women still get fewer work points. And although women do come in for equal consideration with men for the jobs of cadres (or leaders) in practically every sphere, yet, as in the West, at the highest government level there are many more men than women.

Contrary to my expectation, China proved not to be a classless society, as I think the cross section of people presented here in varying jobs and situations might serve to illustrate.

"You have gone the gamut from the highest to the lowest," said one of my Chinese friends when I described what I had done: the workers, peasants, and military personnel; intellectuals, scientists, the religious, and the minorities; officials, functionaries, and authority figures, who are held up as models and examples to the rest. One such was Vice Chairman Liao, who has the equivalent of a Cabinet post in the West. A jolly man, who was on the Long March, he speaks impeccable English and Japanese, and is head of the Chinese-Japanese Friendship Society.

Since China was originally patterned on the Russian mold of communism, I was not surprised to find people at different social levels living different kinds of lives. What did shock me was the existence of millionaires. I spent six hours in an interview with a Shanghai millionaire, Mr. Liu. (He was not interested in being photographed, but finally consented to a single picture.) In his faultless English (he had read economics under Keynes at Cambridge), he talked of the vicissitudes of his life. His father had been one of the wealthiest men in China – coal, textiles, iron, land. His fortunes zigzagged with the country's political tug-of-war. In the beginning, he and his family received 5 percent annually on their twenty-million-dollar (when the dollar was a dollar) investment – a million dollars a year. During the Cultural Revolution his palatial home was invaded by the Red Guards. He and five members of his family were shoved into a single room and there they lived for six years while he did hard labor as a worker in the textile mill of which he had previously been managing director. Now, again, his fortunes had changed. Chairman Hua had declared that restitution would be made to the millionaires, who were to be regarded as "ex-capitalists" and "patriotic democrats." Mr. Liu's house, his works of art, and all other possessions were to be restored to him, along with all his money – plus interest!

He told me three significant things. As a capitalist-taught economist, he believed that in 1949 communism was the only thing that could have saved China. As a millionaire, he thought that when his wealth was returned to him, it would be more than he and his children could ever spend. And, finally, as a man of China, he spoke of the enormous pride his countrymen had felt when told that they had been victorious over the Americans in Korea.

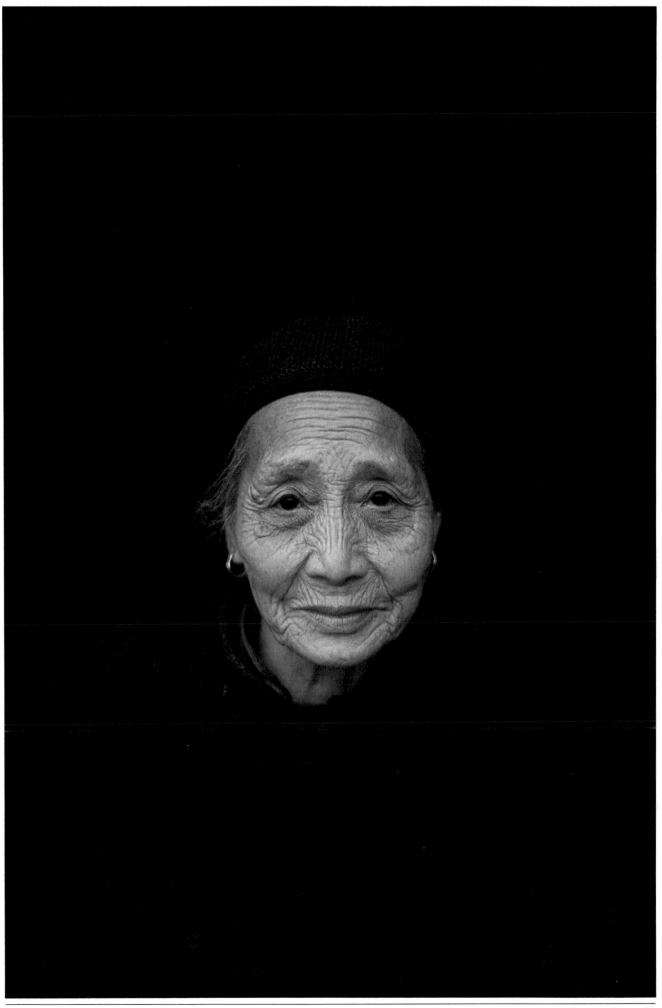

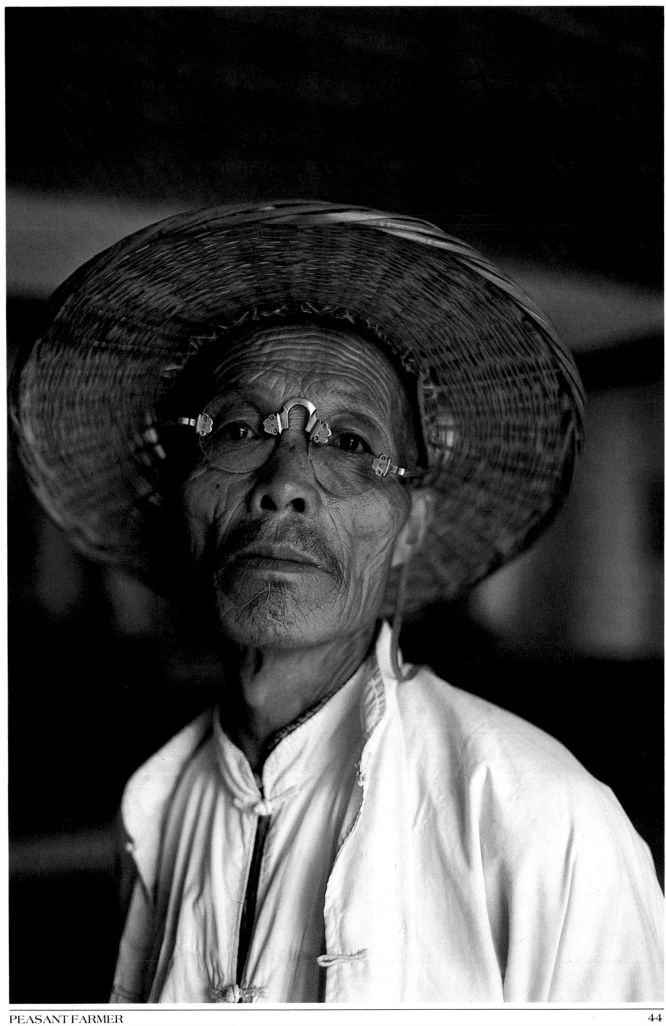

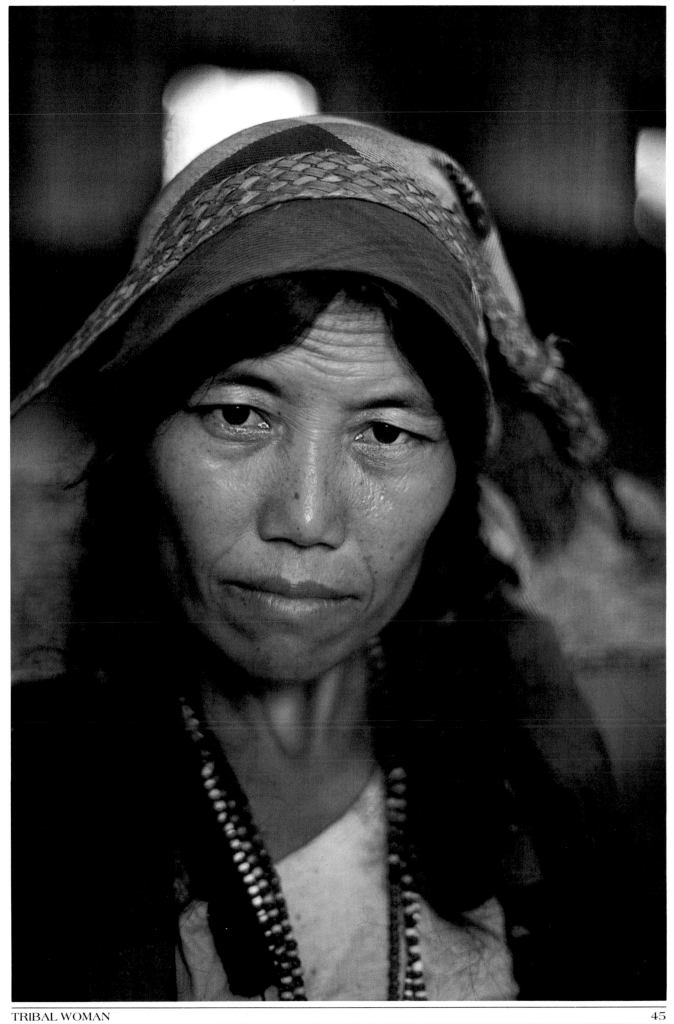

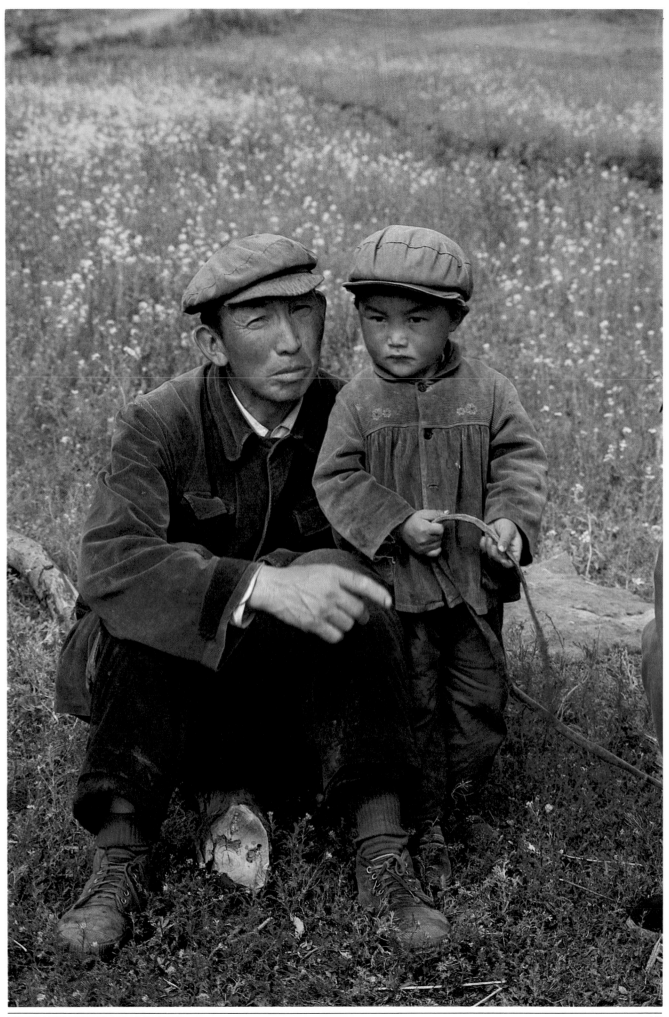

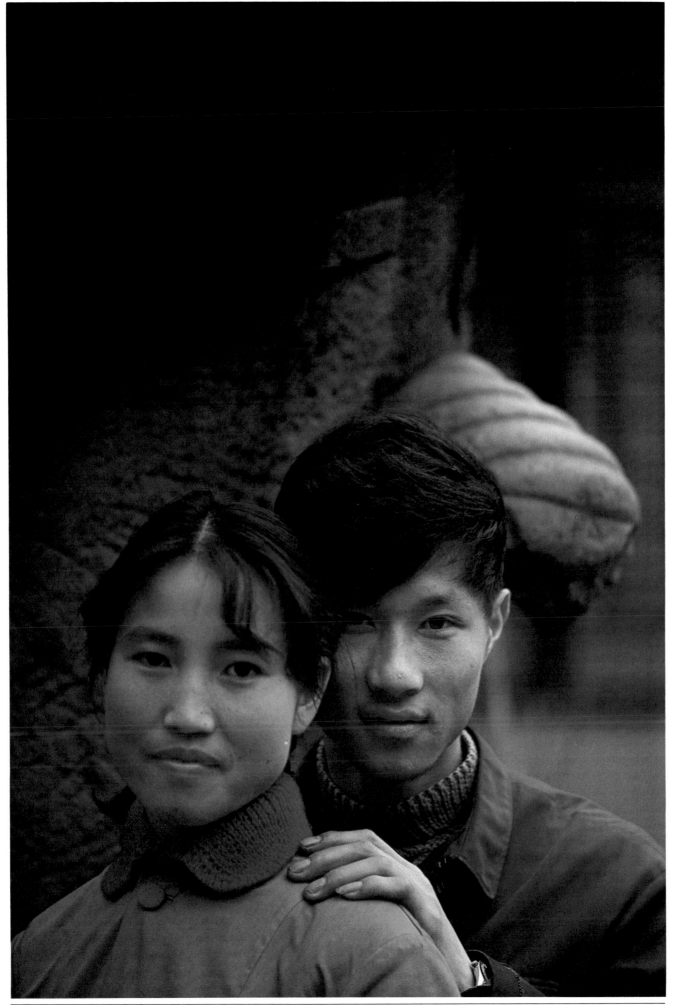

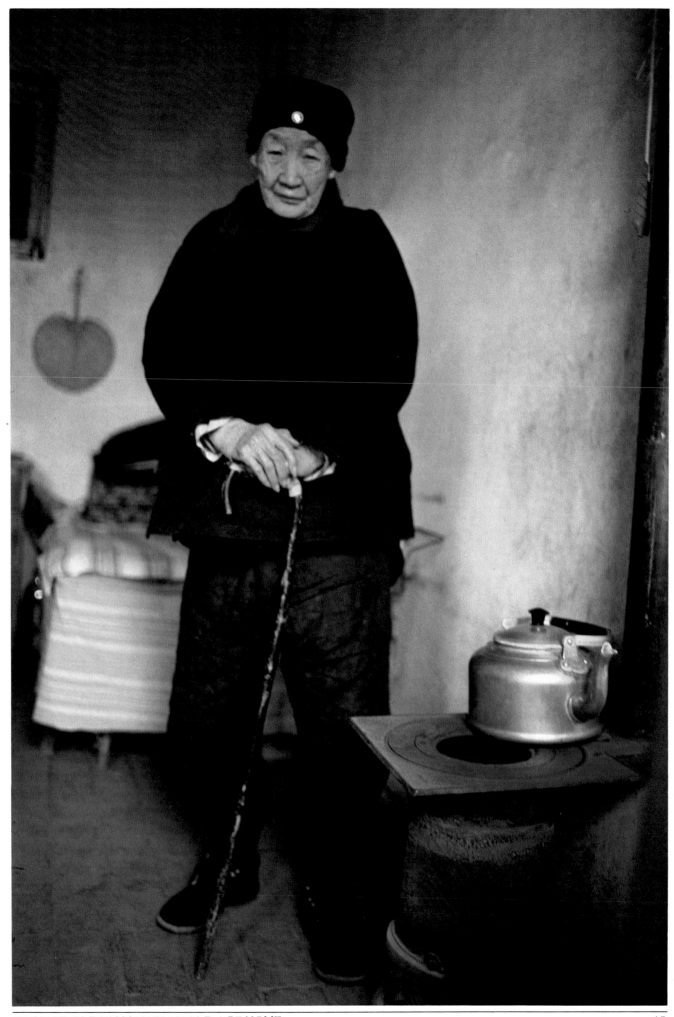

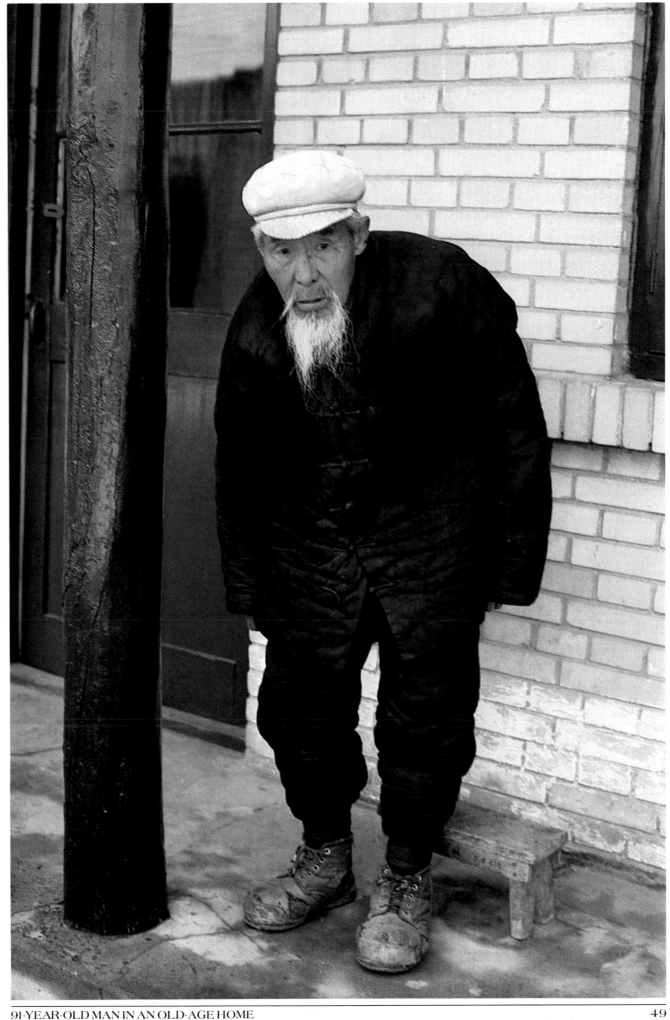

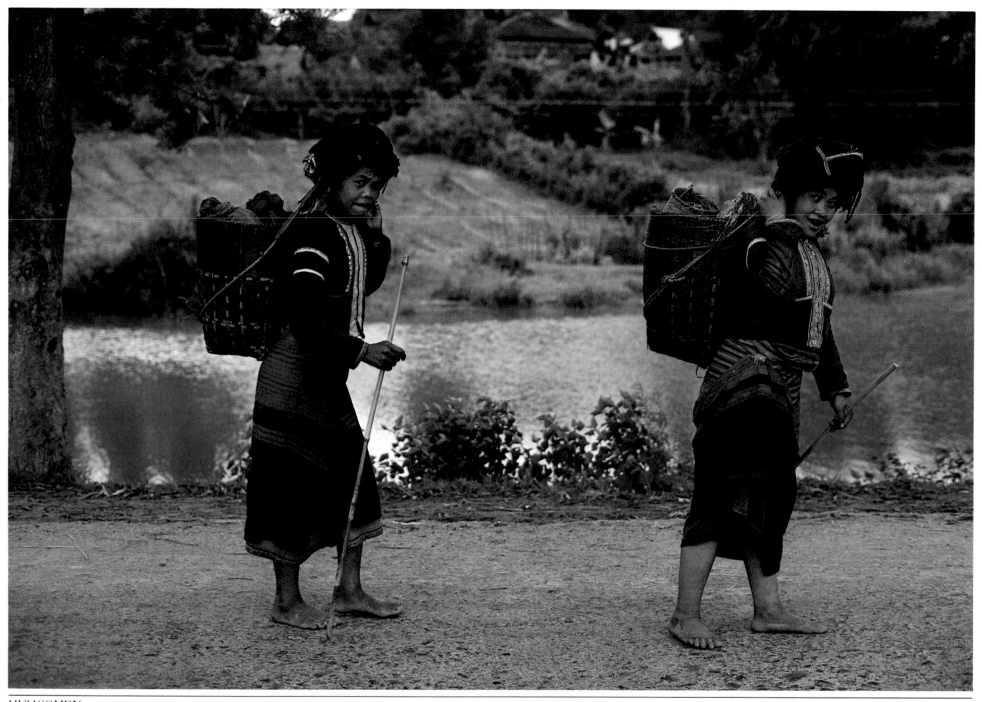

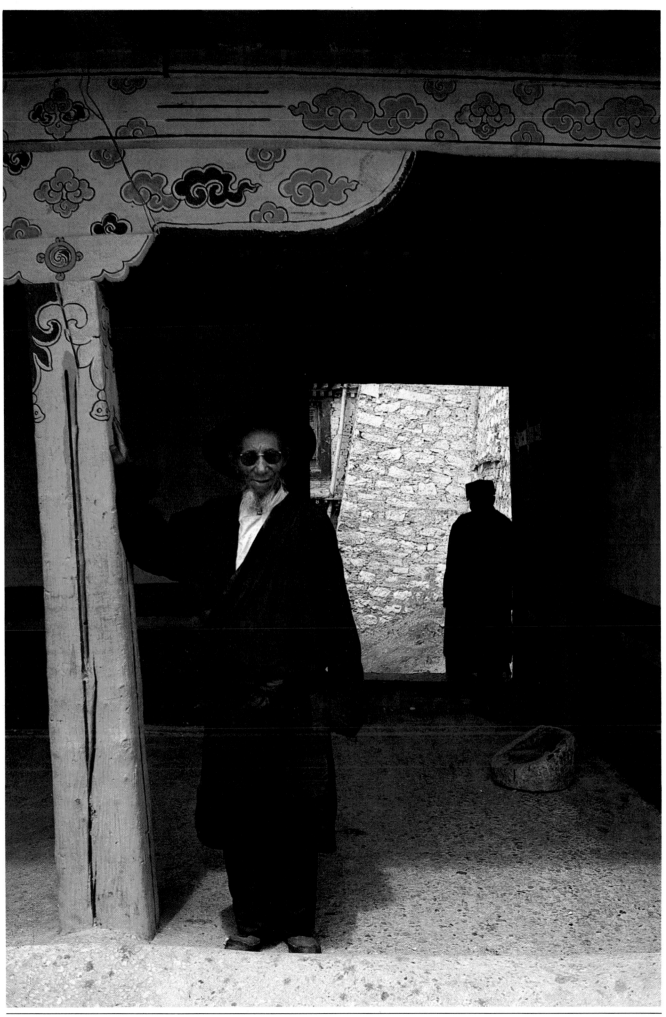

CARETAKER AT THE POTALA PALACE

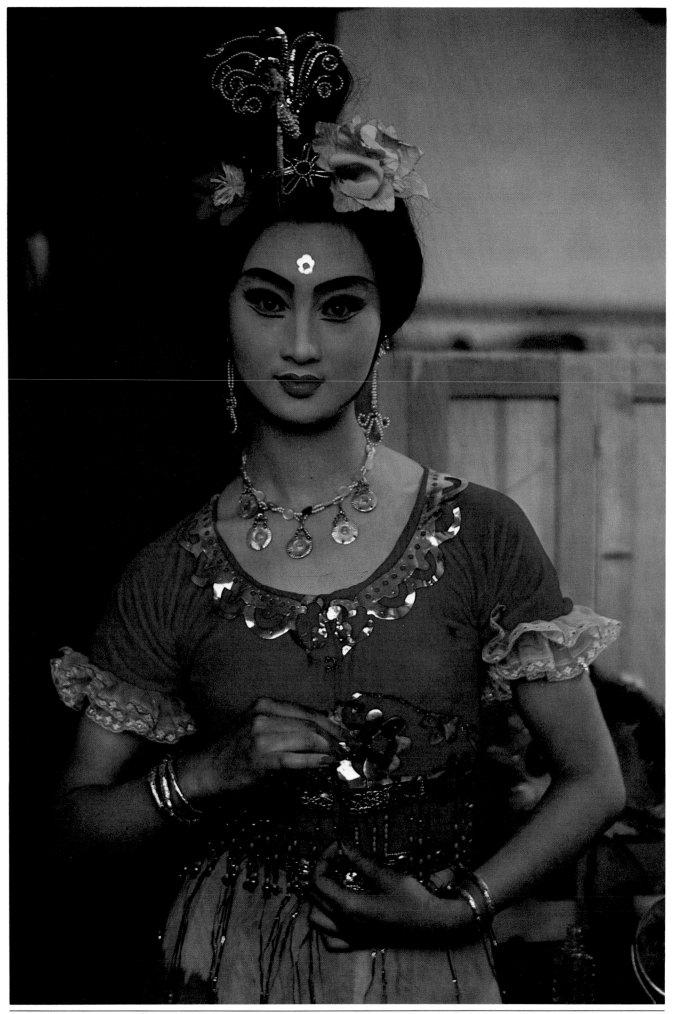

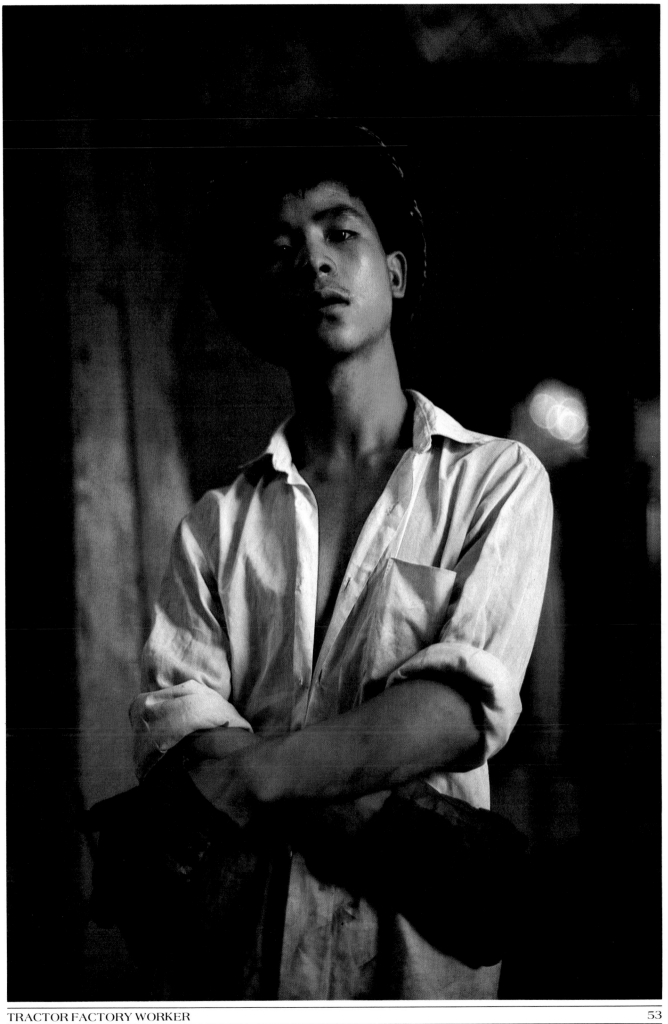

TRACTOR FACTORY WORKER

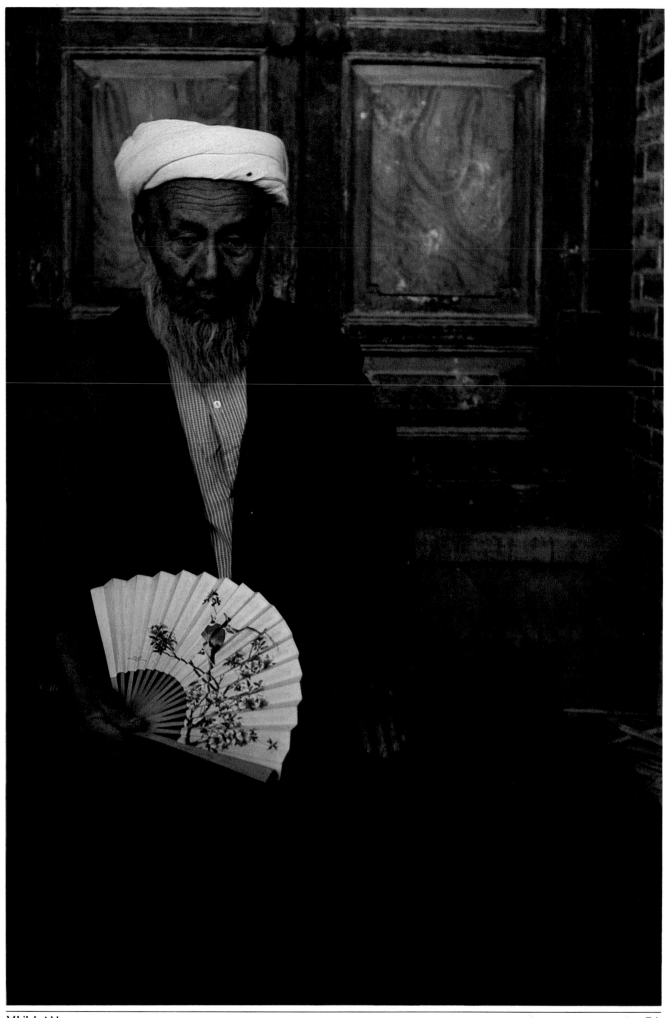

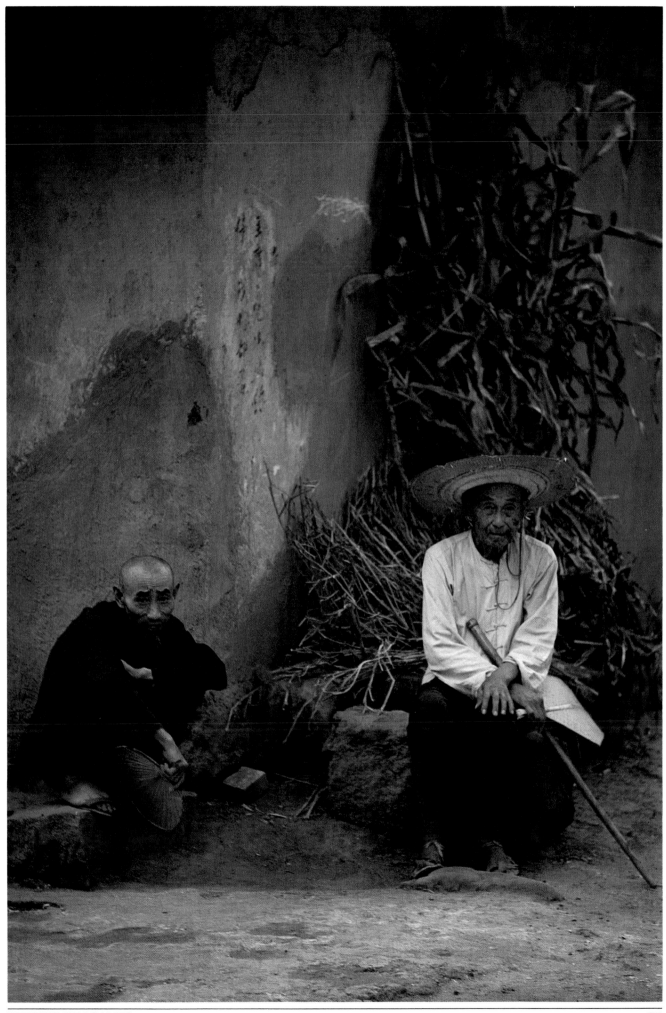

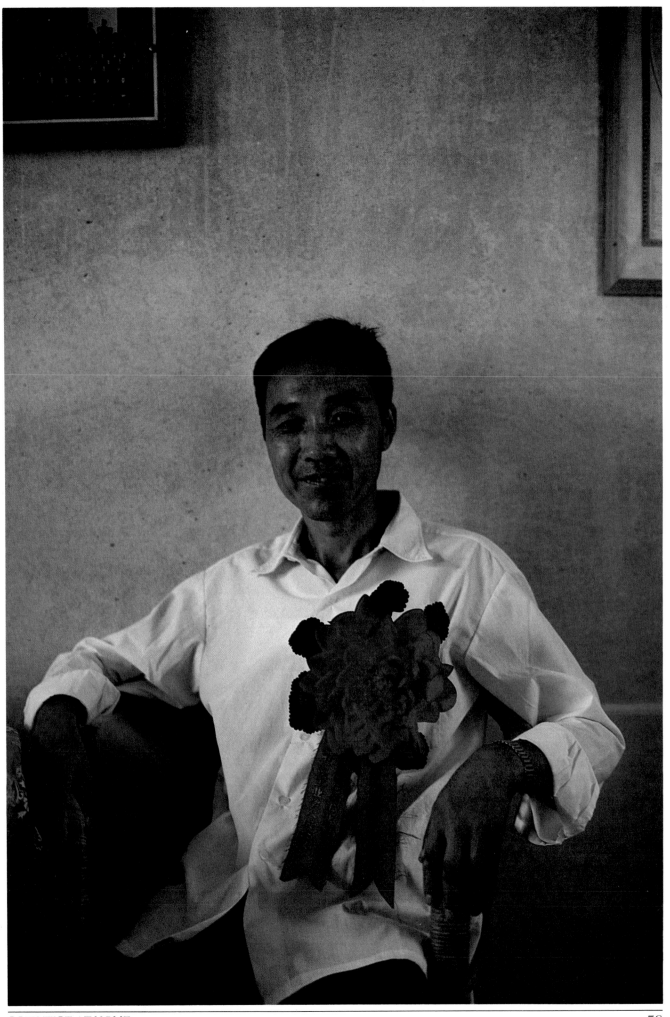

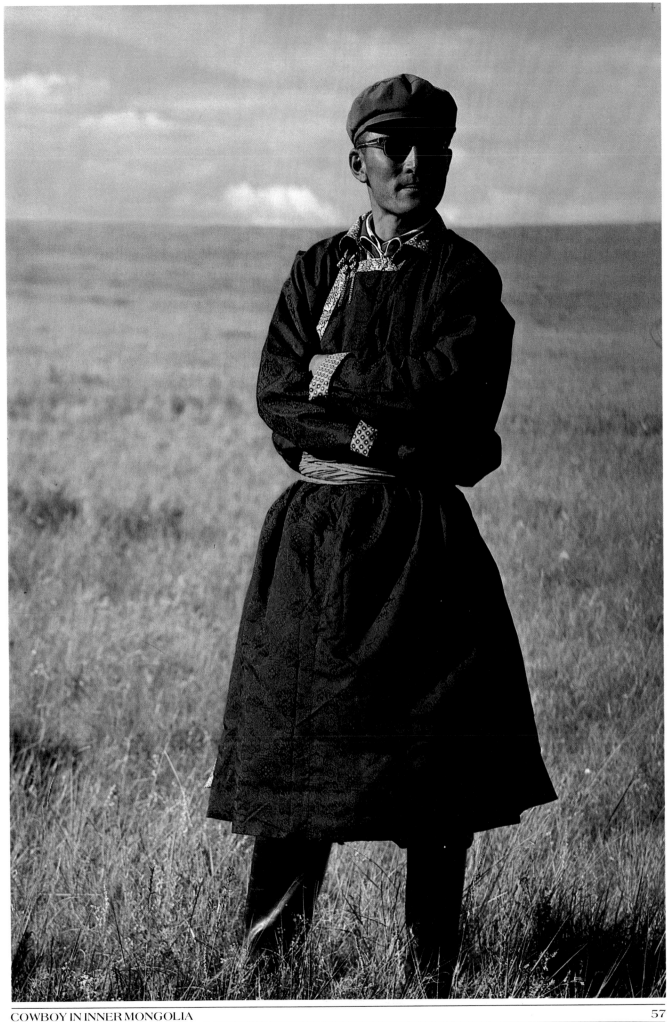

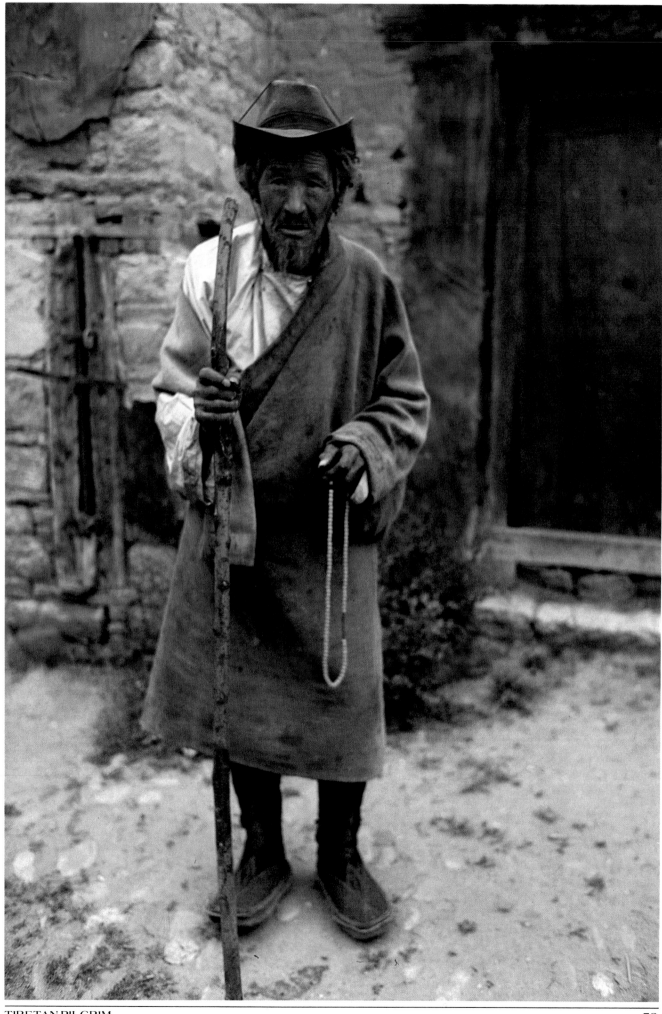

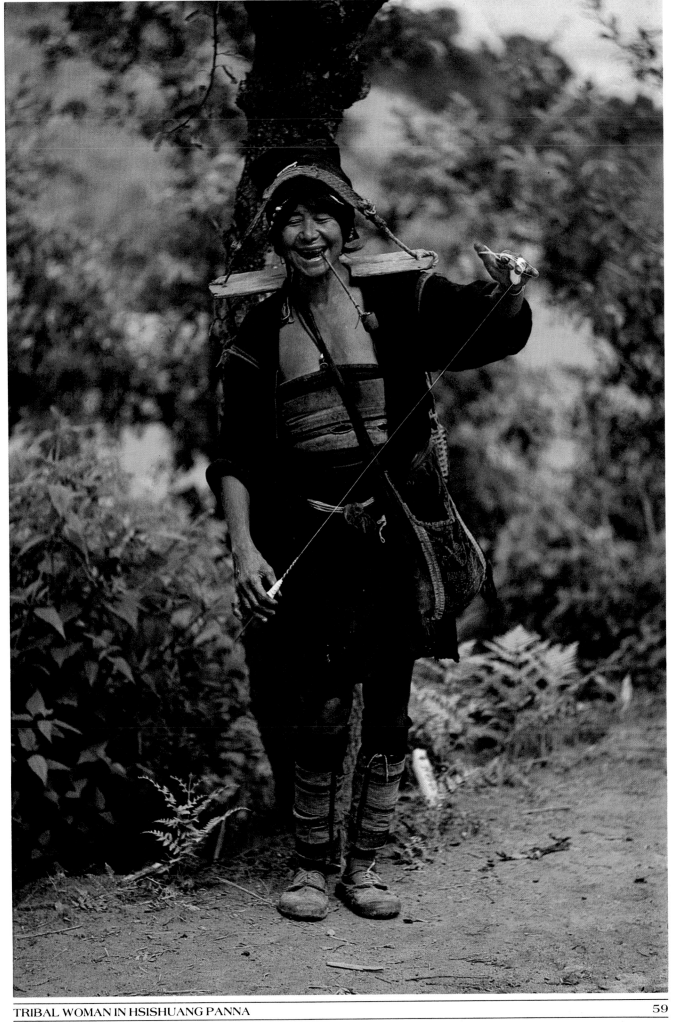

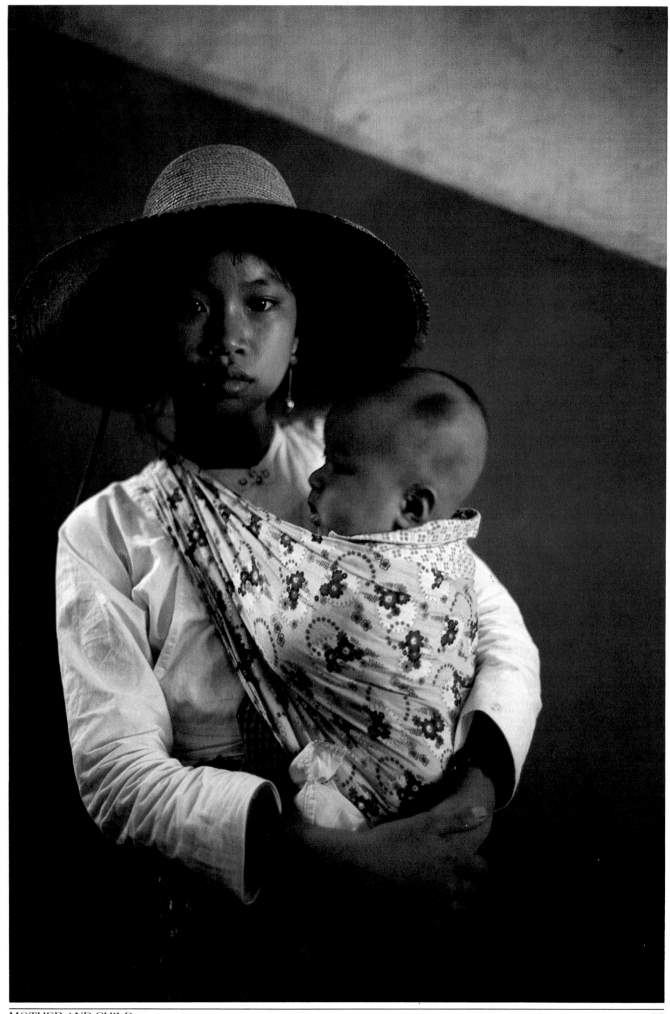

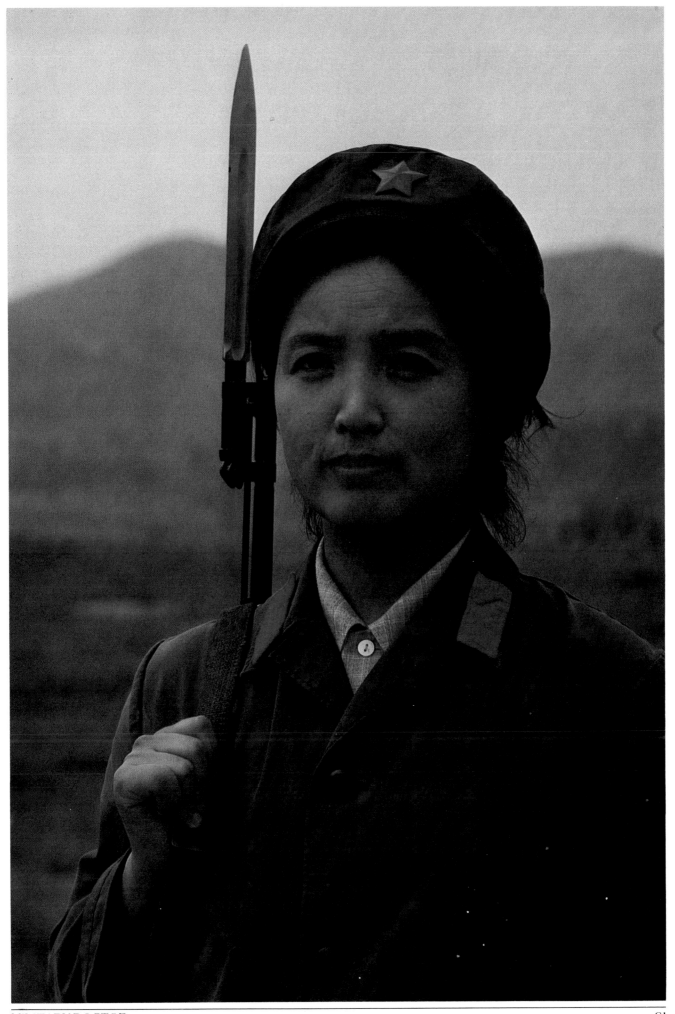

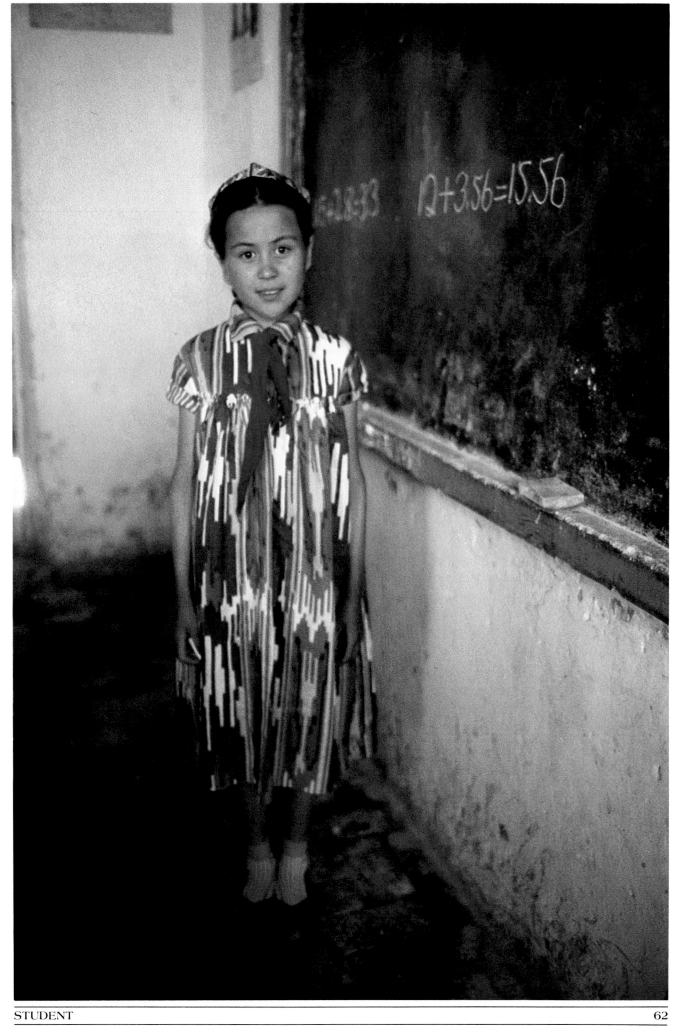

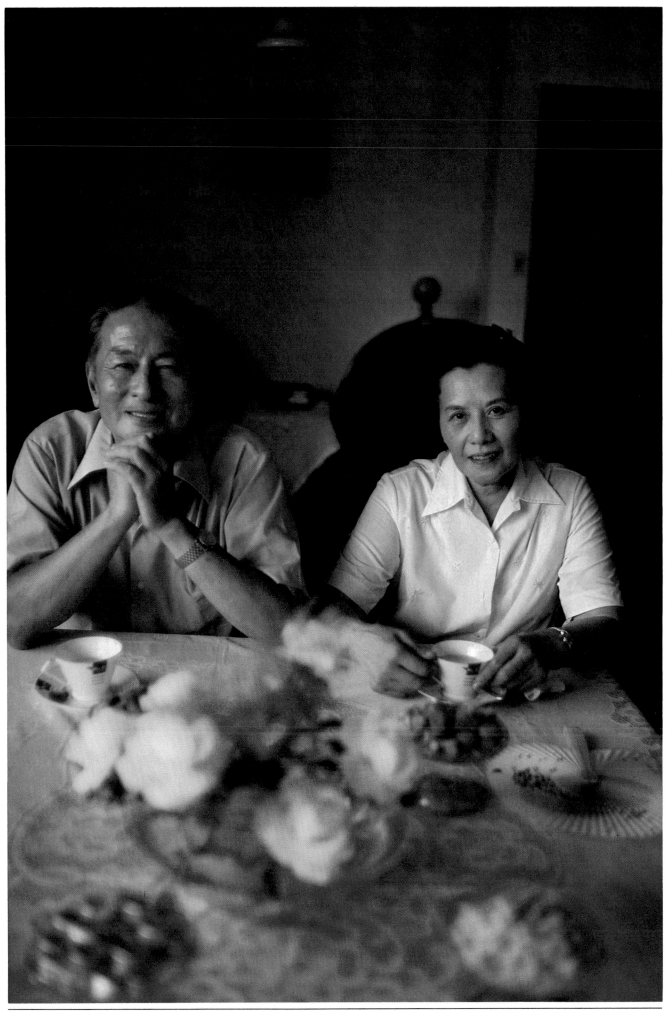

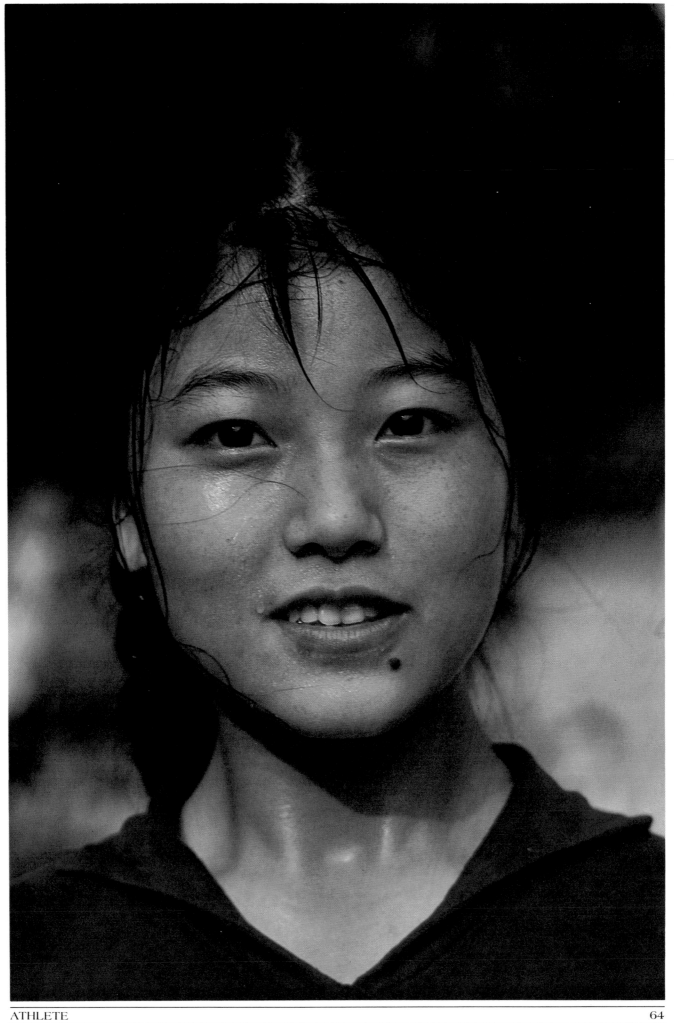

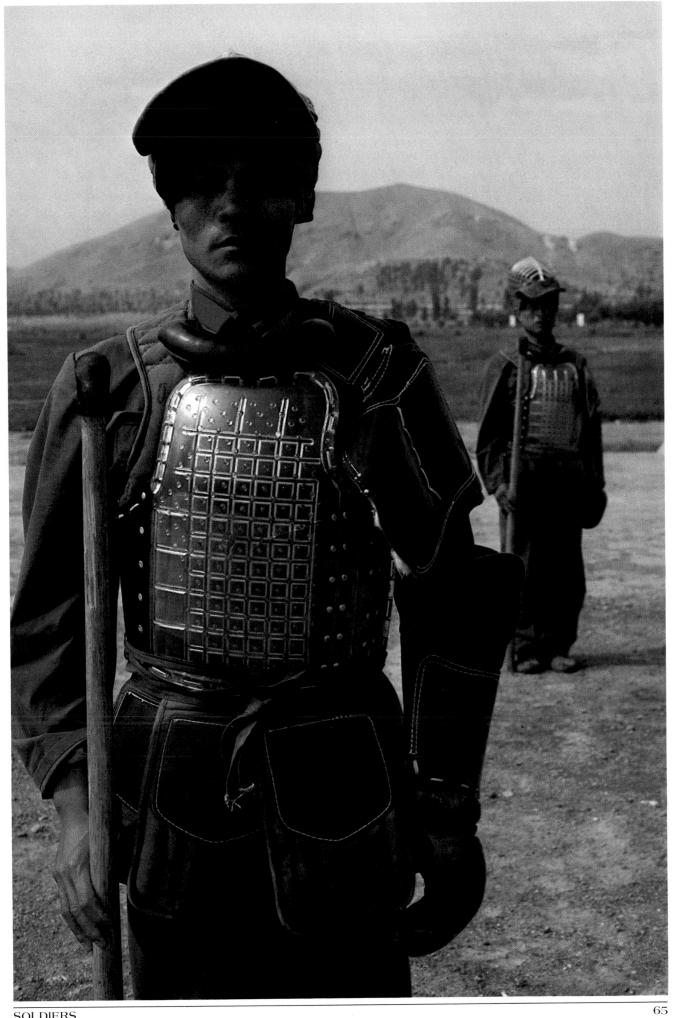

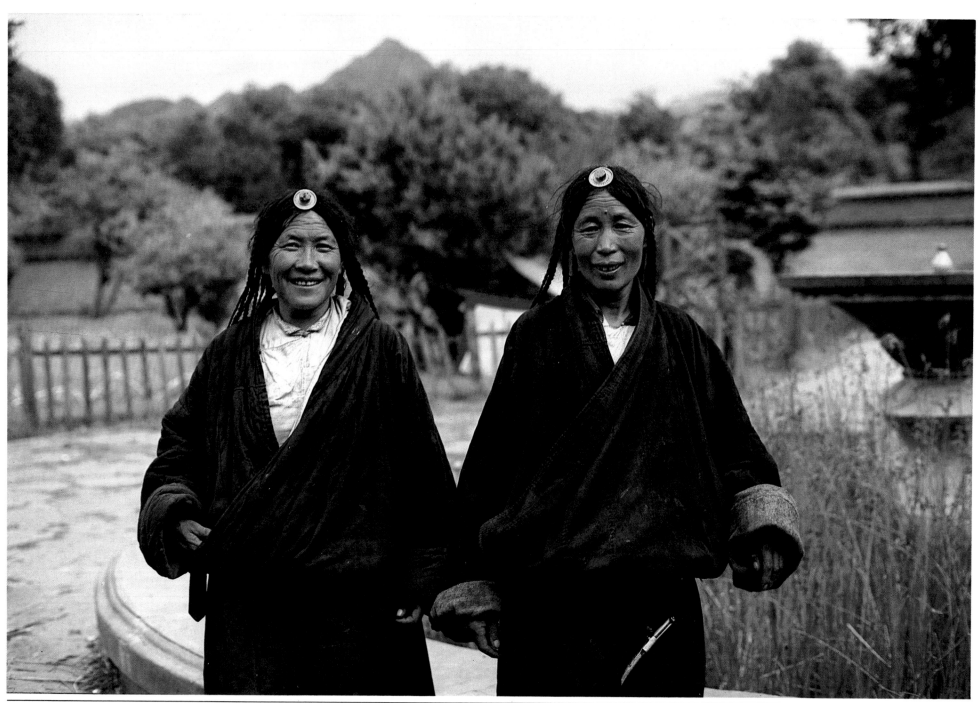

TIBETAN WOMEN ON A SUNDAY STROLL

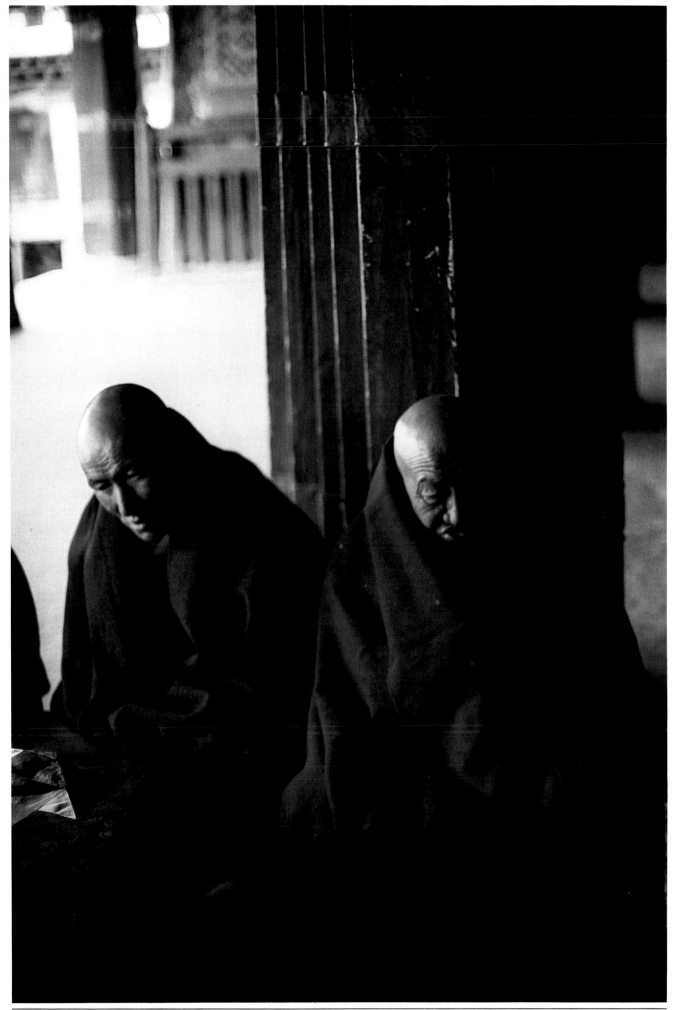

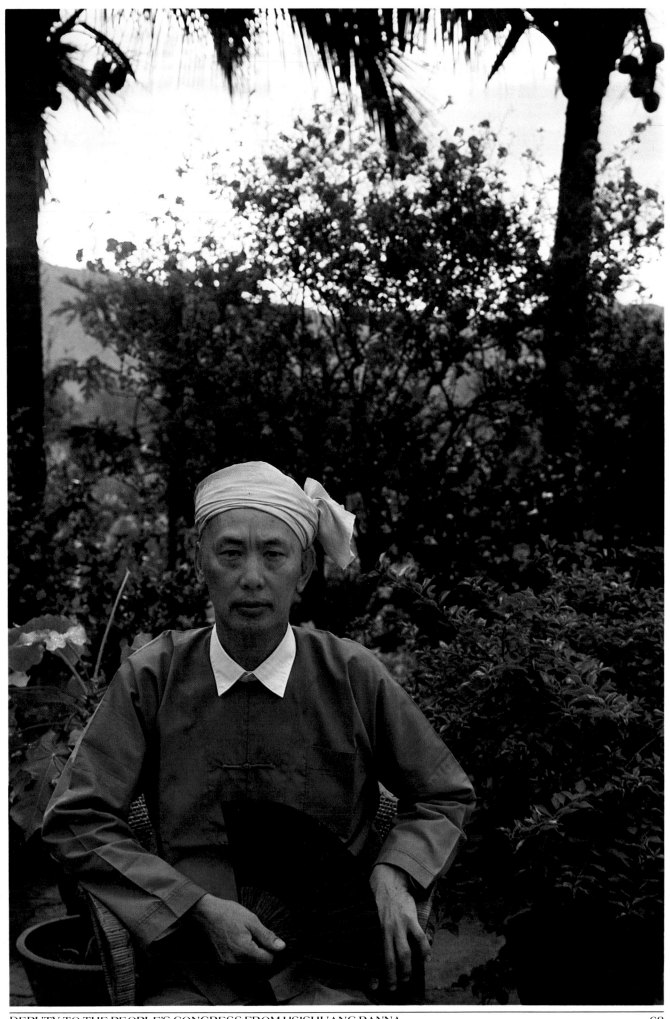

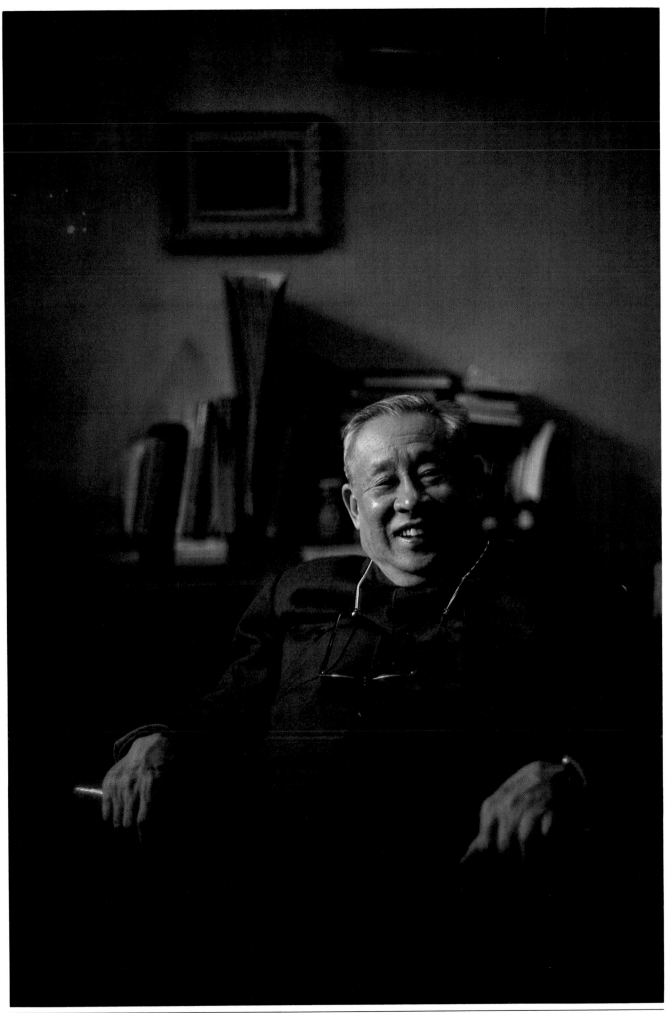

WORK

Since work and production are the heart of communism, when in China I had asked to see a cross section of industry, agriculture, and the professions. Every able-bodied person is expected to work; as the new constitution says: "The State applies the Socialist Principles — 'He who does not work, neither shall he eat,' and 'From each according to his ability and to each according to his work.'" This approach yielded me a most varied mix: scientists, farmers, teachers, film stars, shoemakers, cowboys, road builders, doctors, loggers, oil riggers, rug weavers, pharmacists, dancers, herb sellers, rubber tappers, musicians, accountants, cooks, painters, glassblowers; people who worked in light industry (cotton and beer factories) and people who worked in heavy industry (locomotive, shipbuilding, turbine, and tractor plants); a disc jockey, a fireman, a mayor and his deputies.

According to its overall plan, the country is divided into three basic work units: people's communes, state farms, and factories. The communes are agricultural. The land is owned communally. The peasants (their word) are allotted work points for work done, and these are converted into commensurate shares. State farms and factories are run by the state, and peasants and workers receive fixed wages. There is still collective ownership of shops and small businesses; all other enterprises come under government control.

The Chinese speak of the "rice bowl," meaning livelihood, and of the "iron rice bowl," meaning guaranteed livelihood. Although they acknowledge that there is unemployment, they insist that there is work for all and that they are trying to bring the situation under control. The problem is that most available jobs are in agricultural areas far from the cities and the educated youth who make up the bulk of the unemployed do not want to fill these jobs.

People's communes are multiform. No two are alike. They are large and small, rich and poor; there are agricultural and stockbreeding communes, and combinations of the two. Communes (and factories, too) share the basic concept that they are communities in which people work, live, bear, rear, and educate their children, retire, grow old, and die. They are units of both production and local government. The push is to make each unit self-sufficient and able to defend itself so it can survive in case of war or disaster.

Perhaps a description of the Kuan Kung Commune near Peking will give some idea of how the commune works and what it is trying to achieve. Kuan Kung has 41,000 people in 10,000 households, and engages in farming, forestry, and animal husbandry. It has its own factories to produce agricultural machinery, has set up 8 pumping stations and 600 power wells, and has built numerous irrigation canals aboveground. It grows 120 varieties of vegetables and 2 crops of rice and wheat annually. Last year the commune raised 47,000 pigs. It has 12 nursery schools, 16 primary schools, and 16 middle schools. There are 16 clinics, each with one or two "barefoot doctors," or paramedics; and the commune maintains 2 state-owned hospitals, with more than 100 beds for serious illnesses, where both Western and traditional medicine are practiced. There is an old-age home that houses 70 people. Seventy percent of the people have built or inherited their own homes and many have savings in the bank.

Communes are divided into brigades and teams, which are headed by cadres. All cadres are supposed to be working cadres and are meant, in conjunction with the working people, to solve day-to-day problems on the spot. When there are government policy changes, each unit tries to apply the changes according to its own structure and its own needs. Currently two major, highly emotional changes in direction are being effected: a switch to a personal incentive system of earnings ("Work harder, earn more!"), and allowing individuals to set up their own enterprises — as long as they do not exploit others. On the roadsides there are now herb sellers offering *kingsang* and *tangshan* (long roots) for longevity and *lingchi* (big mushrooms) for potency, and people selling fruit, paintings, handicrafts, and embroidery.

A recent U.S. economic survey estimated the average monthly income in China to be thirty U.S. dollars, with each dollar having a purchasing power of five U.S. dollars. Of course, the cost of living in China is much lower than that of industrialized nations, but then so are the living standards. Incomes vary greatly from job to job. Liu Fuchin, a top woman worker in the Victory Oilfields, earns the equivalent of eighty dollars a month (this includes six dollars' danger money, called "labor protection," and fifteen dollars' prize money for exemplary performance). The lowest paid workers I encountered were the women who work in cottage industries. In the regions around Soochow there were 150,000 women set up to do embroidery piecework during the slack agricultural season. The local lace and stitchery factory gives the women stamped tablecloths, napkins, and bedcovers, which take anywhere from a day to nine months to embroider, depending on how intricate the work is. The more skilled earn eighty to ninety cents, the average fifty cents, for an eight-hour day.

I was amazed by the diversity of the handicrafts. The Soochow Embroidery Research Institute, with its thousand-year history, was particularly interesting. Originally the institute workers wove the silken

dragon robes for the emperors. Today they still weave silk by hand, each thread manually pulled into place. Theirs is a most exotic output — including obis for Japanese geishas that sell for a minimum of a thousand dollars. (It takes up to six months to make an obi three meters long.) They also weave embroidered paintings, silk strand by silk strand, one of which took four years to make. These are sent on exhibitions around the world and are given as gifts to heads of state when delegations go abroad. The weavers work in a lovely old building surrounded by grass and green trees that soothe the eyes. To avoid eye strain the weavers rest every two hours. The pay is from fifty to ninety U.S. dollars a month, depending on the skill of the worker.

I wanted to know how artists, particularly painters, fit into the socialist scheme. To find out, I went to see the painter Huan Yung Yu, who was criticized and ostracized during the Cultural Revolution. During those years he would be dragged two or three times daily into meetings and asked to admit that a painting of an owl asleep with one eye shut (the natural way for an owl to sleep) was actually an attack on socialism and the socialist system. Some said it lampooned Chairman Mao. He withstood the attacks, although being awakened at any hour of day or night took a toll on his health. He continued to paint in secret.

Many people sympathized with Huan Yung Yu and offered emotional support. Gifts of ceramic and live owls poured in; workers came bringing flowers; and one group of workers sent a pine bouquet, which was a symbol: Never be afraid of cold and wind and, like a pine tree, be brave and straight.

Now there has been an exhibition of the eighty paintings he made during this stressful time, and a film about him is in the planning stage. Today he is painting happily. His entire output goes to the state, most of it to be sold abroad for prices of up to ten thousand dollars. He has been given a four-room apartment in a new building in Peking, complete with studio, and enough money to keep him and his family in comfort.

I also sought out people in the media. I met a typesetter at the *People's Daily,* the national government newspaper, a film star and her crew, and a disc jockey. The typesetter set type by hand from a simplified font of 2000 characters (there used to be 7000) — just another of the extreme differences with the West, where there have been serious industrial disputes over bringing in technology to handle a 26-letter keyboard.

I spent two days at the Electric-Shadow-Make-Film-Factory (the literal translation for a Chinese film studio). *The Search,* the movie being made, was a political melodrama, a three-handkerchief saga of a mother who, being a doctor, leaves her infant daughter to go off to join the army during Liberation. The story tells of separation, search, and finally presents a bedroom scene of mother-doctor treating sick daughter without knowing her identity, and, of course, the tearful denouement when they fall into each other's arms.

Chen Chong, called Flower in the film, is a seventeen-year-old student of English at the Shanghai Foreign Language College. While the makeup woman applied layers of red makeup to her round face, the actress talked about her role. She said, ruefully, that she was really too fat to play the poor girl she portrays. However, since the Chinese do not like their heroines to be emaciated, the convention being that they be round and rosy, the audience will be told that she is poor and will believe it. Word and picture do not have to match.

I was told that movie stars do not earn more than factory workers, although it is acknowledged that they play as significant a role in building communism. And they do receive the additional compensation of their fans' adulation.

The disc jockey plays an important part in the community too. The one I photographed in Wanhsien, a town on the Yangtze, is a member of the Dragon Treasure Commune. It is his job to waken the 21,000 members of the commune with the playing of "The East Is Red," and to close the day with "The International." In years past they were awakened by the morning drum and went to bed by the evening bell. (Today practically every household in China has a receiving set, and because there is only one time zone in China, it is possible for the Government Central Broadcasting to give the news all over China simultaneously — very useful in turning the country around when the ideology changes.) After the wakeup call (at 4 a.m. during harvest time and at 6 a.m. otherwise), the disc jockey broadcasts fifteen or twenty minutes of government news from Peking, then the Wanhsien news, commune announcements, local weather, and some indigenous music. The Central Broadcasting news is aired again at noon and in the evening. The local cadres use this system to speak to their people. The same pattern is followed all over China, except that in the cities there is more sophisticated fare — foreign music, sports, and English lessons.

China considers herself both a Third World country (Mao's phrase) and a developing country. In Hsishuang Panna I spoke to a group of peasants who earlier in the day had been working in the rice paddies. Yes, they said, ours is still the ancient way of toil: peasants still ride water buffalo to level the land and plant the rice shoots by hand while standing in mud to our knees. But there have been enormous changes for us since Liberation. The paddies have been cleaned up and we no longer get schistosomiasis from polluted water; there are medical care, retirement pensions, old-age benefits, education for our children. We are involved in building a better world for our children.

Yes, said an old man:

For our sons,
For our sons' sons, and
For ten thousand generations to come.

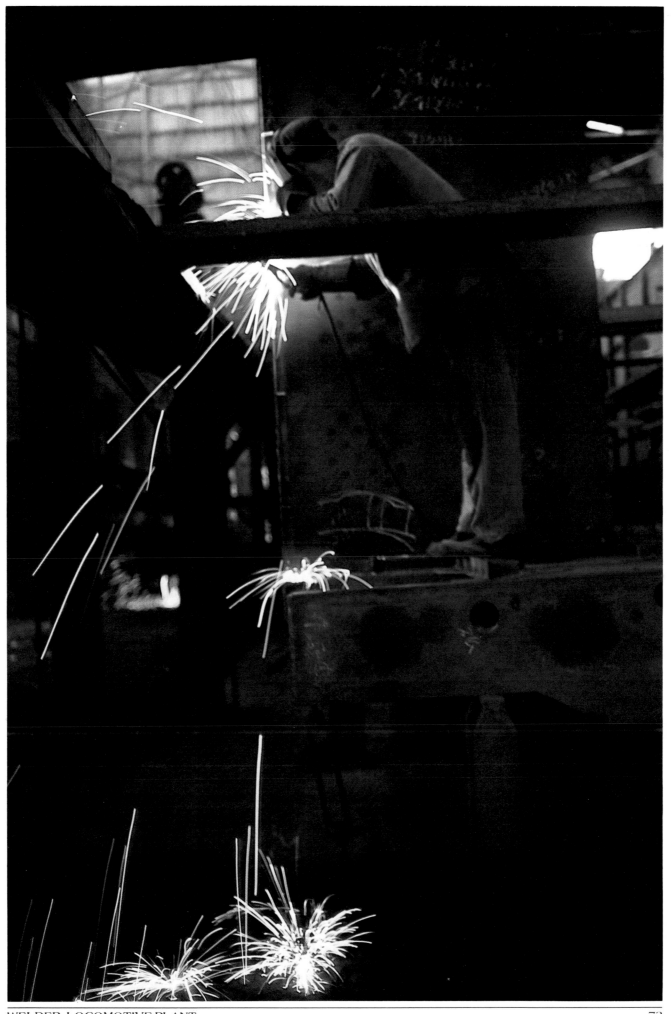

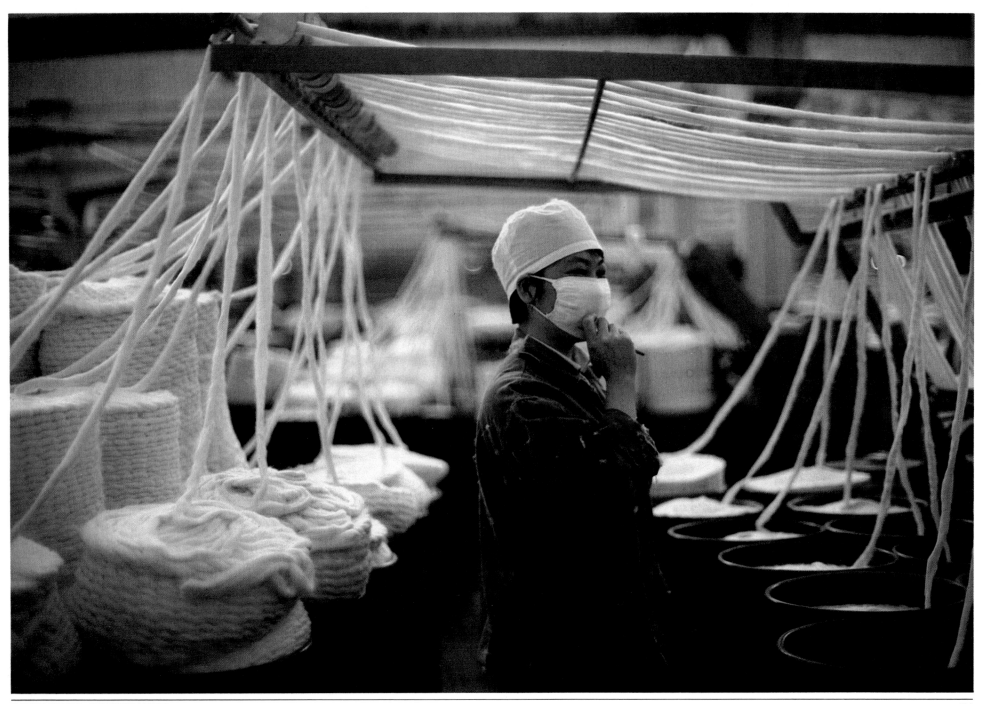

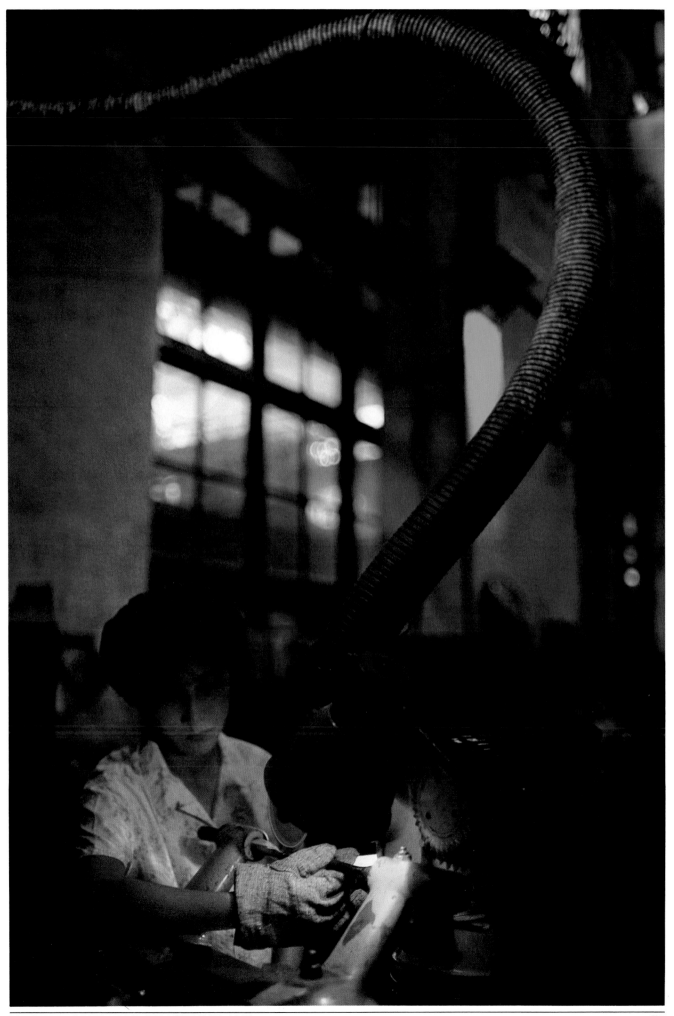

MACHINE OPERATOR, TRACTOR PLANT

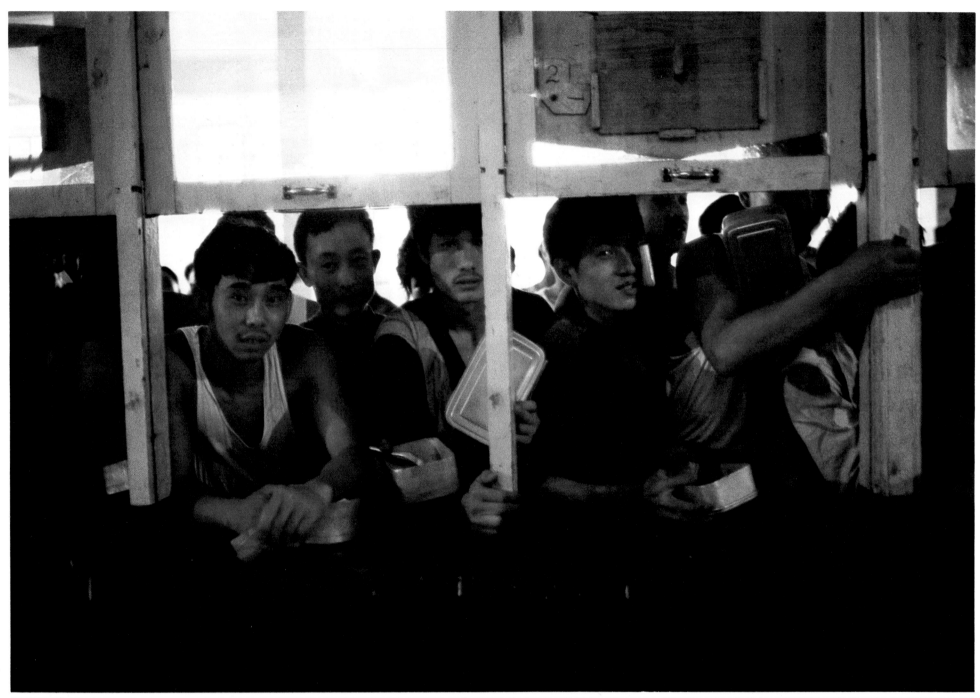

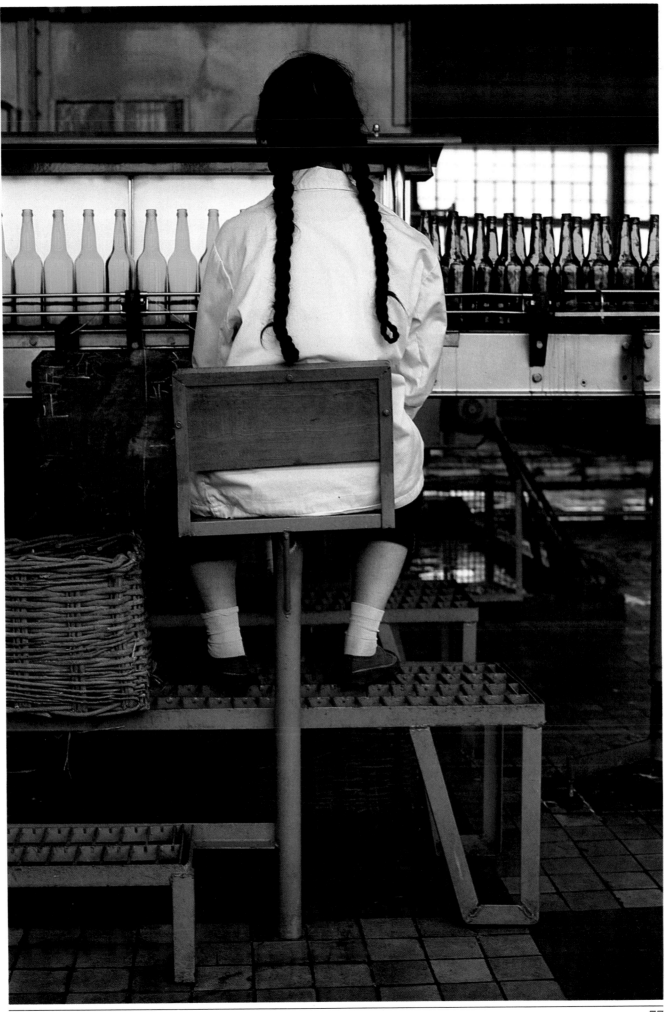

BOTTLER, BEER FACTORY

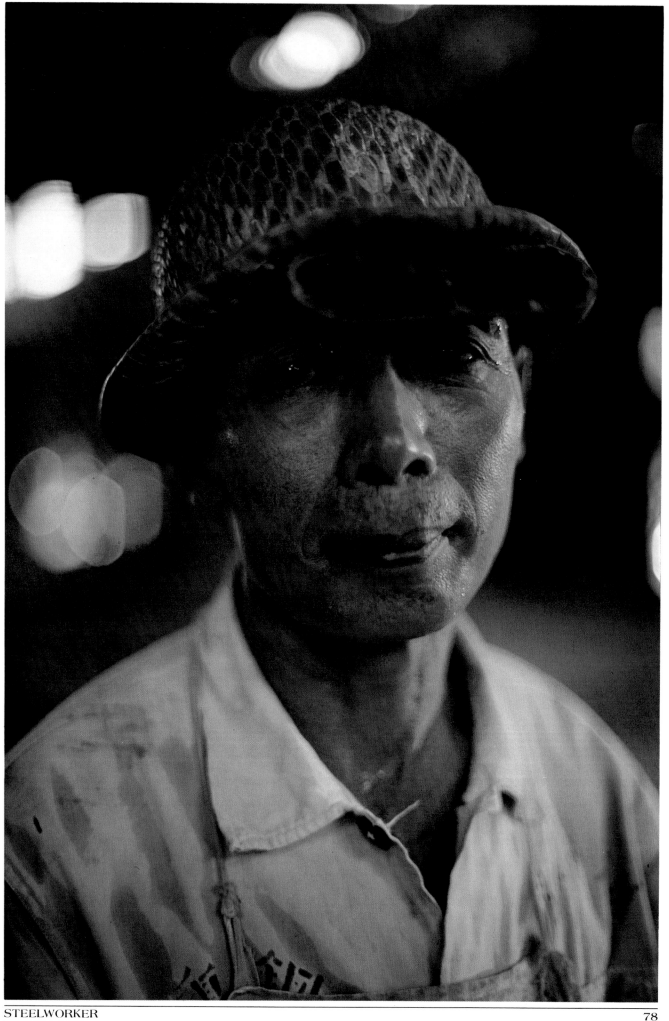

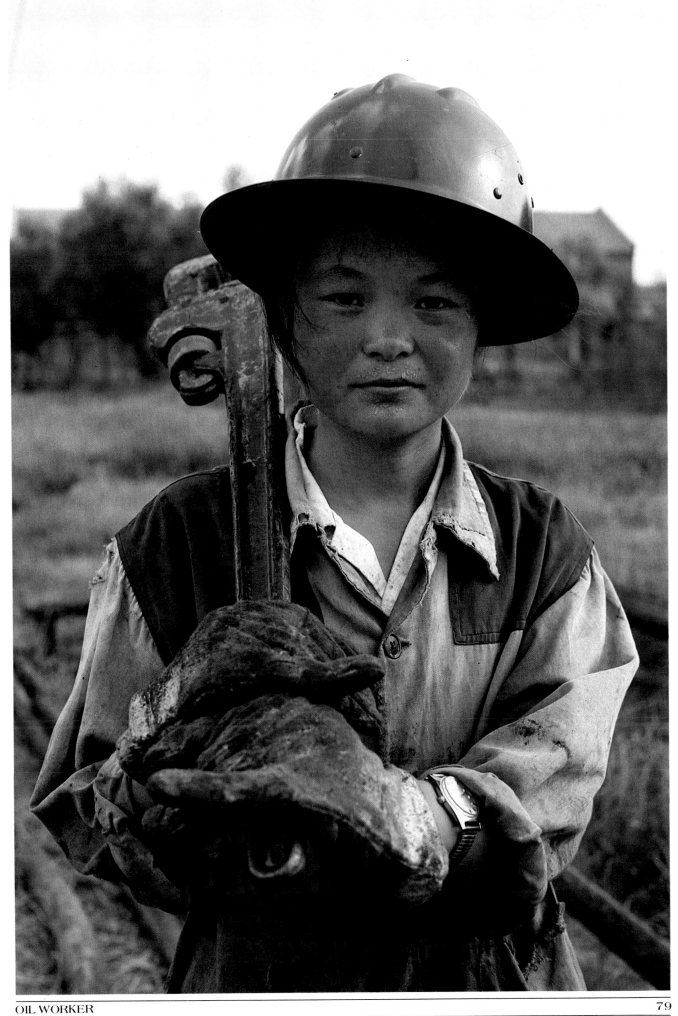

OIL WORKER

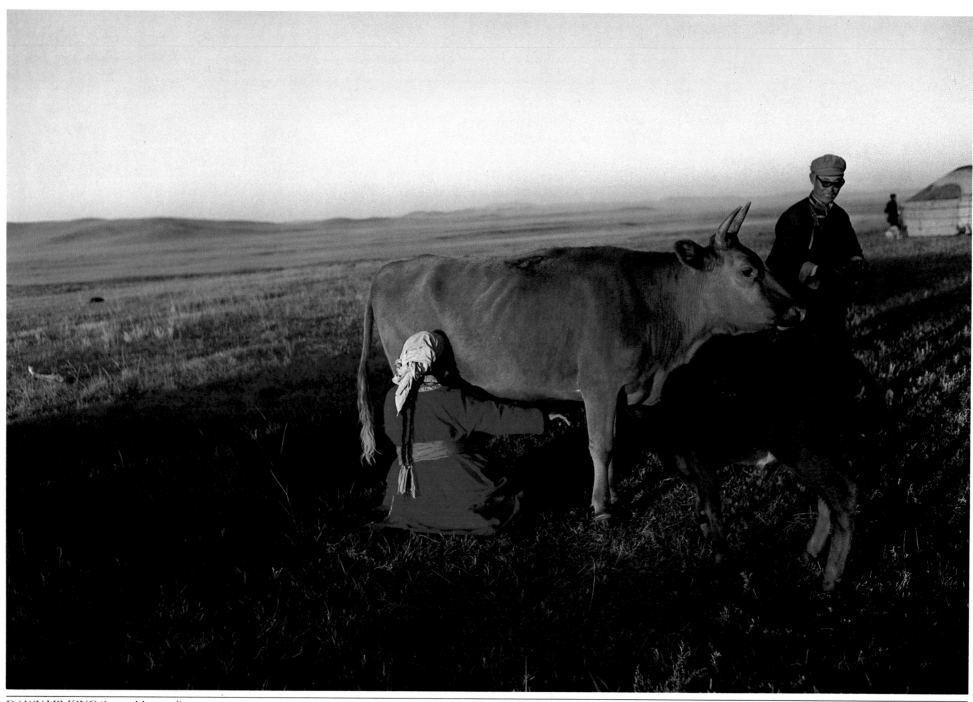

DAWN MILKING/*Inner Mongolia*

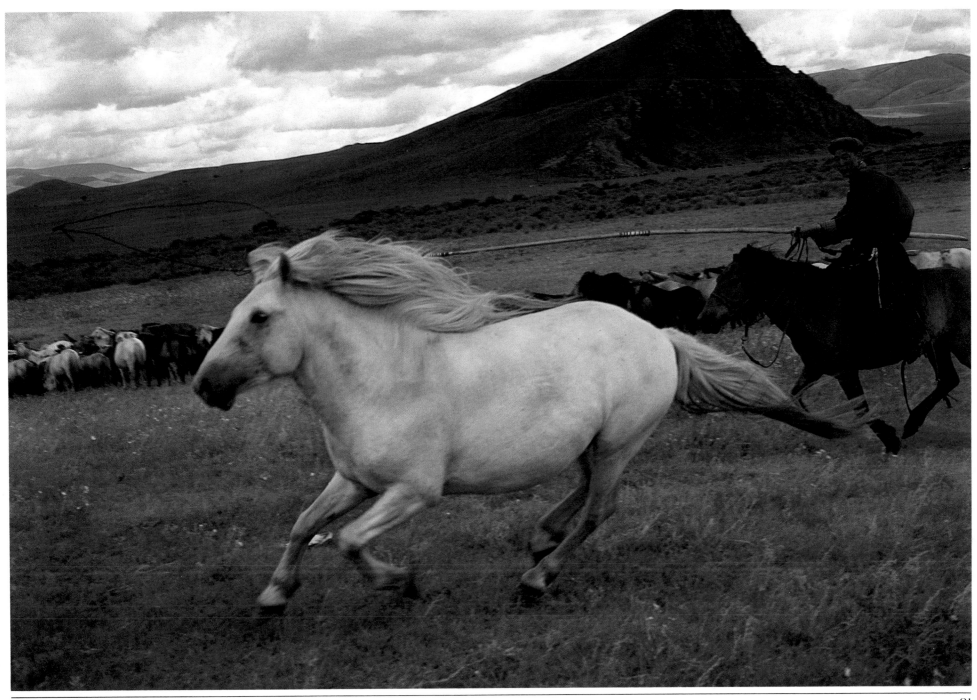

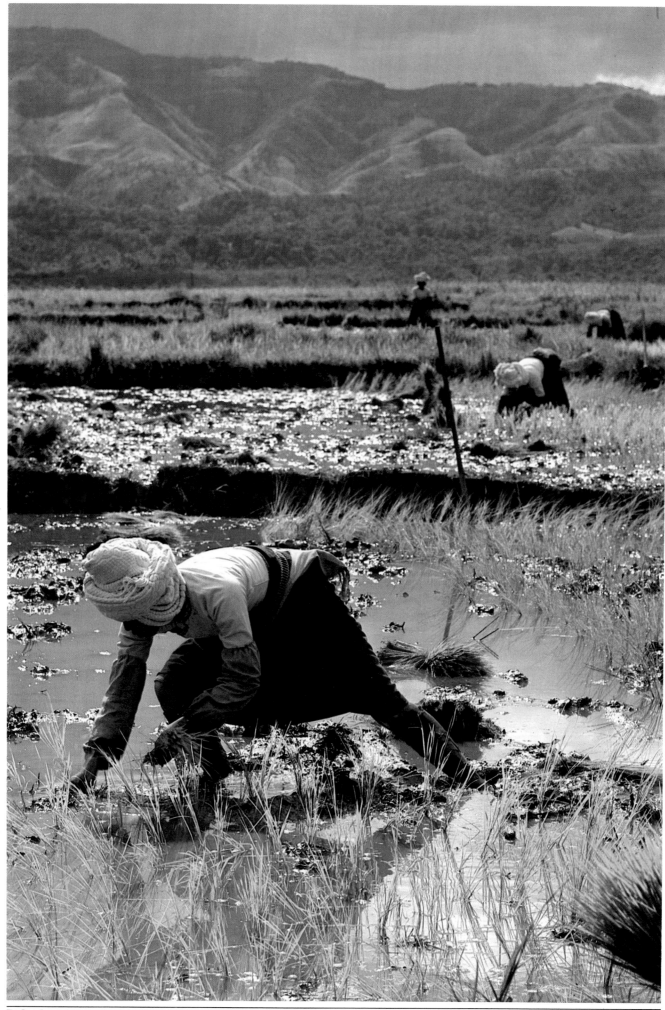

RICE SHOOT PLANTING/*Hsishuang Panna*

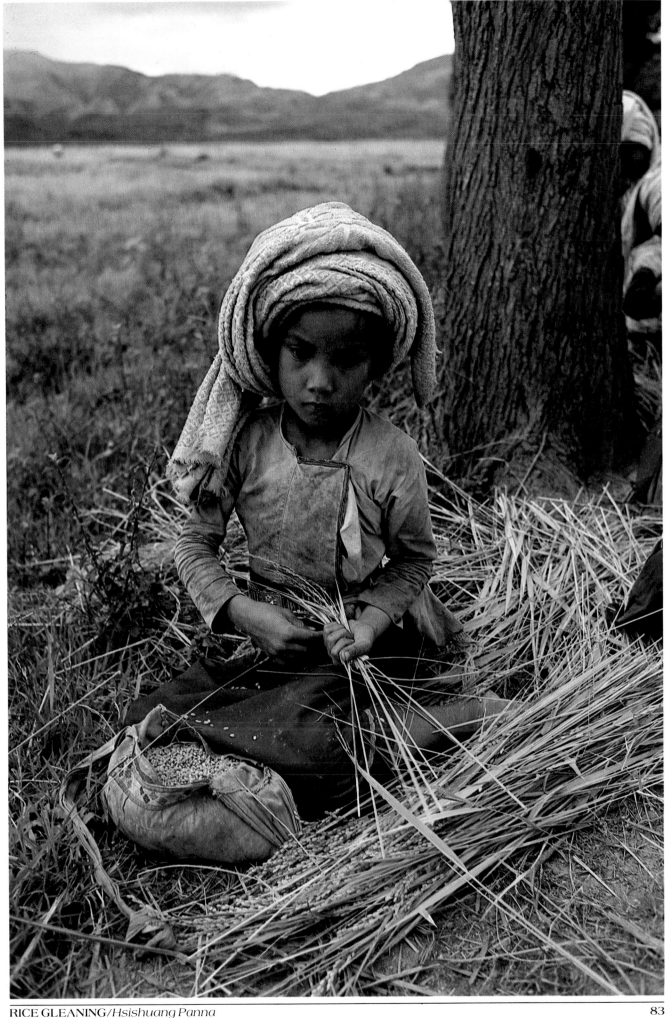

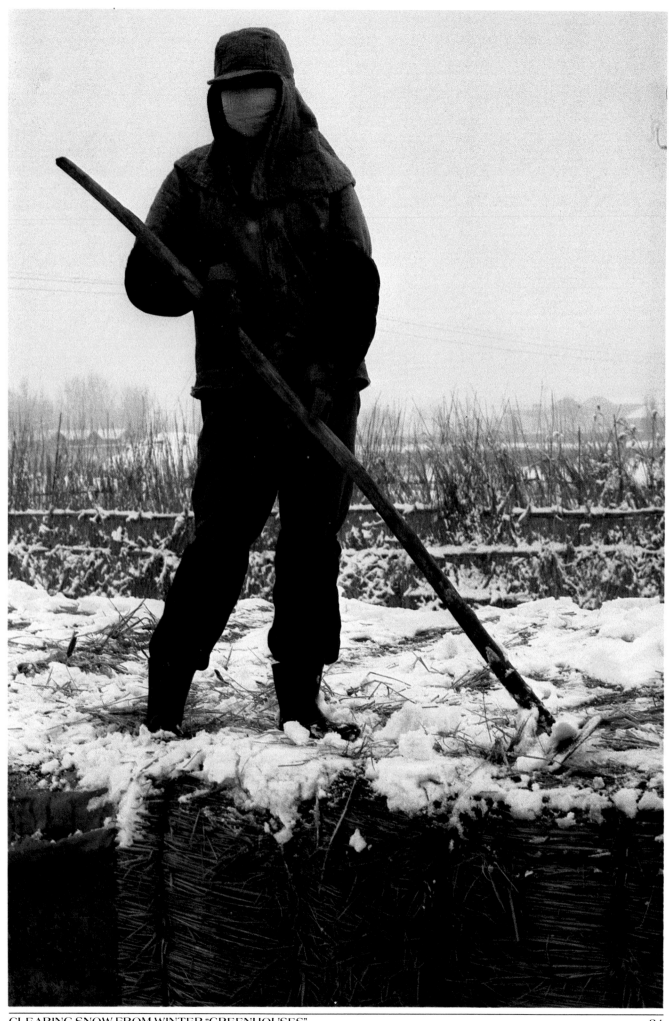

CLEARING SNOW FROM WINTER "GREENHOUSES"

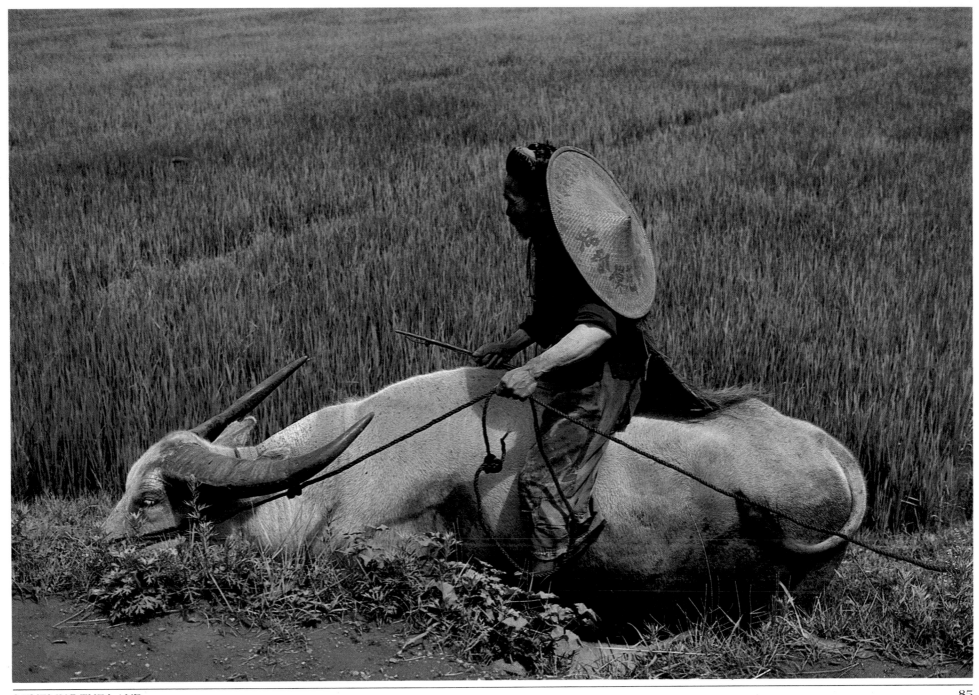

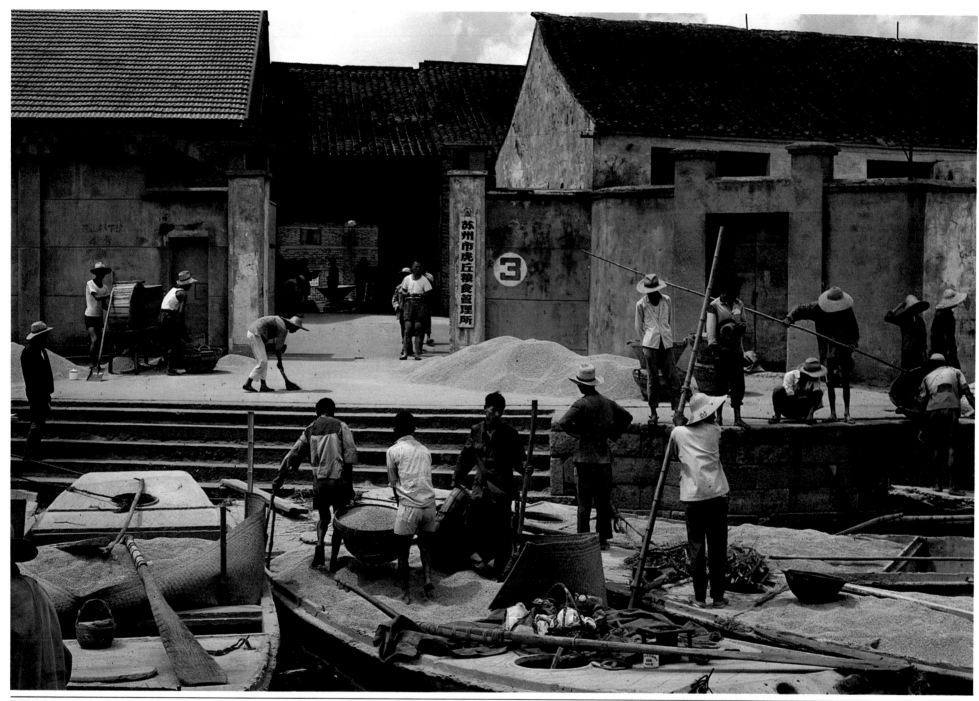

BRINGING RICE TO THE STATE GRANARY/*Grand Canal*

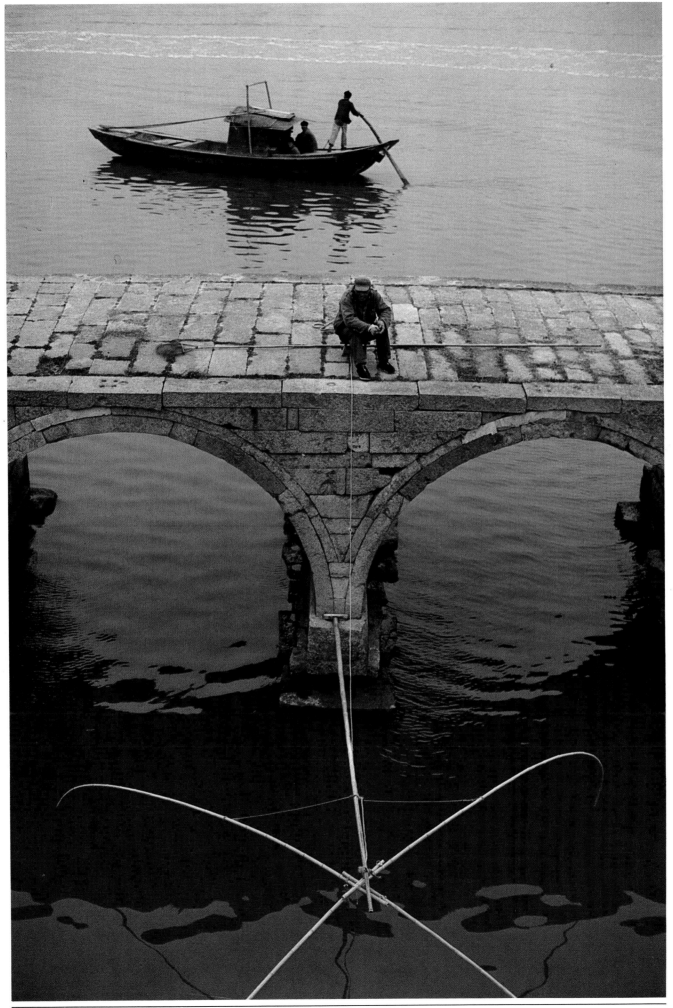

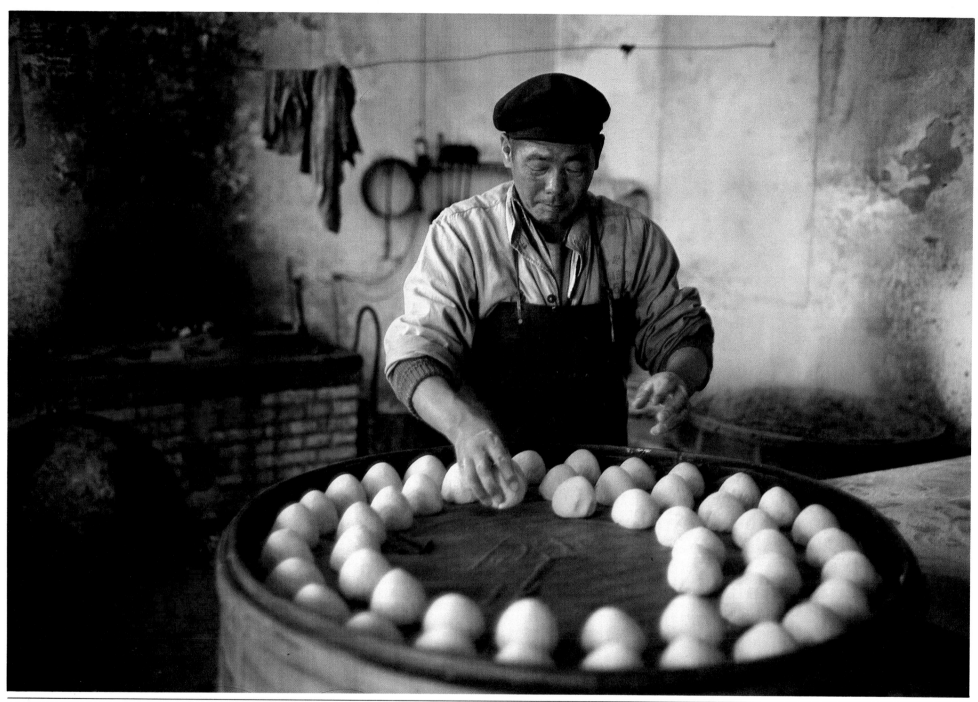

MAKING STEAMED BREAD

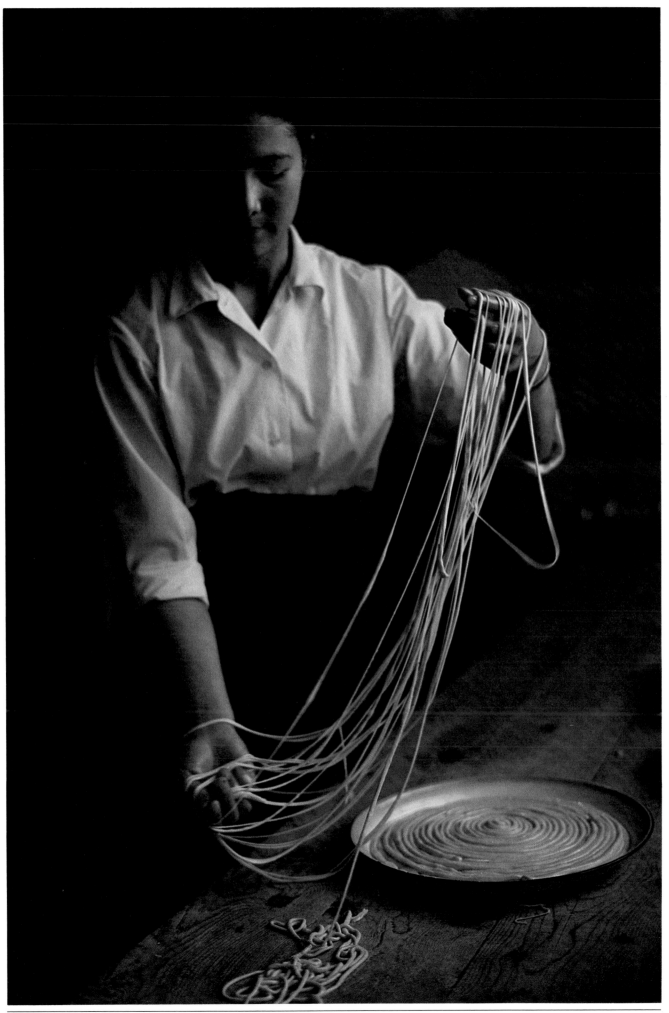

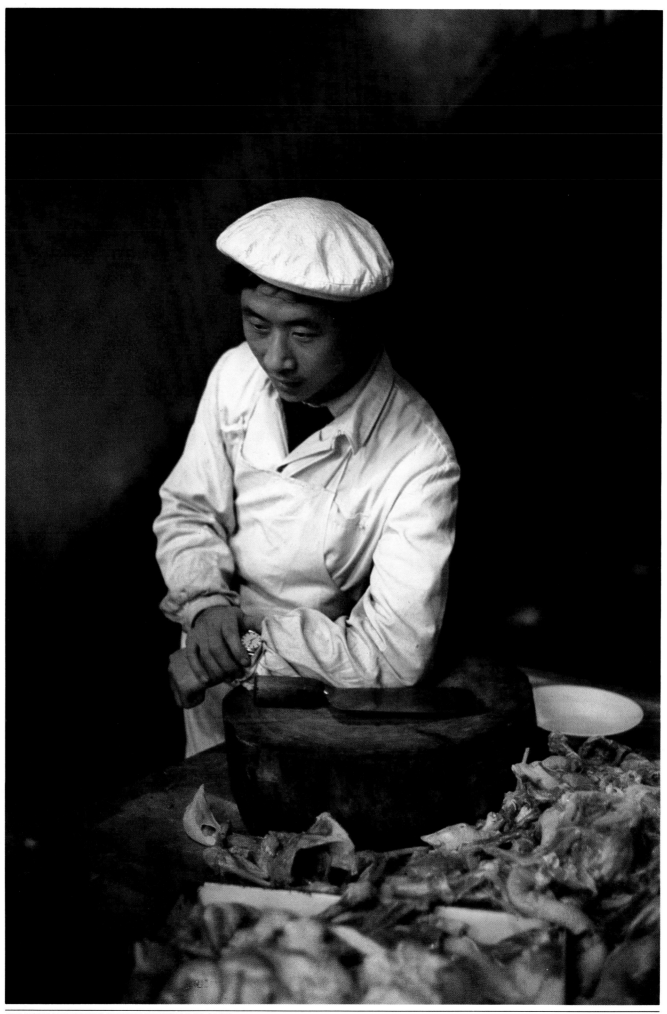

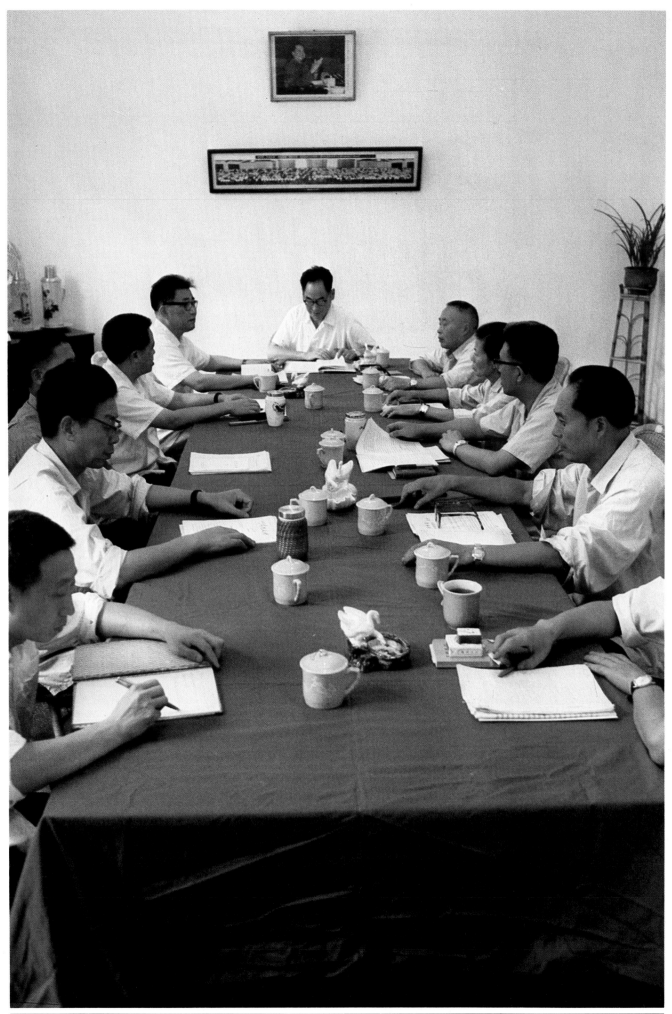

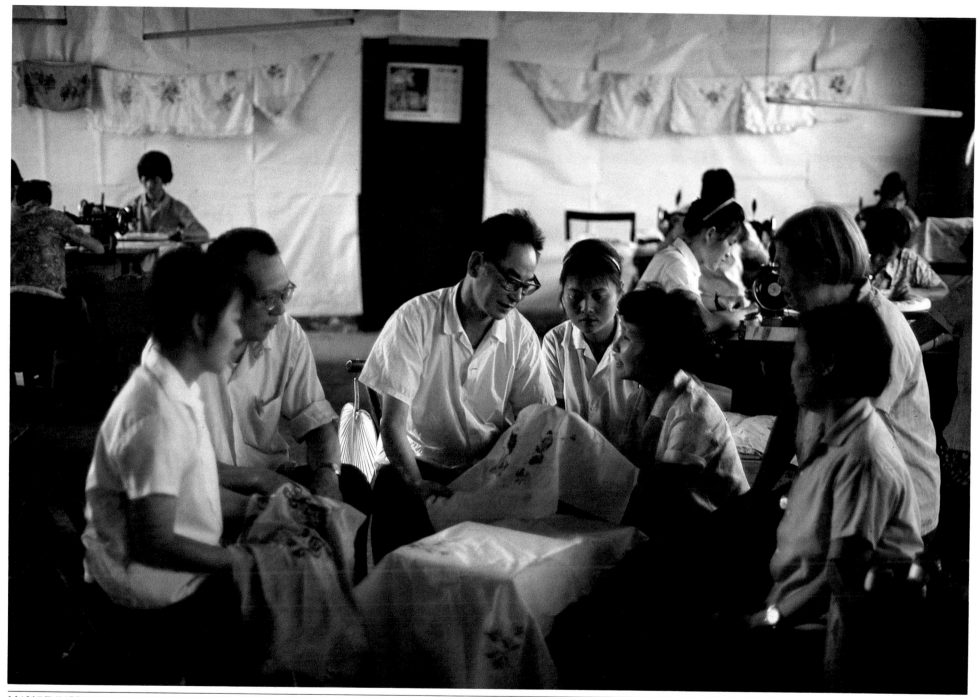

MAYOR INSPECTING EMBROIDERY FACTORY

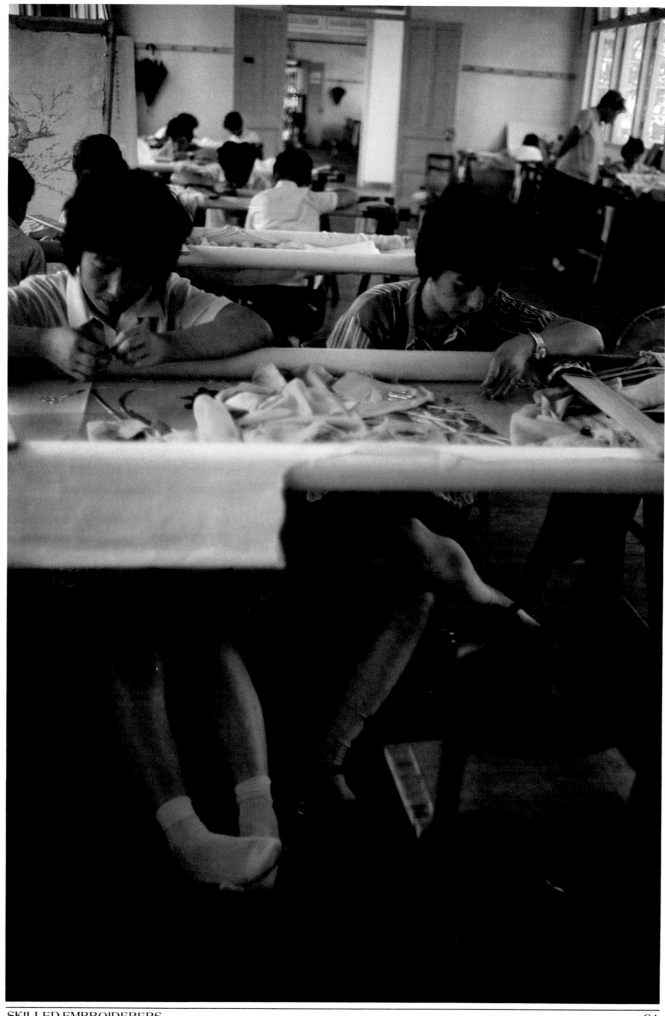

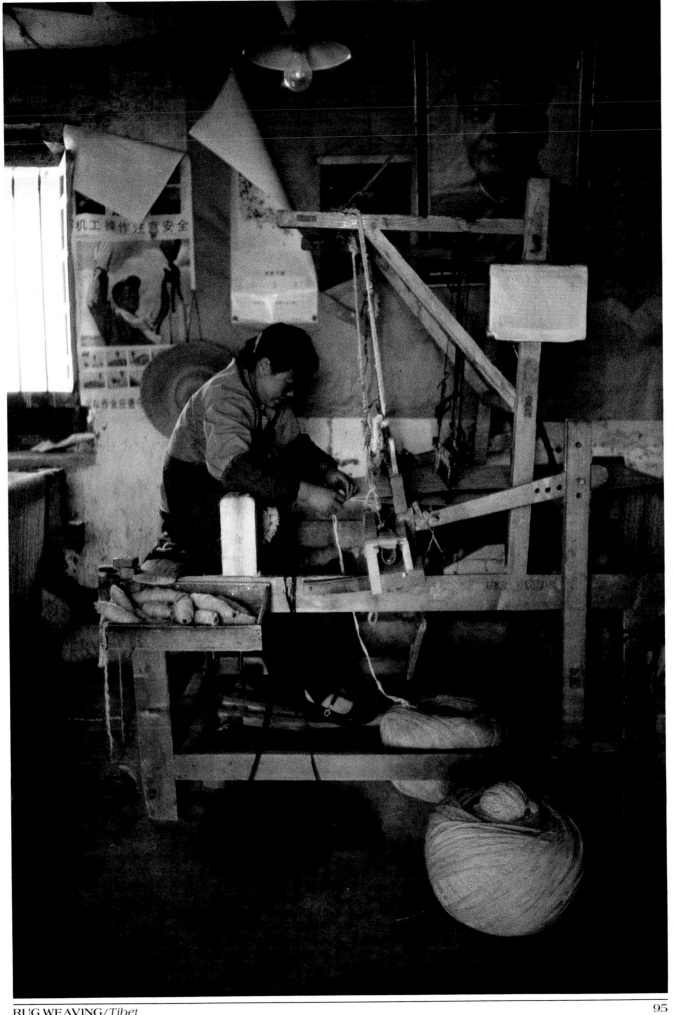

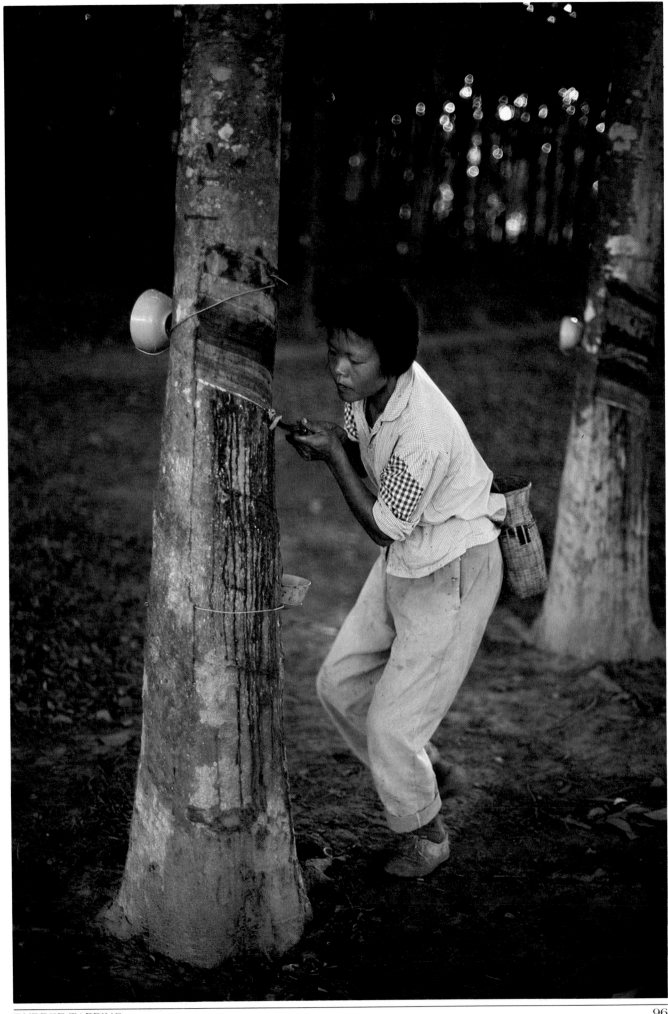

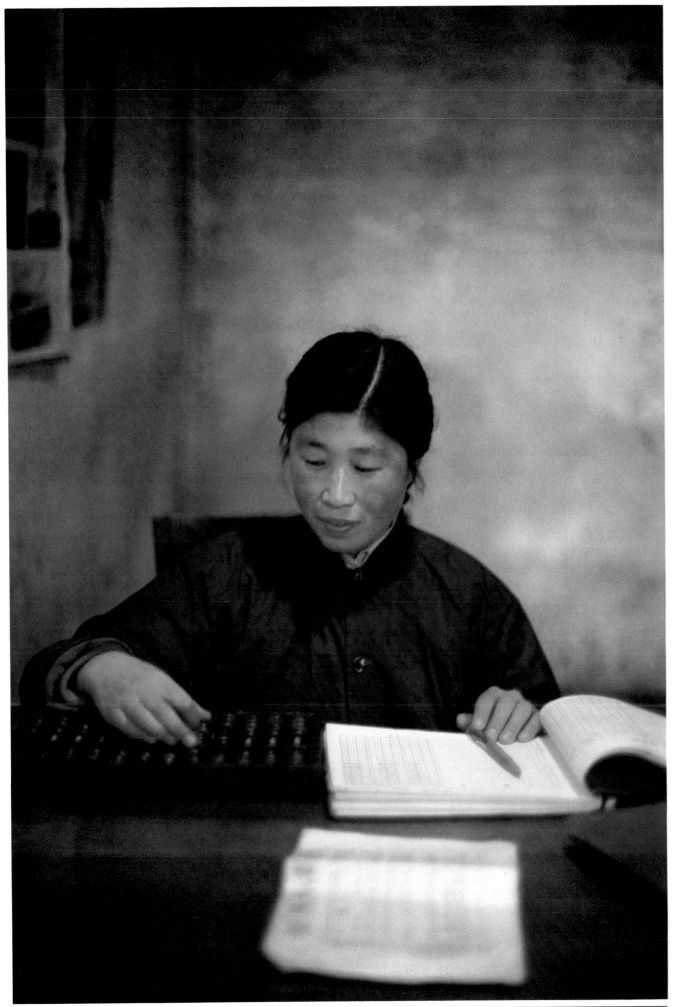

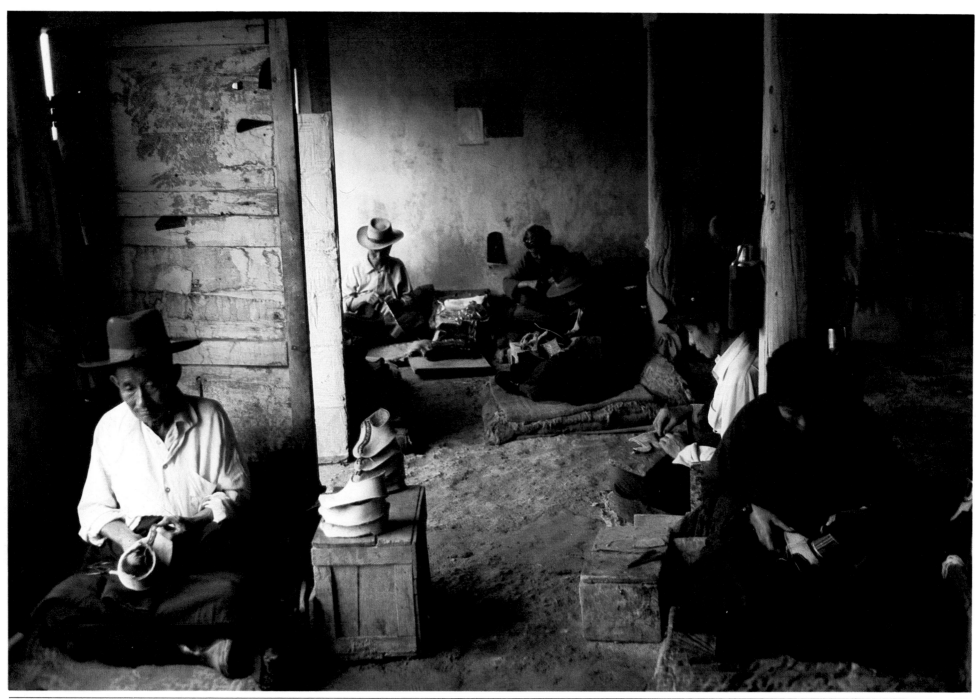

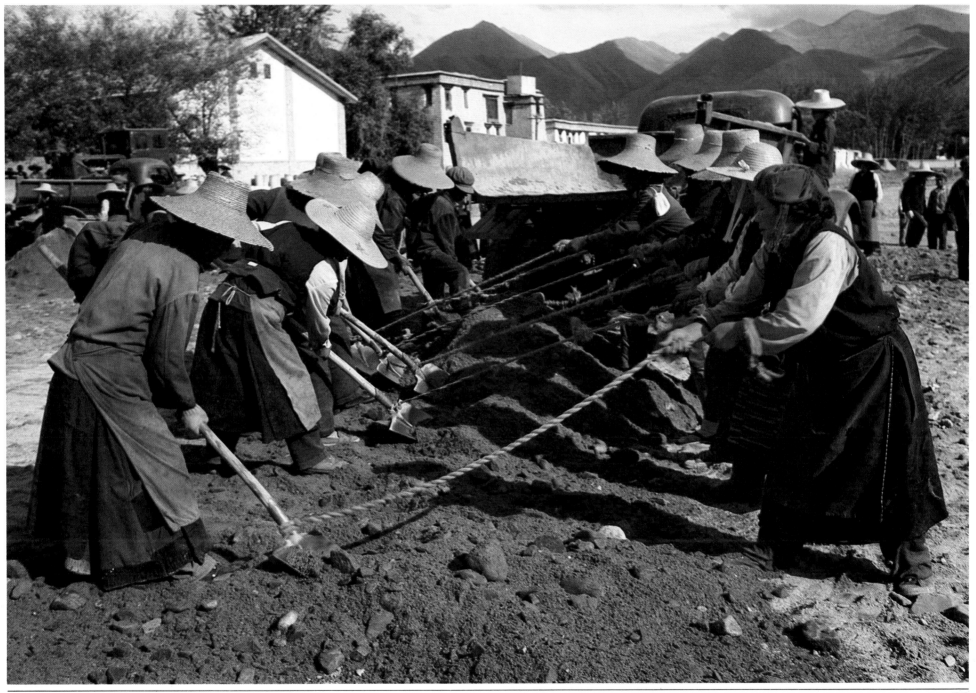

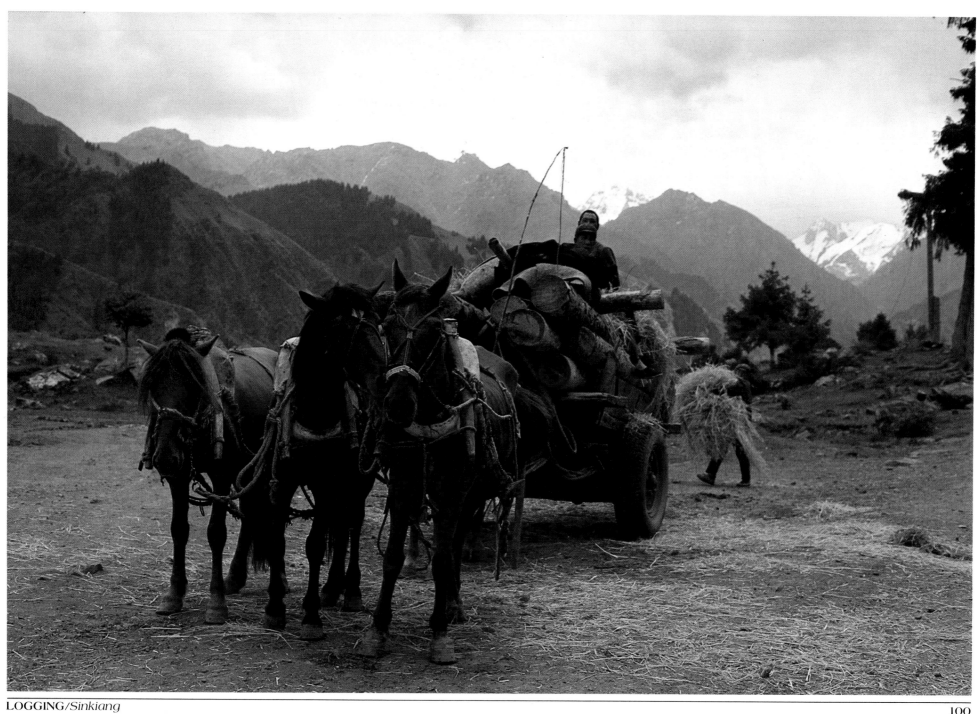

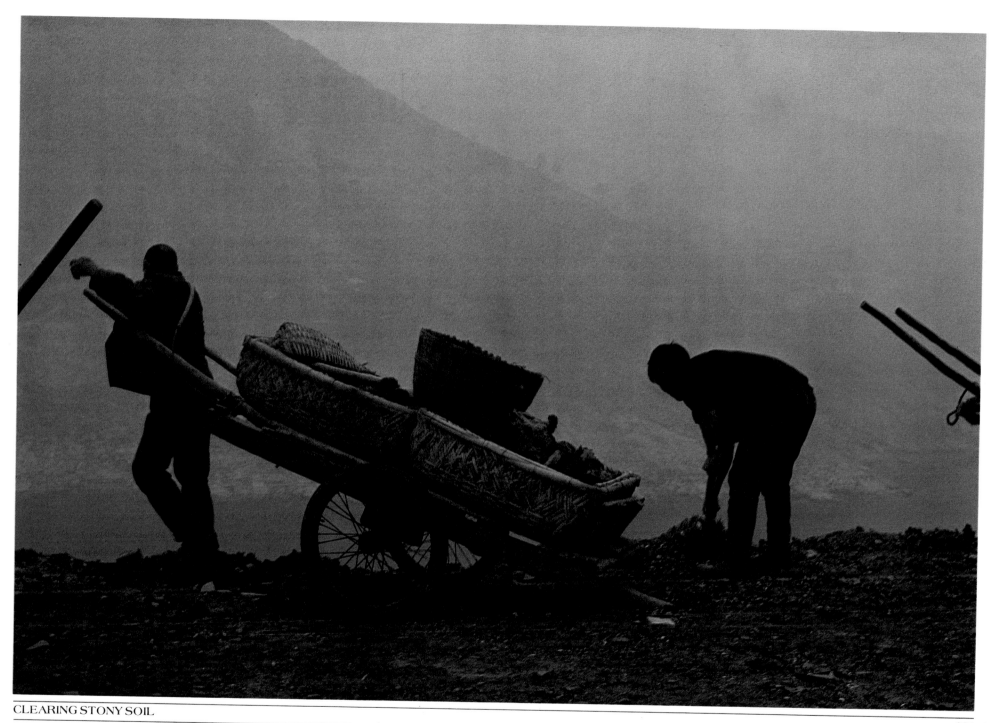

CLEARING STONY SOIL

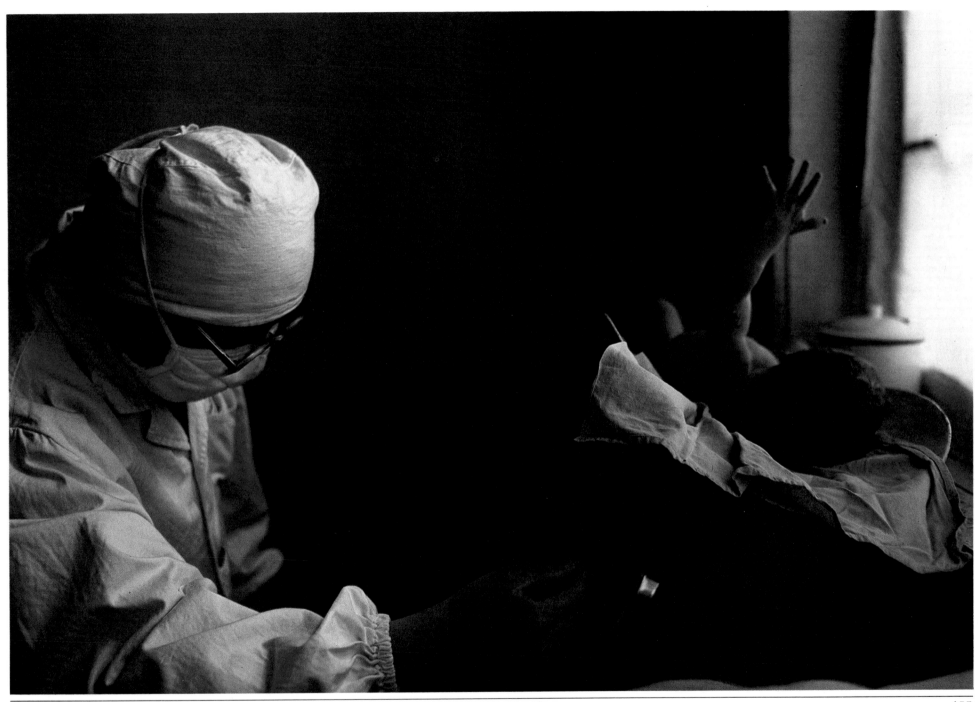

WEIGHING THE NEWBORN, WESTERN-STYLE HOSPITAL/*Tibet*

TECHNICIAN APPLYING MOXIBUSTION

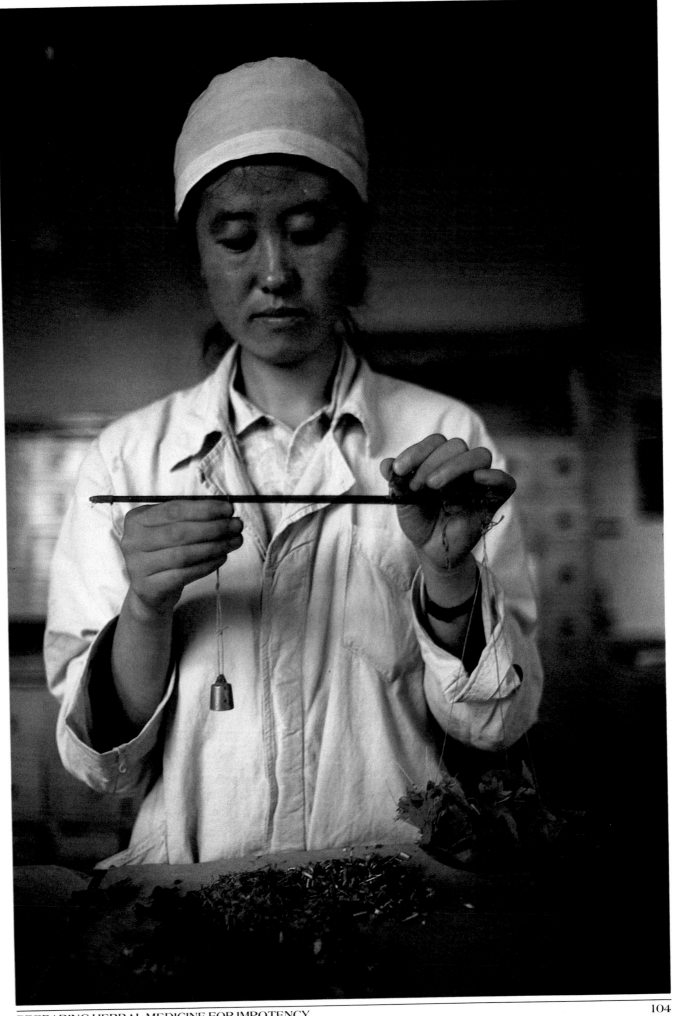

PHARMACIST FILLING PRESCRIPTION

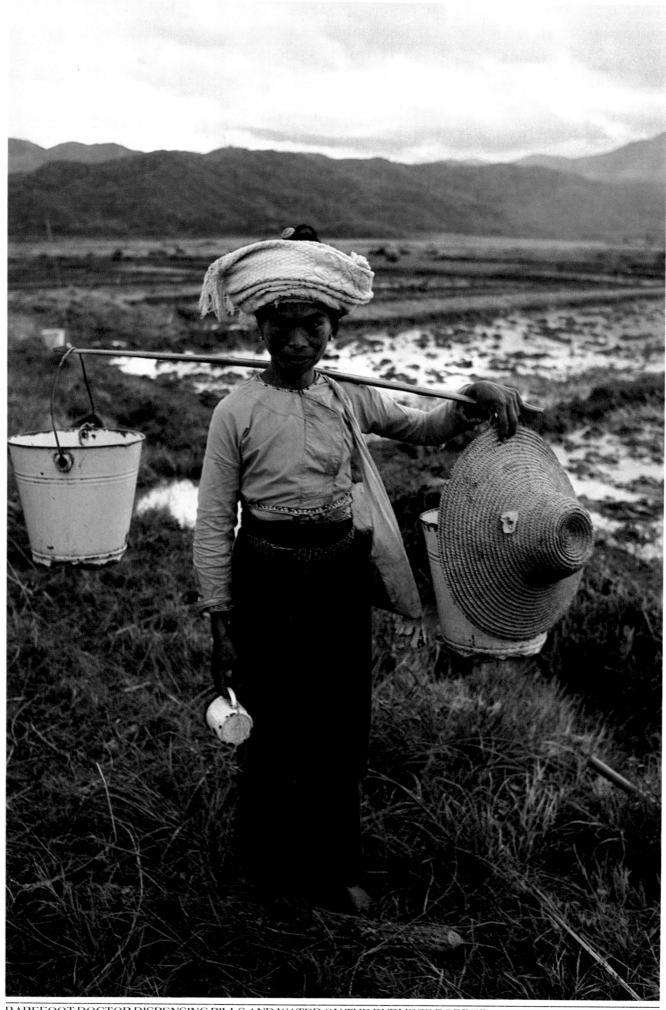

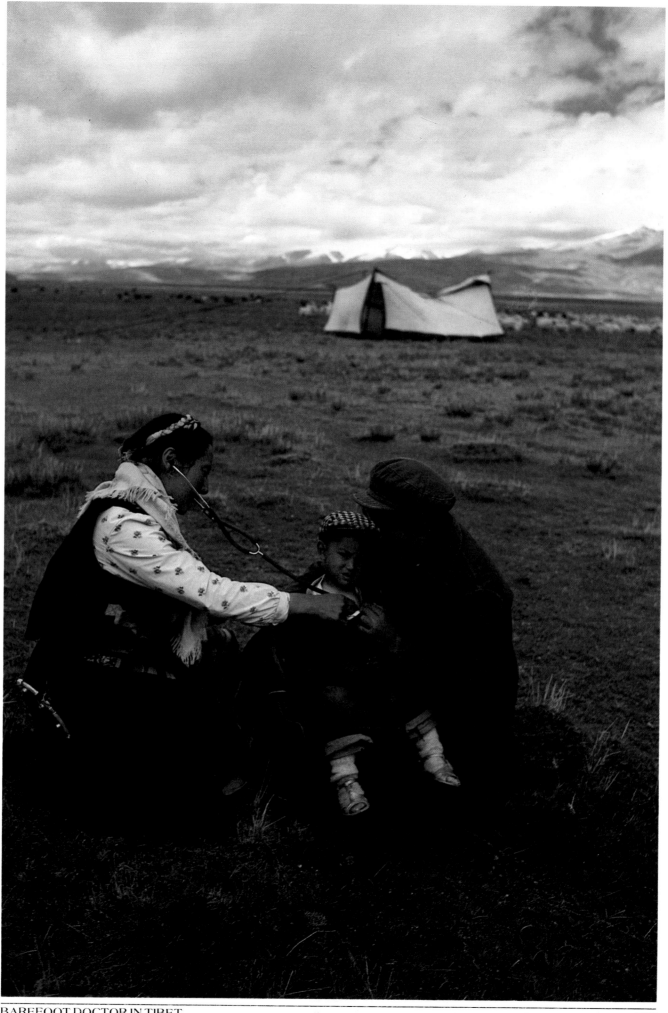

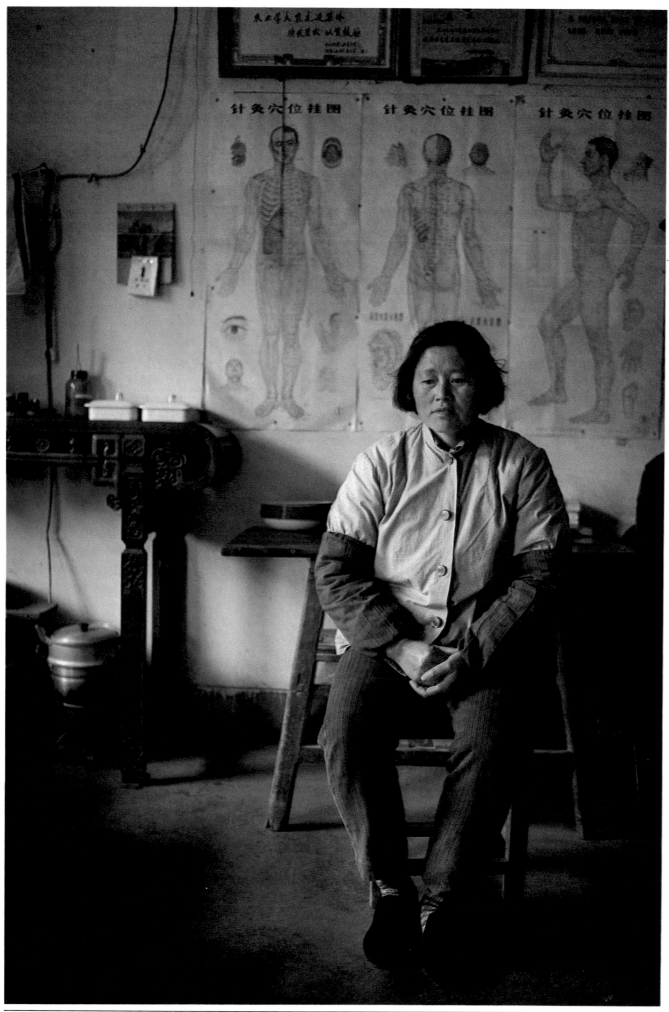

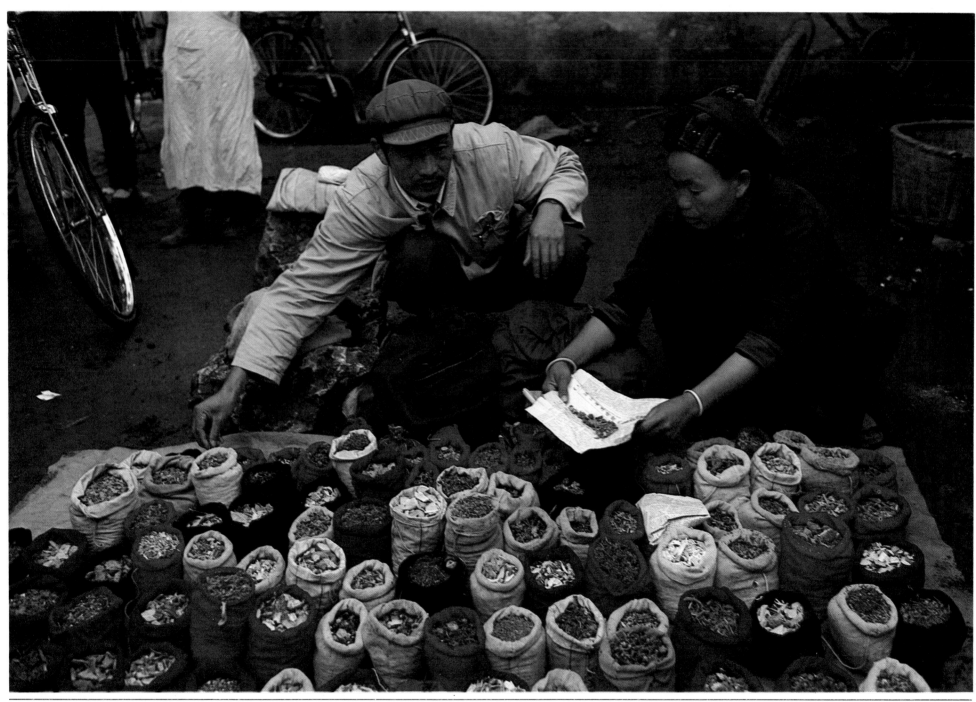

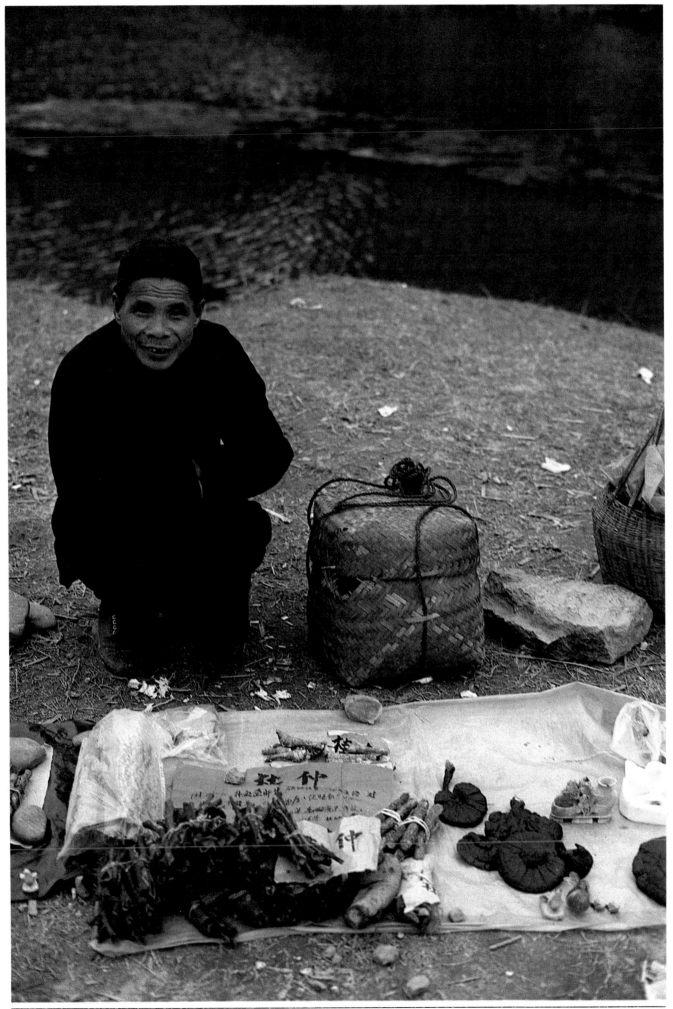

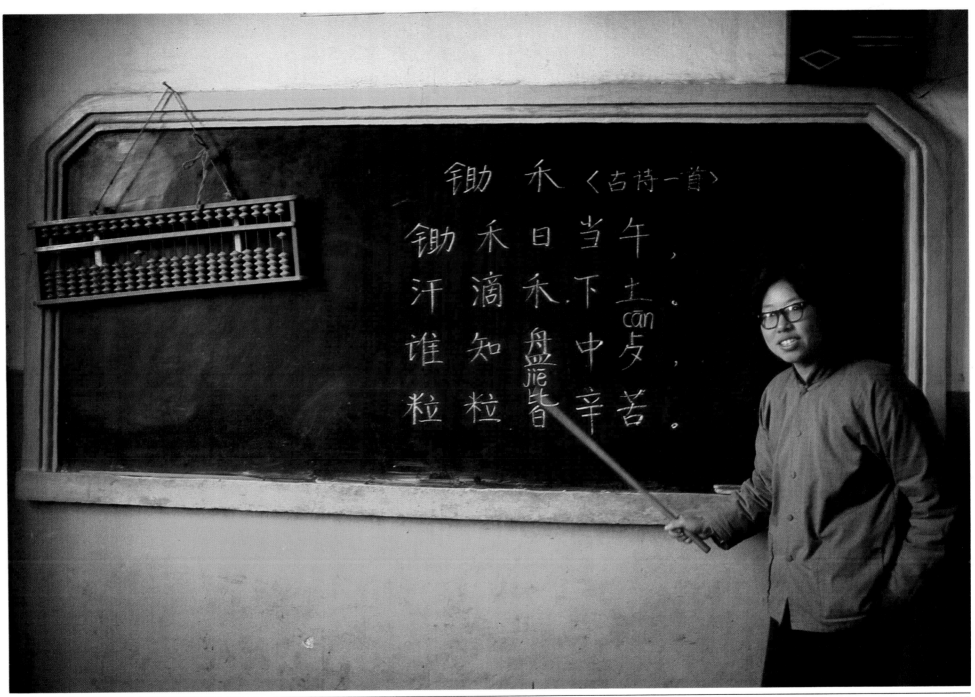

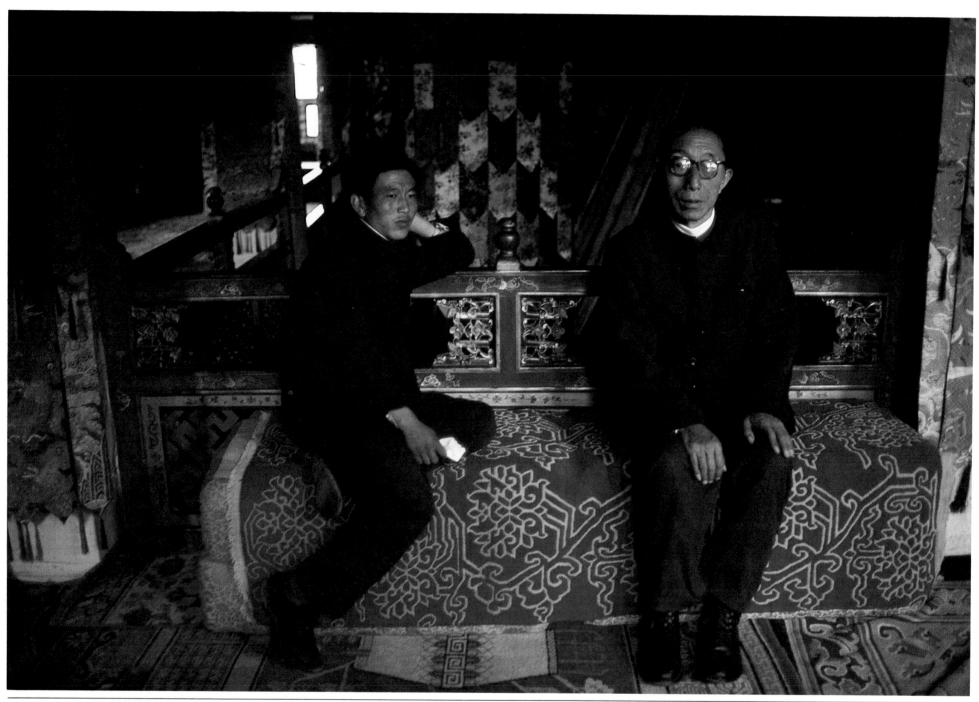

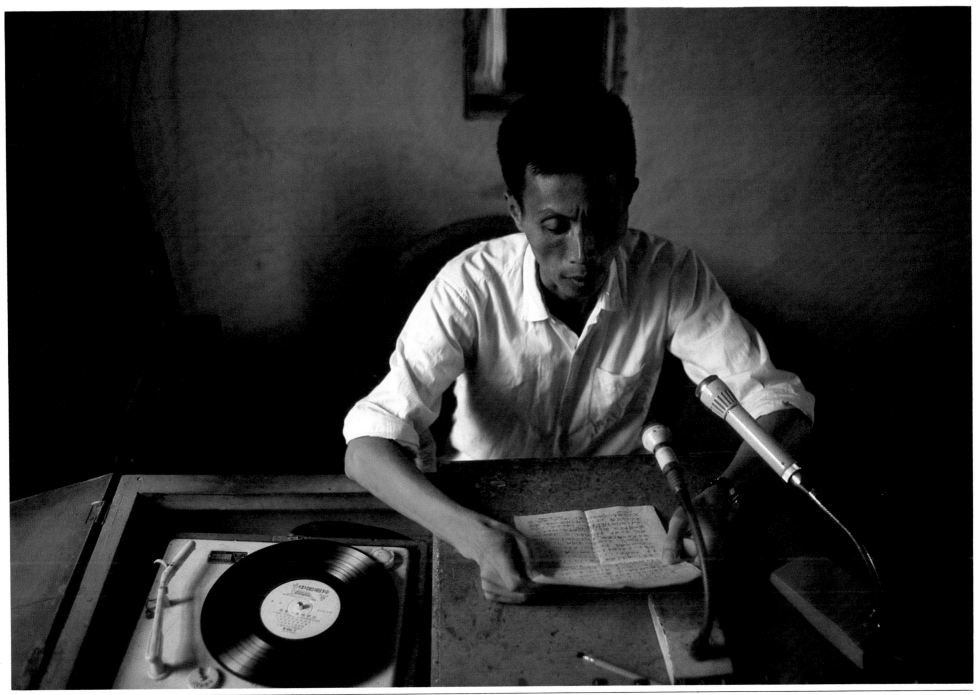

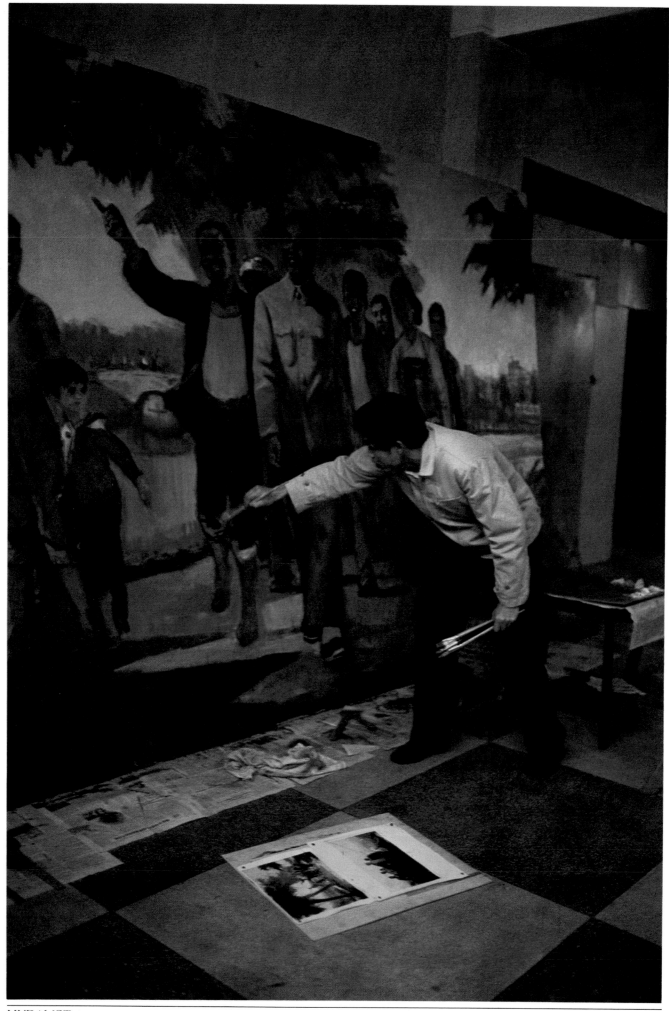

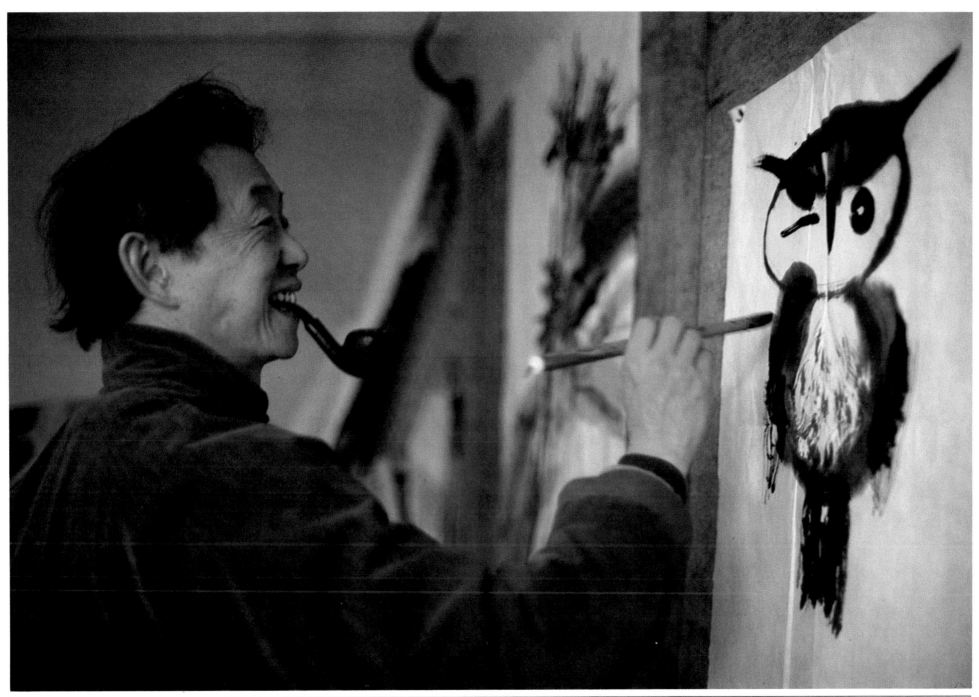

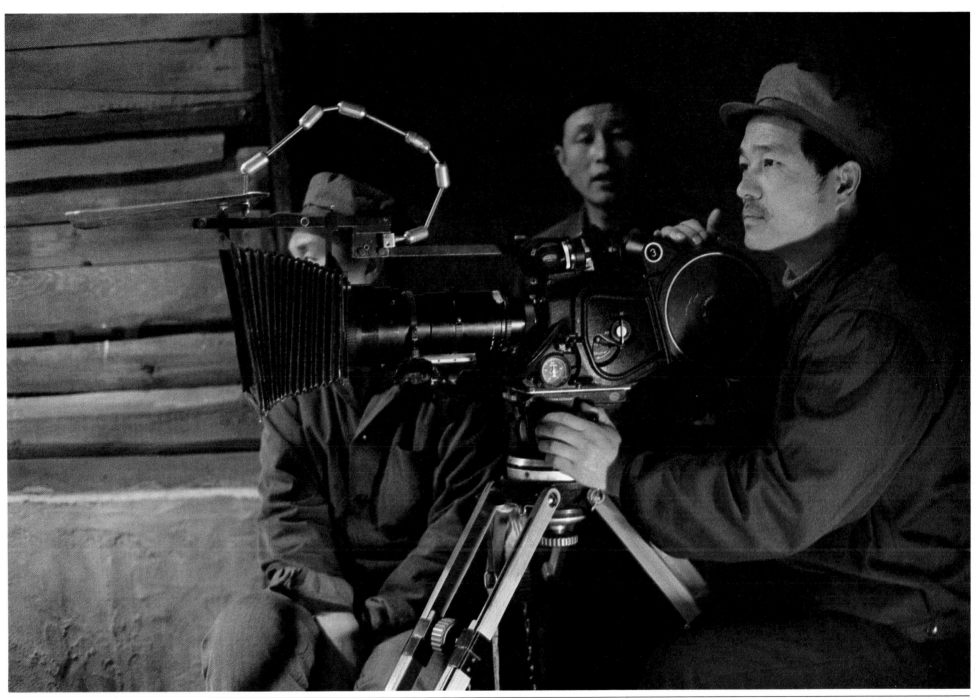

CAMERA CREW, FILM STUDIO

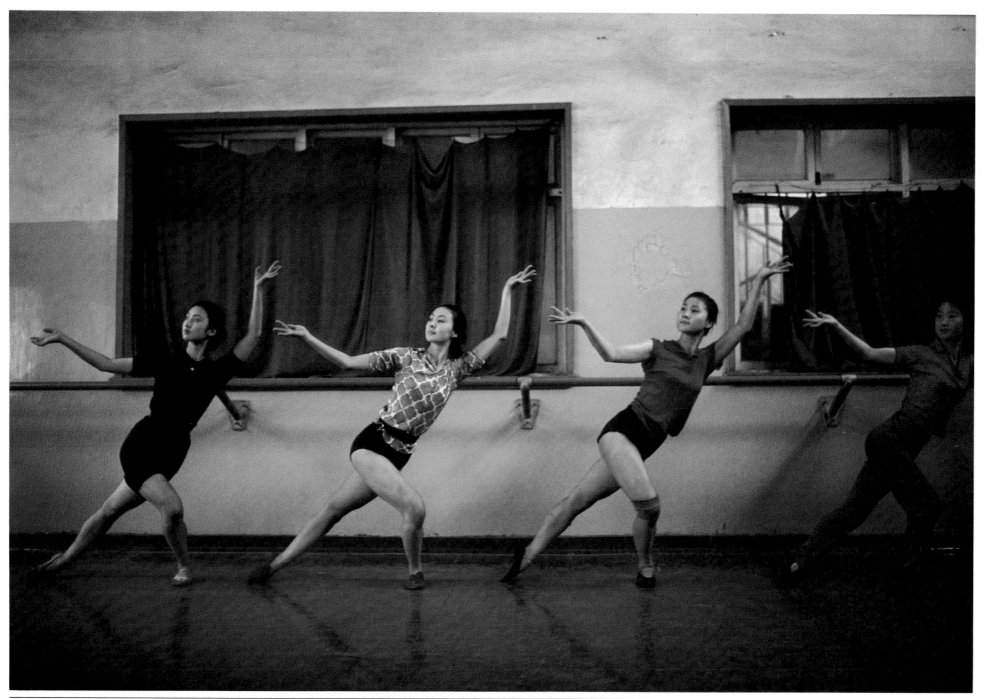

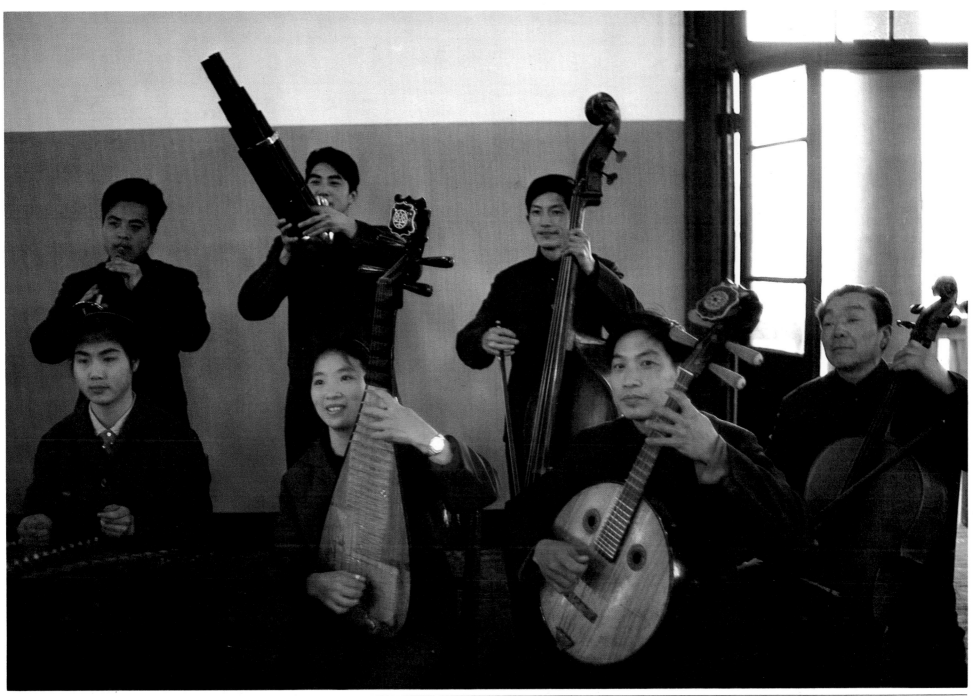

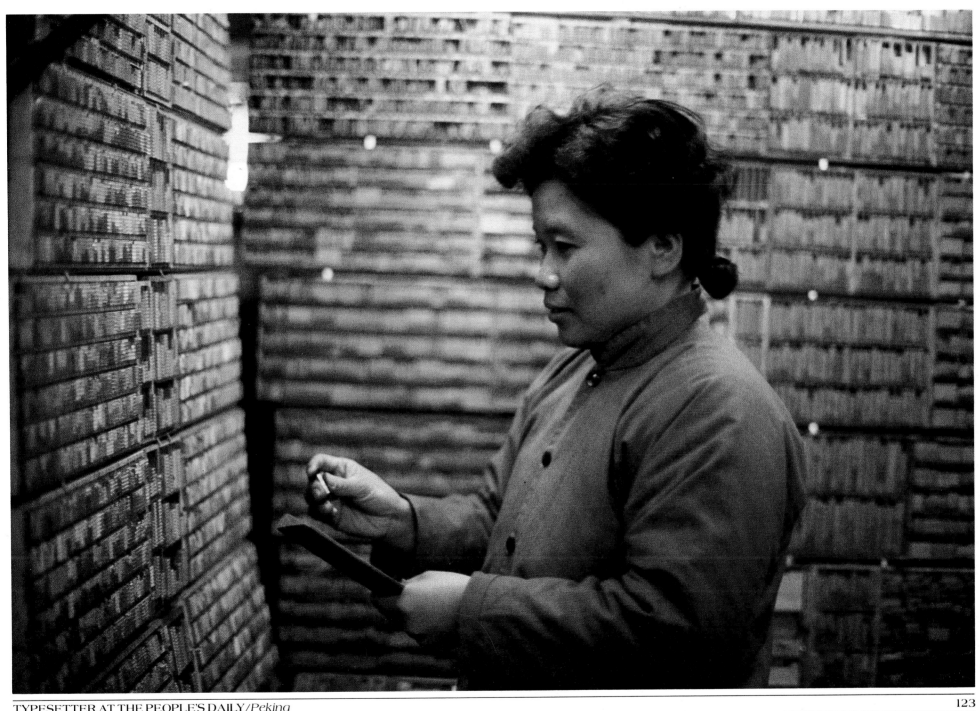

TYPESETTER AT THE <u>PEOPLE'S DAILY</u>/*Peking*

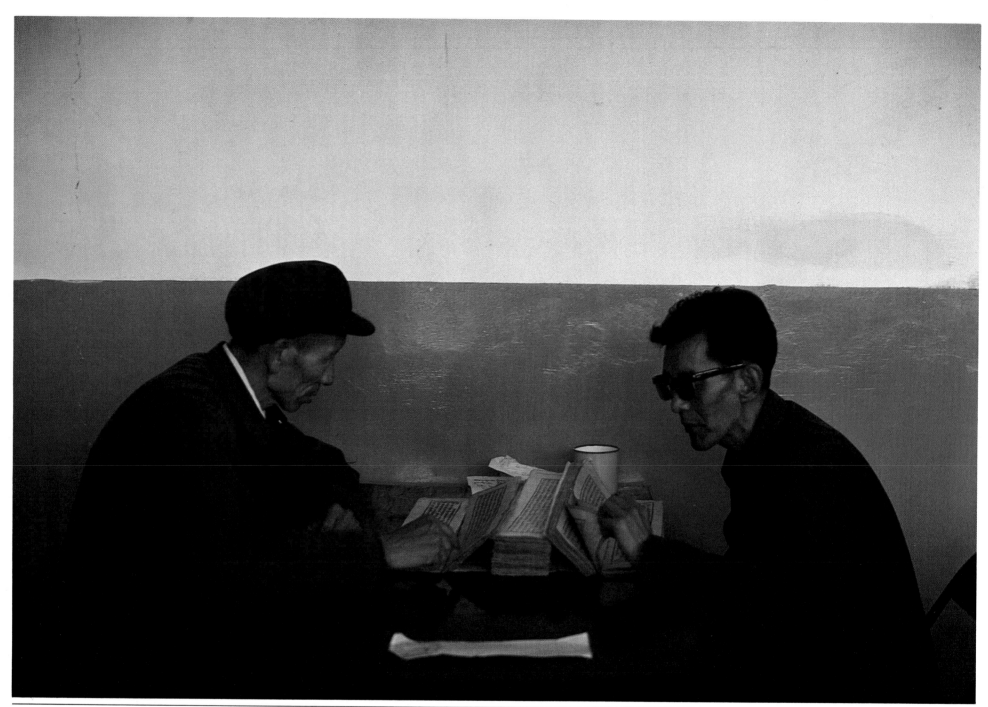

WESTERN-TRAINED DOCTORS STUDYING TIBETAN MEDICAL TEXTS

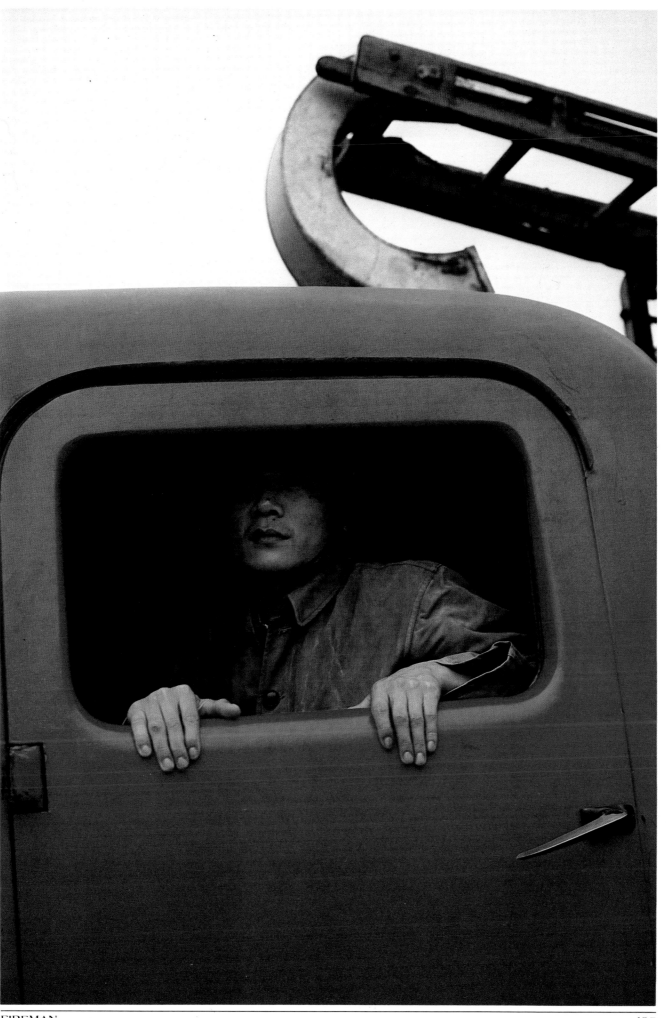

LIVING

For millennia the central core of the Chinese social system was the family. At its head was the autocratic father, who made the decisions for his daughters and sons, who in turn were expected to play their prescribed roles. Their education, their occupations, and their spouses were chosen for them. The dead also played a part in this feudal scheme based on total and unquestioning filial obedience, since ancestor worship was seriously observed. As each father joined the ancestors, he was replaced by his eldest son, who would run the family in the same hierarchical manner.

Now that so much has been swept away, it is interesting to see what remains. The family still lives as a unit – but with significant changes. Ancestor worship is gone, but enormous respect for age and for the wisdom it is purported to breed continues to exist; in place of the autocratic father, there is the state, with its power to determine the lives of the people. This power can be used ruthlessly to shift the entire population, as happened during the Cultural Revolution, or it can be used benignly, as the current regime is trying to do. There are enormous problems and adjustments required to overcome the legacy of the past ten years. During this period, families were torn apart and husbands and wives separated, not only because each might be needed to work in a different locality but also as a means of birth control. This practice, of course, is now over.

The family exists within the commune or factory system as it might within any European or American town or city. It is the nucleus within the whole. Although many young people go off to live by themselves when they marry, many families still have grandparents, parents, and grandchildren sharing the same quarters. To the Westerner, the tight space they share seems cramped and totally inadequate (compare the U.S. statistics of 450 square feet for every person to the 30 square feet available in China). However, there are compensations. Grandparents feel needed after retirement. Their pension money (70 to 90 percent of their previous earnings) helps to maintain the household. They shop, cook, and look after the children, releasing the parents for work and an occasional day off. Above all, there are a closeness and a warmth in human terms that are important in the organization of all their lives.

To report on the family in the abstract seems spurious sociology; to encounter a family in the flesh and to try to understand the experience are something else again. In Inner Mongolia I stayed at the Golden River

People's Commune with a cowboy's family. Their curiosity about how I lived in England was as great as mine about how they lived in Inner Mongolia. Their home was a seventeen-hour jeep ride from the nearest city, and they had never seen anyone from the West before. During the two days I was their guest, they asked the questions. Although the interrogation had to run the gamut of translation – Mongol to Mandarin to English, and back again – everything became easy and direct after we broke bread (steamed) and drank wine (mare's milk liqueur). The Baiyala family consisted of a father and a mother, a twenty-year-old son, a married daughter and her husband, and three children under twelve. These eight people shared two yurts (round tents made of goatskin). Each yurt measured sixteen feet in diameter and was a complete living unit, with a stove, cabinets for pots and dishes, and mattresses that served as seats by day and beds by night.

My hosts were very polite in their questions, but they were clearly startled by my answers about my own living quarters. They found it hard to comprehend that I alone had a living room the size of two yurts, as well as a bedroom, a kitchen, and a bath all to myself. Sitting with them in the candlelight, I found it a bit excessive too. Did I have children? Yes, a grown son, and a daughter-in-law and two-year-old grandson. Ah, said the mother, they live with you. No, they live in a city two hundred miles from me. But why? She could neither understand nor accept why I should live apart from my own blood. Did other people live this way? Yes. There was nothing I could say about our way of living that she could comprehend. When she tactfully inquired about my daughter-in-law, I realized that she thought we didn't get on together, and that this was why I didn't share my home with my son and his family. When she turned to her young children and asked them to sing for me, I saw in her pride for her family that she felt sorry for me, that she felt I was missing one of life's great gifts. I was inclined to agree with her.

I was invited into the homes of other people – a scientist at the Victory Oilfields, a family of peasants in Lhasa, a barefoot doctor in the Tibetan pasture lands, a factory worker in Szechwan, a vice chairman in Peking – and visited a thatched cottage on the Burmese border and a modern housing development in Kweilin. This exposure gave me a feeling for the perspective in which housing and possessions are placed. We in the West spend an enormous percentage of our earnings on

housing and utilities. In China, living accommodations and necessities are cheap, kept at a much lower proportionate cost, so that housing and utilities average less than four U.S. dollars a month. With joint incomes, families manage not only to own their own homes (which they can bequeath to their children) but to save money (on which they get interest).

China is experiencing a countrywide building boom. In Sinkiang there were middle-school children making bricks for their own dormitories to go with the school they had already built; in Kweilin there were new multiple-family dwellings being finished to house factory workers; in Peking there was a modern seven-story Peking Duck restaurant under construction; and in the Tibetan pasture lands permanent housing was being built for nomadic shepherds.

At the Victory Oilfields, completed in 1964, a knowledgeable cadre who had worked in the U.S.S.R. and had been to Europe looked out over a village street, with its houses, shops, and surrounding green fields, and said, "You in the West would have built one large city; we have built ninety-seven self-sufficient worker and peasant villages." Each of these communities is organized so that the husband works in the oilfields and his wife works on the land. (If the husband is moved to another job his wife and family are moved with him, because in rural communities, according to peasant tradition, wife follows husband. In cities, if the wife's work is more important, the husband and family follow the wife.) The women also work in the shops and in the small factories where clothing and other necessities are made. At harvest time men and women pitch in to bring in the crops.

The plan to grow food near the source of consumption eliminates the need for long-distance transportation of goods. For example, in the United States spinach is grown in California and shipped by refrigerated trucks to New York. In Peking the spinach is carried on shoulder poles from the farm and brought on foot to the consumer market. Not only does this reduce costs substantially but it means that food is always fresh. To have greens year-round there is an additional crop grown in "greenhouses" (actually under plastic or straw) in the winter.

Most visitors are nonplussed to find within spartan socialist China so much attention and pride lavished on food. As I looked at and smelled the food of each meal I became increasingly aware of the application of the three ancient principles of color, fragrance, and taste. I found it amusing to compare food eaten in China with food eaten in Russia. Except for the caviar, the Chinese won hands down. (Chinese caviar wasn't bad, but didn't measure up to the best of Russian.) It seemed to me that just as the form of communism developing in each country reflects the individual character of its people, so too does its cuisine.

In China I ate meals that ranged from the sublime (a fourteen-course dinner, not counting numerous cold hors d'oeuvres, given me by the mayor of Wanhsien) to the rare (a dish of the gelatinous inner pads of camel hooves in Huhehot). In between, meals went from the ordinary to the memorable, and all the dishes were as much a delight to see as to name: Butterfly Meat, Kidney Flower, Rice Thread Across a Bridge, Snow Lotus on Ice Mountain, Phoenix Tail, Winter Worm/Spring Grass Soup (containing a rare caterpillar that changed from the animal to the vegetable kingdom according to the cook). One dish I'm glad I was not offered is called Struggle Between Dragon and Tiger (snake cooked with cat).

The Chinese people do not eat as well as the visitors. The native diet is based mainly on grain. Food is rationed, as eggs, meat, and fish are limited. In the livestock pasture lands, meat is more plentiful and dairy products are available — cheese, yogurt, and a crème fraîche so delicious it challenges the French.

In the cities an effort is made to help ease the burden of cooking after a hard day's work. In an American-style supermarket one can buy for 20¢ to $1.25 a platter of chopped meat, fish, or chicken and vegetables that will serve four. Each meal is arranged in its own dish ready to be dropped into a heated wok. There are also bakeries that are experimenting with Western-style bread.

One thing that held my attention as I traveled throughout the country was the preoccupation with children, as evidenced by the attention paid to birth control and the love and affection showered on those already born. Faced with the unhappy prospect of a population of one billion by the year 2000, the government is waging a militant campaign to keep each family down to two children, with the eventual goal of a single child per family. One stringent measure is to give food coupons to only the first two children; if there are additional children, the family must feed them through pooled rations.

In the days of the Russo-Chinese honeymoon, the Chinese, on the advice of the Russians, campaigned to increase the population on the grounds that an emerging socialist country needs people to work hard and to help achieve its goals quickly. In those days mothers of twelve were decorated for valor. Now that the reality of the situation has exposed this reasoning as fallacious, there has been a total reversal of the original scheme. The government makes broad policy, but each community tries to set up its own family-control system. Abortion is legal, easily

available, comparatively safe, and costs 10 yuan – about $7.50. Sterilization is available on demand but requires the husband's consent. As for men, vasectomy is easy though few men have resorted to it, and the new male pill the medical profession is experimenting with was introduced too recently to judge its effectiveness.

The minorities are exempt from population control not only because for the most part their religions forbid it, but because most of them live in sparsely populated border areas. Under the present labor-intensive agricultural system, it is essential to have a large farm labor force.

I talked to a professor of gynecology at the No. 2 Hospital attached to the Western Medical College in Wuhan. She said the birth-control clinic averages 200 births, 65 abortions, and 35 sterilizations a month. (When I returned to England, I checked these figures against an English city hospital of equal size and found that the figures were about the same in both places.) The professor said the pill, the ring, the intrauterine device, the condom, and birth-control instructions are all available free at the outpatient department. Abortion, too, is considered a form of birth-control, and between labor pains doctors sit with their patients and point out the advantages of limiting the family.

Compared to the Wuhan hospital, which seemed to be a big-city mopping-up operation for transients, the family-planning clinic at the Shanghai Turbine Factory, in which the same doctors looked after the same 1400 women workers year after year, appeared a controlled program. The Turbine Factory offers birth-control devices identical to those available at the Wuhan hospital. In addition, for the past ten years the Turbine Factory has administered a once-a-month injection (done on the fifth day of the menstrual cycle) called Chang Hsiao Huang Ti Tung, which translates as "long-acting progesterone preparation." Since it is a monthly dose, it leaves the woman free of worry between periods. The only side effect is that it makes women grow fat. Unfortunately, the injection is in short supply. The clinic at the Turbine Factory is being used as an experimental control center.

Family planning is carried still further at the Shanghai Turbine plant. There are both a day-care center for infants and a kindergarten for children when they are ready. The mother is given a fifty-six-day maternity leave, and when she returns to work she brings her child with her. Twice daily, morning and afternoon, she goes to the nursery for thirty minutes, to feed the child. If she has twins, the time is extended to forty-five minutes. The child is looked after at the factory until school age.

From early childhood great emphasis is placed on physical fitness, and everywhere physical training is not only part of the educational process but also part of each day's recreation. There are basketball and soccer teams and track and field sports. Parks and byways are filled at dawn and at twilight with people moving rhythmically through everything from gentle Tai Chi to the more muscular forms of Wushu — a general term for the martial arts. These exercises are also used for exhibitions, and bear the traditional names: Drunkards Boxing, Movement of Birds, Eagle Claw Boxing, and Monkey with a Cudgel. There is sword and spear play. Wushu is being further developed, with new routines devised in the countryside for two, three, and four persons performing together using hoes, spades, and shoulder poles as weapons against imagined rifles.

Education is perhaps the most effective weapon the Communist Party wields. The Chinese population is almost totally literate; wherever one goes there are people avidly reading. Workers in the factories snatch minutes from the half-hour lunch break to read the latest report from the People's Congress, and early in the morning long queues of people wait patiently for bookshops to open. Children are taught in early childhood that education is a serious business. It is based on political study, hard work, and the understanding that each person will be accountable to the community and help in the modernization of China. From their formative years, children learn through doing; during their summer holidays they put on political plays and act out skits in the street exhorting the citizens to look after their personal hygiene, keep their homes clean, and kill flies and insects. After school hours there are extracurricular activities at the Children's Palaces, where everything from ballet to airplane model-making is taught. These activities not only help to develop and focus the interests of the young, but also assist them and their teachers in determining their capabilities and possible direction as adults. Are they university material? Do they belong in the sciences? the arts? Is there a special area toward which they lean? Education stretches and occupies the students, helps fit them into the community, teaches them to use leisure constructively, and, to my cynical way of thinking, keeps them off the streets.

The most interesting educational institute I visited was the Art College in Chungking. A class was learning to draw from a vast plaster head of the Michelangelo *David*. At first I thought it only a contradiction in terms that Chinese students were learning to draw from the mythic, heroic forms of the Italian Renaissance in order to be able to glorify the common man in their own socialist realist art. Then I began to worry when I remembered the political ends toward which fascist Italy had stretched these same models. I do not understand why the Chinese fail to use as models some of their own remarkable sculpture. Surely plaster casts made from the amazingly beautiful Chin figures found recently in the excavation at Sian should be their inspiration.

I asked what the requirements for enrollment in the art colleges were and was told that, in addition to an entrance certificate from a junior school, good health, and proper ideology, it was required that the applicant

1. Know the works of Chairman Mao by heart
2. Put the proletariat in political command
3. Be prepared to grasp every moment to do his job
4. Help the country strive for the four modernizations
5. Be dedicated to serving the people after graduation.

Although there are still militant Communists who fear that traditional art will be instrumental in leading China back into the evils that existed before 1949, it is common to find painters painting butterflies and bamboo leaves, birds and flowers, and there are institutes whose sole purpose is the preservation and continuation of the old forms. (During the Cultural Revolution a painter could not show a man and a woman together without getting into trouble; anything that suggested coupling was taboo: two birds, two butterflies, even two flowers were suspect.) It was revealing to learn that it is not considered plagiarism to copy another artist's work, even stroke for stroke; rather it is regarded as a mark of high regard for the original artist.

There is a great deal of excavation, restoration, and maintenance of the fine arts taking place throughout China — of sculpture, architecture, and painting. The purpose is both political and practical. Politically, the state hopes to impress the world outside and the Chinese themselves with the genius of China's cultural heritage; in addition, this pride in the past is intended to inspire people with confidence in the future, to make them feel they are building a new world on a solid foundation. Practically speaking, China is providing a great showcase to attract the hard-currency tourist money needed to help modernize the country. This government attention to the fine arts also helps to rehabilitate the artists and intellectuals who were almost destroyed in the Cultural Revolution and gives work to a lot of people.

For those of us who had hoped to see a renaissance in Chinese art, or at least something comparable to the temporary burgeoning just before and immediately after the revolution in Russia, there seems to be nothing of the sort. Perhaps we in the West have made the mistake of deploring the low level of current Chinese art by comparing it with China's classic periods or with fine art in other cultures. The present Chinese "art" is propaganda art and should really be compared with folk art, comic book art, and commercial art in its various forms of promotion and advertising.

On my first Chinese trip I saw the large-character "democratic" posters that were one means of free expression guaranteed the citizens by their new charter. When I returned three months later, things had changed and the same spaces in Shanghai were occupied by billboards advertising pens, medicine to ease menstrual pain, fabrics (nylon, polyester, and cotton), a special cabinet in which to clean precision instruments, industrial streetlamps, Japanese toys, Bulova watches, Mitsubishi trucks, and Molsidomin, a Western medicine for heart pain that can be bought over the counter. On the main street there was a billboard advertising Lucky Cola (their own brand of Coke) cheek by jowl with a poster of workers who seemed hewn from rock exhorting the populace to "Learn from Taching," the commune model for all.

Advertising is spreading to other media. The Shanghai television station is experimenting with a half-hour of commercials per week. Because the purpose of Chinese television is political propaganda, if the station does decide to run advertising on a permanent basis it will be severely limited. Advertisers are mainly foreign companies, and the rates are 160 yuan per minute, or $120.

Another interesting spectacle is the ritual ceremony as a reward for services rendered the state. Such ceremonies are now taking place all over the country, and they follow pretty much the same pattern. As a tribute, a small party is given at the factory or commune where tea is drunk, speeches are made, reminiscences are exchanged, and gifts are given, and then the whole party takes to the streets to serenade the guest of honor with cymbal and drum, gaiety and laughter, all the way home.

Such a joyous celebration marked the retirement of Comrade Wang Jei Lau, a fifty-three-year-old woman cadre in the No. 2 Peking Cotton Mill who was also a "responsible member" of the committee that runs the factory. Normally, women factory workers retire at fifty-five, but Comrade Wang is a diabetic and asked to be relieved of her post. Arrangements were made and one of her daughters replaced her. (As a measure to relieve unemployment, a child can take over from a parent and the parent can retire early at 70 to 90 percent of the normal earnings.) At Comrade Wang's party the big moment came at the beginning when the Glory Flower, a large red rosette, was pinned to her chest. It said "Happy Retirement" in gold letters. Her colleagues gave her a Turkish towel, a citation, and a red thermos bottle. She will retire with 90 percent of her pension — 65 yuan (U.S. $48.75) per month. She can expect to spend the rest of her life in the confines of the same cotton mill where she worked for twenty years. She will be respected as one of the elders, she will do some community work, she and her friends from the factory will visit back and forth, and she will be an honored guest at all factory functions.

* * *

There is very little ceremony in China. Marriage is simply registered. It is usually marked by the couple having wedding pictures taken. The local photographer lends them the wedding clothes for the pictures, so each bride will wear the same white formal wedding dress and each groom the same dark business suit and tie. All couples are taken in the same three rigid poses — one full-length, one chest-length, and one mid-length — with the bride on the left and the groom on the right. For an additional fee, the photographer will make a smiling portrait of the bride alone.

The young men save for years to be able to marry. The husband and his family are expected to provide the home and its furnishings as well as the girl's trousseau — usually materials for clothes, sweaters, and a coat. This custom probably derives from the old days when parents exacted a "bride price" for their daughters. The girl's dowry will be quilts; a good dowry might be eight quilts, enough to last her and her expected family their lifetime. In the past, so ingrained was this practice that to save face on the day of the marriage a poor bride would borrow quilts to make a good showing.

In the countryside, a mother of two sons and one daughter said it was easy to get rid of a daughter — just give her the quilts and away she goes — but a son might leave the family in debt for years. A future daughter-in-law insists on a home before marriage, because life in rural areas is so uncertain. The men have no fixed incomes; they receive only work points, and a bad harvest could be disastrous for them. So homes have to be provided, and a four-room house costs as much as a thousand yuan to build. In the cities, girls do not have to be as demanding, because men receive wages and apartments are cheaply rented.

Recently the Chinese have been laughing at a rhyme based on numbers that has to do with the vanity of a girl in her demands from her bridegroom. The rhyme is based on numbers from 1 to 9 and, roughly, the idea is this:

He must have

One unit of furniture (a complete suite, consisting of bed, table, chairs, wardrobe, writing desk, etc., called "the forty-eight legs")
Two parents (who should be high-ranking cadres who can help the couple financially)
Three sets of wheels that go around (bicycle, sewing machine, and wristwatch)
Four forty square meters of living space
Five handsome features (eyes, eyebrows, nose, mouth, and ears)
Six close relatives that he can reject (grandparents, brothers, sisters, aunts, uncles, and cousins)

Seven seventy yuan per month in income
Eight at least eight sets of friends — in other words, be popular
Nine in Chinese the word for liquor has the same sound as the word "nine" — so he should be neither a drinker nor a smoker

There are variations and jokes on the above, and one man I got to know, a cadre in a cotton mill, said he had married off his son and he thought he had better begin saving so he could help his grandson (not yet born) to get a bride. He hoped that inflation could be held at bay because he was getting old.

I had heard jokes about the demanding brides on my first trip, and people were still laughing at them when I came back. But when I asked about it they looked embarrassed and said if you use the rhyme in your book, please say that we are now affluent and happy enough to build houses and make jokes.

The young seem shy with each other and do not yet appear to have rid themselves of centuries of sexual taboos and arranged marriages. There are few parties or social functions, and people of marriageable age have difficulty getting together. I kept hearing of matchmaking going on among friends who understood the requests and conditions of both people: a party member wanted, a middle-school or university graduate required, etc. After the initial descriptions are given, photos are exchanged and the couple meets at the home of the friend making the introduction. According to ancient custom, no man under thirty was thought competent to marry, and no woman under twenty. Now it is usually twenty-eight for the man and twenty-five for the woman.

Very little ceremony marks birth or death. Increasingly, people go to hospitals to die, and from there the body is sent to a crematorium, where friends and relatives hold a memorial meeting. In contrast to the brilliant colors of the memorial wreaths — reds, pinks, oranges — the people wear only cool colors — blues, grays, whites, and blacks — to the services.

Chinese concern with the health of the people is impressive, and their emphasis on preventive medicine particularly so. Medical care is built into the structure of their lives and, depending on the economic viability of commune or factory, medical care either is free or costs the worker and his family no more than two yuan a year. Medicines are free or charged at a negligible cost. Chinese medicine ranges from the primitive in the countryside to the most sophisticated Western-style medicine in the cities — from cupping to high technology (again, the Mao idea of walking on two legs). Sometimes one sees the interesting phenomenon of the traditional used together with the Western. At the International Peaceful Maternity Hospital in Shanghai (founded by Mme Sun Yat-sen with the

money given her when she won the Stalin Peace Prize), acupuncture was administered (not acupuncture anesthesia) to decrease pain and to accelerate delivery while a Western machine monitored the baby's heartbeat.

Although we have had an overdose of reporting on acupuncture, I would like to mention some little-known facts about it. As practiced by the Chinese, acupuncture is often a three-stage treatment: first the needles (acupuncture), then the moxibustion (fire treatment), and finally the cupping (heated glass suction cups applied to the afflicted part). In the countryside, the methods I saw were primitive: the needles were moved by hand, and the fire was a bare flame lit from dried herbs. In the city, the needles were moved by electric impulses via a machine that was attached to the needles through electric cords, and the dried herbs were encased in cotton wadding and covered and ignited like a cigar, the ash giving off heat to the afflicted part.

It is wonderful to see the Chinese paramedic system at work, whether the barefoot doctor (the Chinese are trying to change the term to "red medic," but it doesn't seem to be sticking) is in the rice paddies in Hsishuang Panna at harvest time dispensing drinking water and pills, or auscultating a child in the Tibetan grasslands. It is estimated that the paramedics can handle up to 65 percent of all medical problems. Their training takes anywhere from eight months to two years, depending on the responsibilities they are to assume (the woman in the paddies had trained for eight months; the one in the grasslands had trained for two years). The two-year training period included courses in physiology, pathology, anatomy, acupuncture, traditional herbal medicine, and a hospital training course designed to enable the paramedic to deal, under supervision, directly with the patient, diagnosing and prescribing. She is qualified to treat colds, minor bronchial and stomach infections, and malaria. She can deliver and vaccinate babies, immunize patients against various diseases, and she is expected to know where her expertise ceases, when to call in a more qualified doctor, and when to take a patient to the hospital. But perhaps her main responsibility is the distribution and promotion of birth-control devices and medication.

The Chinese are not only endlessly experimenting with old methods but imaginatively trying to find new ones. I encountered both of these situations. The first was the use of sand therapy, an ancient treatment for arthritis; the second was a controlled experiment using rubber seed oil for people to cook with in the treatment of heart disease. I observed the sand treatment in the Turfan depression in Sinkiang, where people buried themselves in the broiling sand dune in 120° heat. The dune had originally been left as a reminder of what the area had been like before Liberation, before it had been reclaimed from the Gobi to become fertile,

arable land. The doctors in charge of the project offered the following information, based on a three-year survey of 2446 patients treated for rheumatoid arthritis and unspecified chronic back and leg pains:

73 recovered fully
707 showed noticeable results
1499 showed some improvement
153 showed no improvement
14 went from bad to worse

The experiment with oil pressed from the seeds of rubber trees was first tried on mice on a rubber plantation near the Burma border. There were two groups: one was fed on rubber seed oil, the other on peanut oil and animal fat. When sample mice were operated on, it was found that the ones with the rubber seed oil had smooth veins while the others had clogged veins. When the process was reversed, the results were reversed, and doctors tried giving people with heart disease and high cholesterol levels a few drops of the oil as medication. The results were so satisfying that the patients were given rubber seed oil to cook with; three thousand people have been using only that since 1970, and it has proved highly effective in lowering their cholesterol counts and in the treatment of heart disease. The people I spoke to said they like the way it tastes. Scientists are now trying to press the oil into pills to give to a group of workers in pork refrigerating plants who eat more pork than the average and seem to have a concomitant higher cholesterol quotient.

I tried to get statistics on health in China — not only as concerns heart disease, but on cancer and other killers — but there were none available. I was told that even if figures were available it wouldn't be possible to draw conclusions about percentages, because there has been no census. Figures on longevity were of course lacking as well. However, no matter what the average span of life, the Chinese are concerned about the quality of life for the aging. I saw old people who lived on their own in Sinkiang, and I saw an old-age home in the Kuan Kung Commune on the South Hunting Ground near Peking, where the emperor used to hunt. The old can stay with their families if there is room for them, or they can choose to live in the old-age home, where food, clothing, medical care, entertainment, and funerals are provided free. They are also given three yuans' pocket money every month. If they live with their families, the commune pays two hundred yuan annually toward their upkeep.

When I spoke to one woman, Mrs. Ching, who was 105 years old, she was reluctant to talk about her age. The interpreter explained that in feudal times people were superstitious about three numbers, and that people are still uneasy about it and so will deny that they are over 100. Mrs. Ching was reminded that she had had to produce birth records

(when she was seventy-five) to prove her age to participate in land reform. She shrugged it off, but the other people in the common room started to talk about numbers: 73 is considered a disastrous number, but if a person makes it to 73, he can go to 84, another disastrous number. Of course after 100 he can go on and on...

Mrs. Ching finally started to talk of her life of misery and near starvation before Liberation. Her husband and his father had pulled carts for the emperor's family. It was bestially hard work and life was cruel. She had a daughter. When the Japanese came and the country was ripped apart, she lost touch with the daughter, who had married and moved away. She searched for years, first alone, then with friends, and after Liberation the government tried, but nothing happened and she never saw her daughter again.

Now here she is in her old age. Her husband died last year, right after they came to the home. She has a comfortable room and every year she receives her portion of corn, grain, and rice. She shares a canteen with comrades, and every day there is meat and steamed wheat bread. Life is good.

I asked the old people about religion as I had asked others throughout the country. The consensus seemed to be that by the time the Communists took over in 1949, the "three ways to a goal," the three religions of China — Buddhism, Taoism, and Confucianism — were already in decay. What remained was ancestor worship, the fundamental religion of the Chinese people, which was so deeply rooted that it had a stranglehold over society. Now it too has disappeared.

The constitution of the People's Republic of China states: "Citizens enjoy the freedom to believe in religion and freedom not to believe in religion and to propagate atheism." There are practicing Muslims in large numbers (the only restriction being that a Muslim or any other religious person cannot become a member of the Communist Party). The Catholic church in Peking has reopened and mass is served there twice on Sundays; there are Buddhist monks and Tibetan nuns; lamas are still observing their religion and Tibetan lamaseries are maintained in splendid order. I saw lamas at prayer at the Drepung Monastery and at the Jokka Kang in Tibet. There are probably political reasons for permitting the various religions: not only an unwillingness to fight the minorities' strong ties to religion, but recognition of the sympathetic world view about Tibet and the Dalai Lama, the wish to keep contact with other Asian countries that are Buddhist, and the desire not to antagonize the Christian West.

During the Cultural Revolution and its reign by the Gang of Four, temples were severely damaged, Buddhas were destroyed, and the famous Han Shan Temple built in the T'ang Dynasty (A.D. 700) in Soochow was used as a nuts and bolts factory. Now all over China new Buddhas are being made and temples are being restored and readied for use as museums. The idea is to have people look at the old places of worship and the Buddhas as works of art made by man, not as objects of supersitition to be feared.

For me, the best part of my trip was seeing people enjoying themselves on their time away from work — the summer vacation, the day off, or just hours snatched at day's end to refresh the soul — looking at a scroll in a gallery, marveling at the skill of acrobats whose feats go back to the days of the warrior kings, delighting in the precision of a goat in a country circus taught to walk a tightrope so that he ends up with all four feet planted on a two-inch circle atop a tiny pedestal, or listening to a group of entertainers and musicians brought to the grasslands to amuse cowboys.

Just as there are many levels of art in China, from the most simple folk art to the most sophisticated fine art, so in theater the range is from slapstick song-and-dance routines celebrating an upswing in pig production to the most esoteric Peking opera. There are local repertory theaters, prestigious large-city theaters, and traveling groups. It is estimated that between four and five million people go to the theater daily. Theater parties are made up by factories for the workers and by communes for the peasants at costs from a few pennies to a half-dollar. Theater and film are media through which politics and morality are taught, and they draw upon centuries-old symbolism that even the young children understand. Faces are painted according to convention: a "white" face means treachery, so that instantly the cruel landlord or vile warlord is recognized as such; the heroine is rosy and her eyes are painted in a slanted fashion; red makeup means craftiness, black means integrity or hot temper; the clown, known by the white patch around his nose, plays the same role the clown played in Shakespeare's day, speaking the truth in witty asides or addressing the audience directly.

The props that are used tease the imagination. In a two-hundred-year-old opera I saw in Chungking, the setting was the netherworld beneath the sea. The chorus of pretty ladies-in-waiting to the queen of this aqueous realm moved, rowing paddles gently back and forth to indicate water. A horse is represented by a tassled stick mounted from the proper side and then, in lopes and swoops, ridden around the stage; a battle becomes a dazzling tour de force, a combination of thrust and parry, of fancy footwork, dance, and mime. There is a ritual way to laugh, a ritual way to weep, and a ritual way to show love and passion, even though the lovers never embrace.

The Chinese adore the water; all over the country they use the waterways constantly and imaginatively, not only for cheap transport (of goods and people) but for recreation. On any day of the year the weather allows, beaches are filled with bathers, rowboats are afloat on lakes, contestants are racing motorboats along the shoreline, and riverboats are carrying passengers along scenic routes such as that of the Yangtze from Chungking to Shanghai to see the Three Gorges.

To try to get an overall view of the quality of life in China, I went to cities where people live in clusters within complex industrial sites, and to agrarian communes of all sizes. Most of the communities I visited had suffered during the Cultural Revolution, and many of them were now being changed by contact with the West and the new industrialization program. I know that no community lives in a test tube; still, I thought it would be interesting to try to see one that was sufficiently isolated from the mainstream to have pursued its course without too much interruption. Such a one was the Golden River People's Commune, a livestock community in Inner Mongolia whose growth and development had been organic and so represented a truer version than most communes of the ideal projected by the Communist Party in 1949. And because it was far from the center of things, it did not face the day-to-day changes imposed on the populace by the civil war that raged for a decade.

Here are a proud, independent people who are trying to forge a socialist community and still maintain their own culture. For them, they said, life is better than it was thirty years ago. There are schools for their children and medical care for their families and livestock. They are building for themselves and for their children's future.

As soon as a child is old enough to sit on a horse he is taught to ride, and as soon as he is able to hold a rifle he is taught to shoot. The shock force for the commune (2536 herdsmen and their families) is the Golden River White Horse Company, trained in production, propaganda, and as a fighting unit. Every factory and commune in China has its own militia training program, which takes its own form. Obviously, wooden swords and rifles are not protection against planes and tanks in conventional warfare; still, the Chinese people are prepared psychologically to defend themselves in case of attack from the outside. The target the women of the White Horse militia are shooting at is a man cut out of wood, but they are indoctrinated to think of him as "the enemy." When one sees the beautiful white horses that they train to lie still so they can shoot over them, it all seems a romantic fairy tale from another age; yet it remains understandable in a culture where the language is pictorial, the ideogram represents the word, and the epigram takes the place of long-winded explanation. This symbolic training can be seen as a method to teach discipline and resolve from infancy, as a basic training which stresses physical fitness and toughness that can be used to create a fighting armed force when necessary by supplying the right weapons at the right time to a people prepared to fight. Within this group morale is high because its members function as a unit and make their own entertainment (they sing their own songs and have their own special dances, wrestling, and recreation).

In contrast to those living in the more isolated areas, there are the urban dwellers, who are exposed to foreign music, are learning foreign languages, are seeing foreigners on their streets, and are in some slight degree adopting foreign ways. When on my first trip I saw young men playing guitars on the streets and dancing in public places, I overreacted and took these straws in the wind as a total turnabout in attitude, as evidence of imminent Westernization. By my second trip, the guitar players and dancers had been reprimanded and criticized in the press, and had been replaced by earnest young men on the march demonstrating against unemployment. Even though these actions may be spontaneous, I realized that they happen because the government allows and controls these changes — sometimes subtly, sometimes blatantly. These shifts are said to be the way the government suppresses her young revolutionaries and keeps them at bay.

In light of what I was hearing and seeing in China, it was amusing to read afterward what the intrepid China watchers had been writing in the press during my visits. Many of them had been in Hong Kong for years, and this was a first time in for them. They were overreacting as I had in the beginning to the token changes taking place. A couple holding hands or snuggling in the bushes was blown up to mean "a sexual revolution." A big-hoopla personal promotion for Pierre Cardin, showing his Paris fashion collection in Shanghai, Peking, and on the Great Wall, was reported as though the Chinese could hardly wait to drop their blue suits in favor of Parisian chic. (Actually, Cardin was an adviser to the Chinese textile industry on exports.) China is changing and will change, but how fast and how radically it is too soon to tell. She seems to be testing and weighing possibilities and direction gravely for the short term, seriously for the long term. She is intent on learning quickly and, with this in mind, is permitting an influx of businessmen and media people, technicians and artists, musicians and scientists. The list is impressive, the attention paid is flattering, but in the end one comes away with the feeling that the Chinese will keep their own counsel and make up their own minds. They are determined not only to become a global power, but to restore to China its former significance for the world.

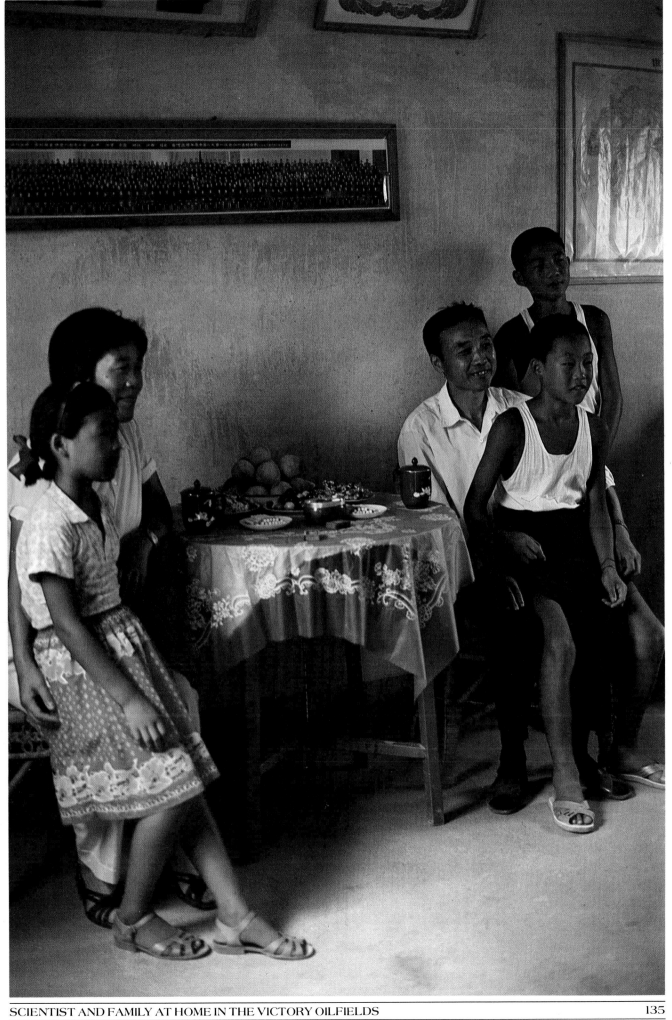

SCIENTIST AND FAMILY AT HOME IN THE VICTORY OILFIELDS

ARMY OFFICER AND FAMILY ON HOLIDAY IN WUHAN

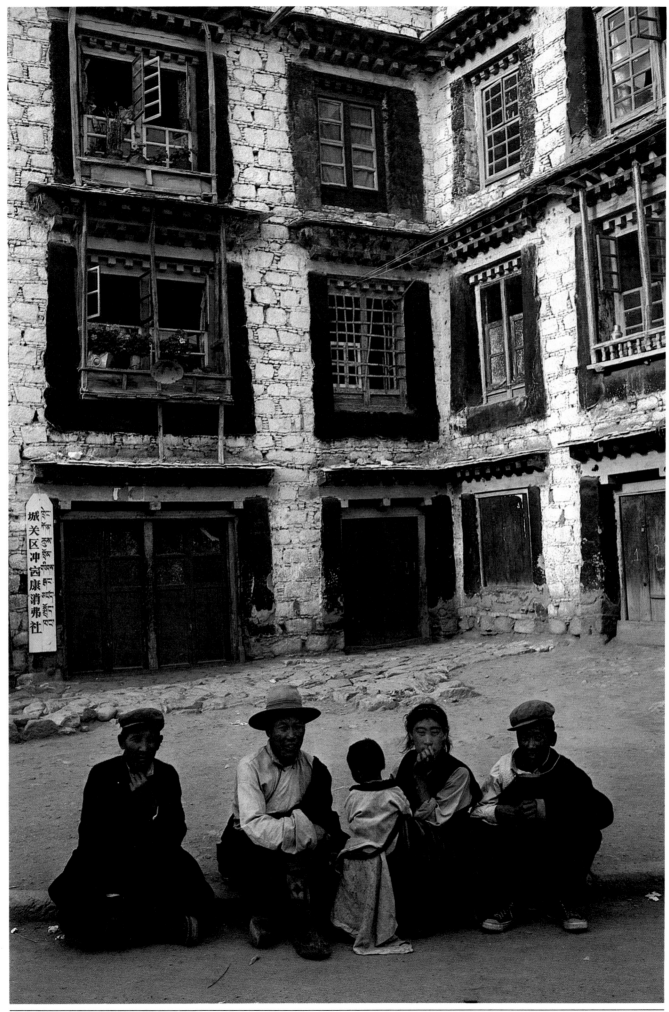

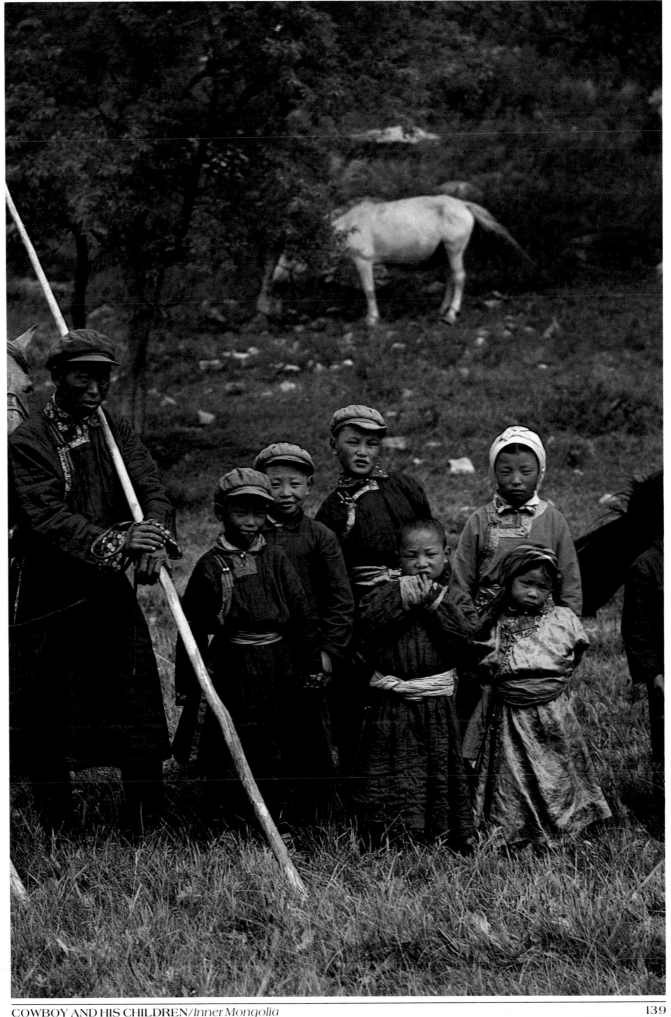

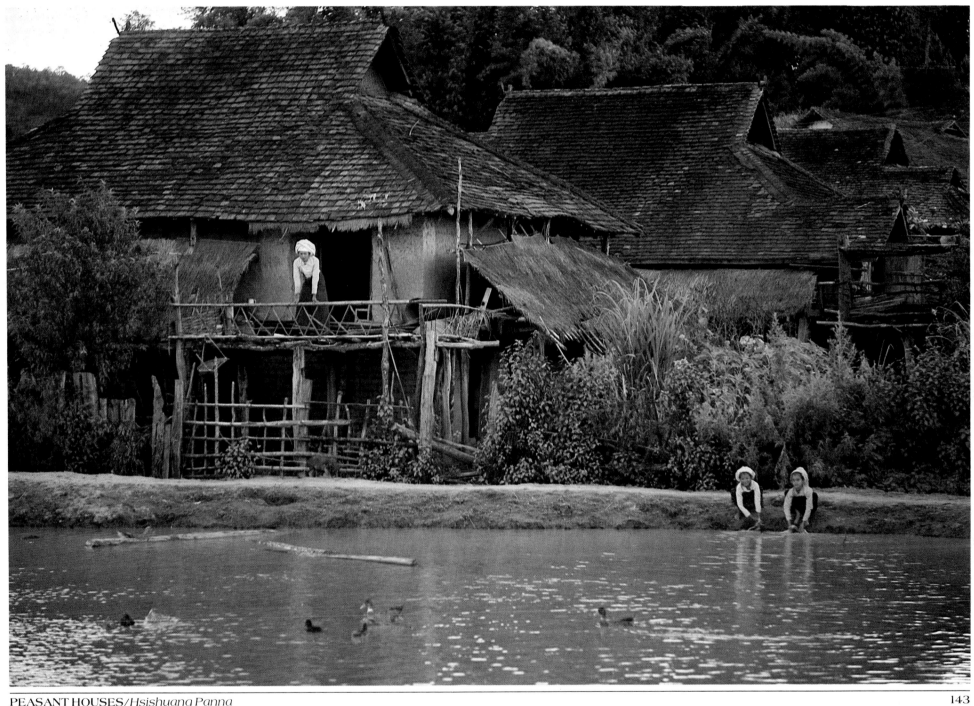

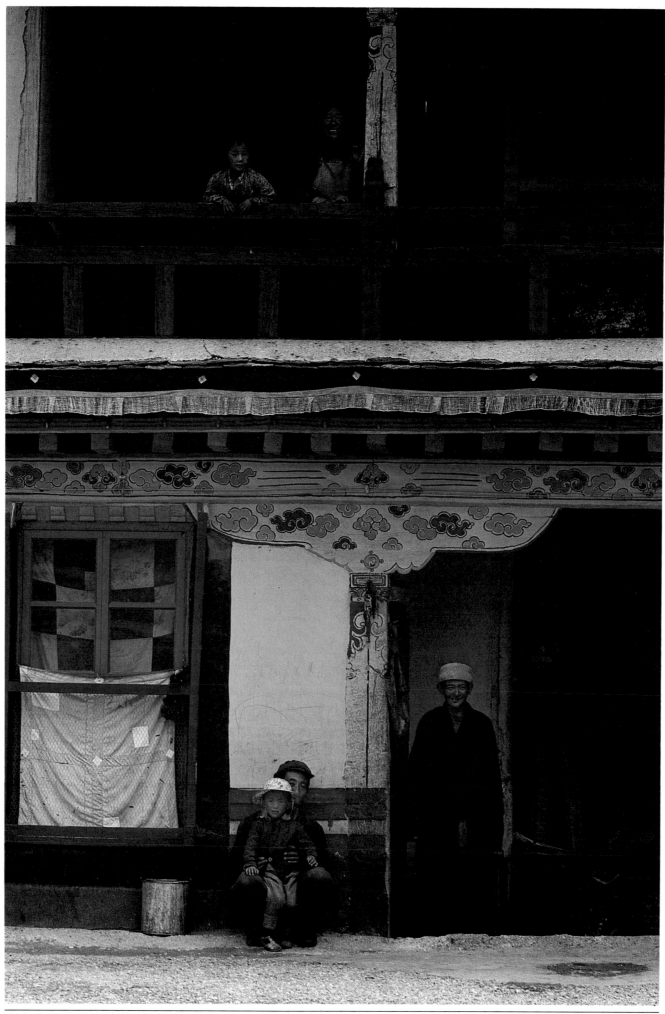

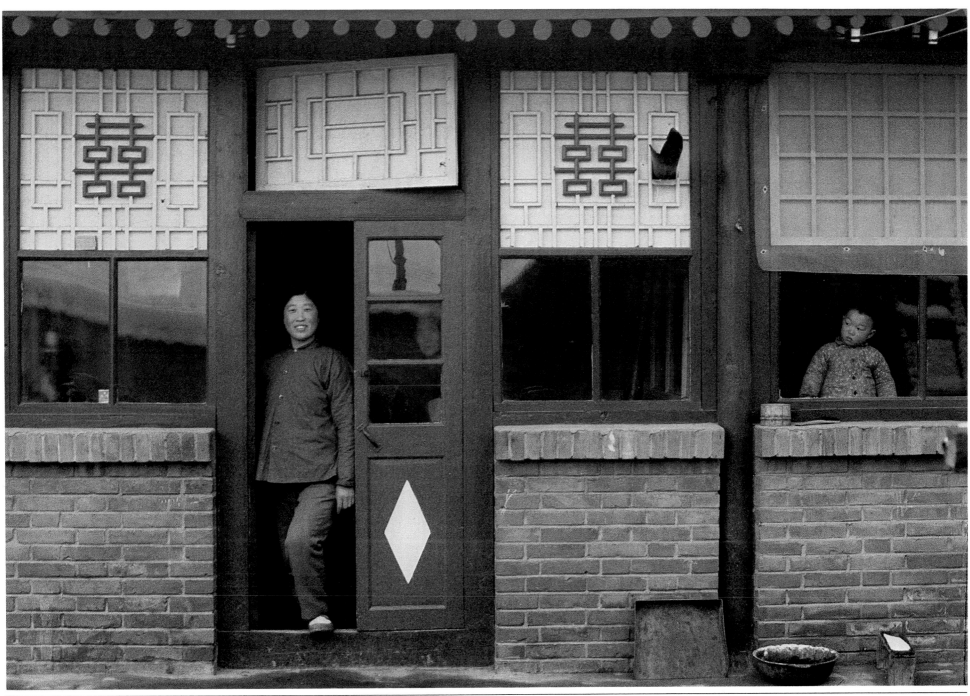

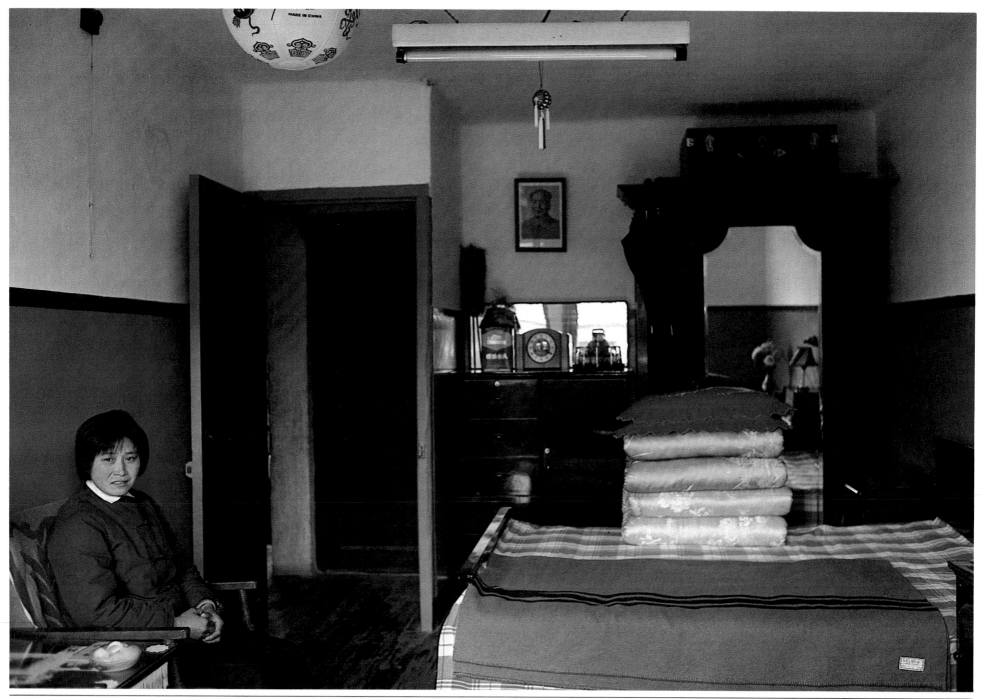

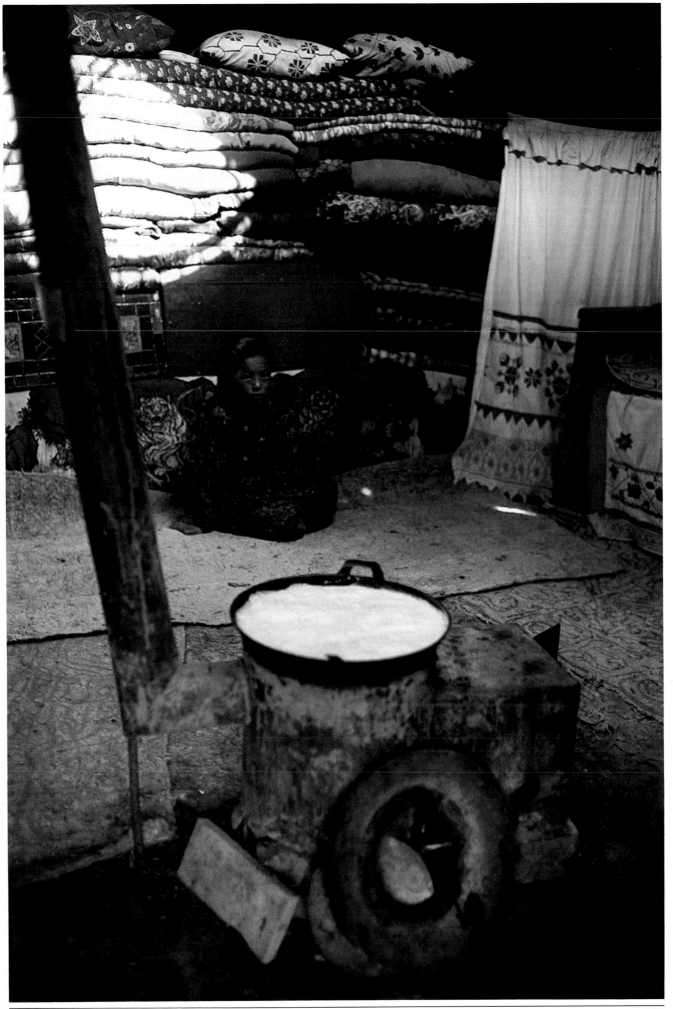

YURT INTERIOR, HEAVENLY LAKE/*Sinkiang*

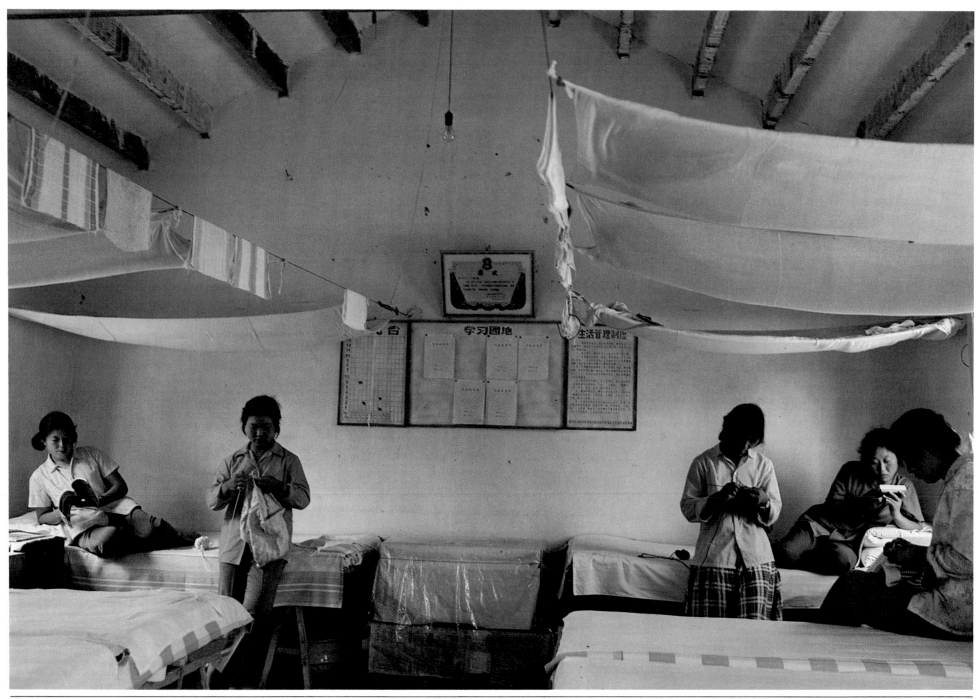

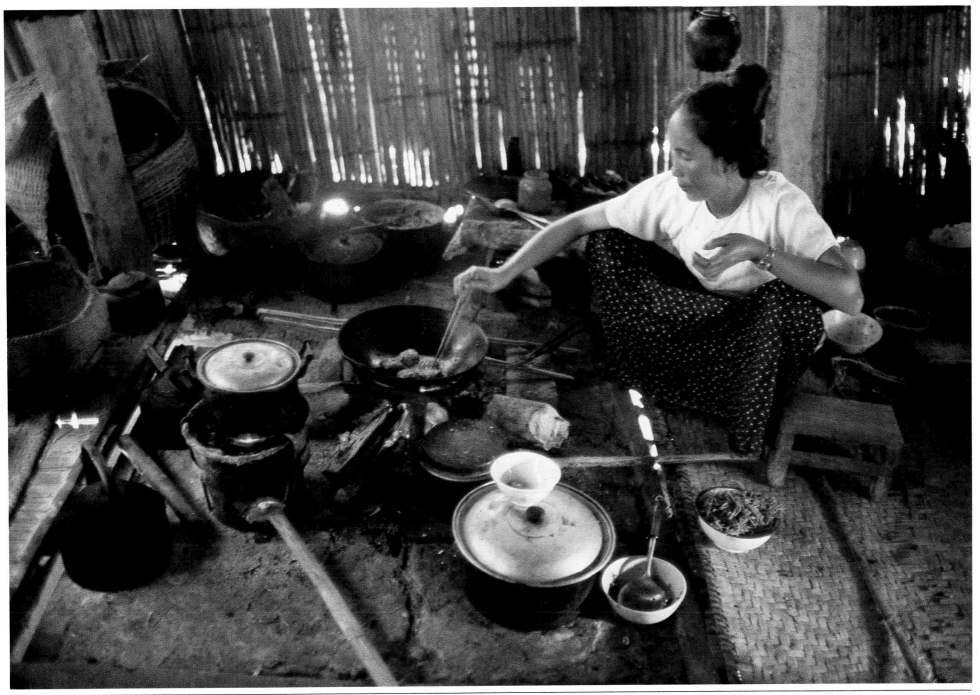

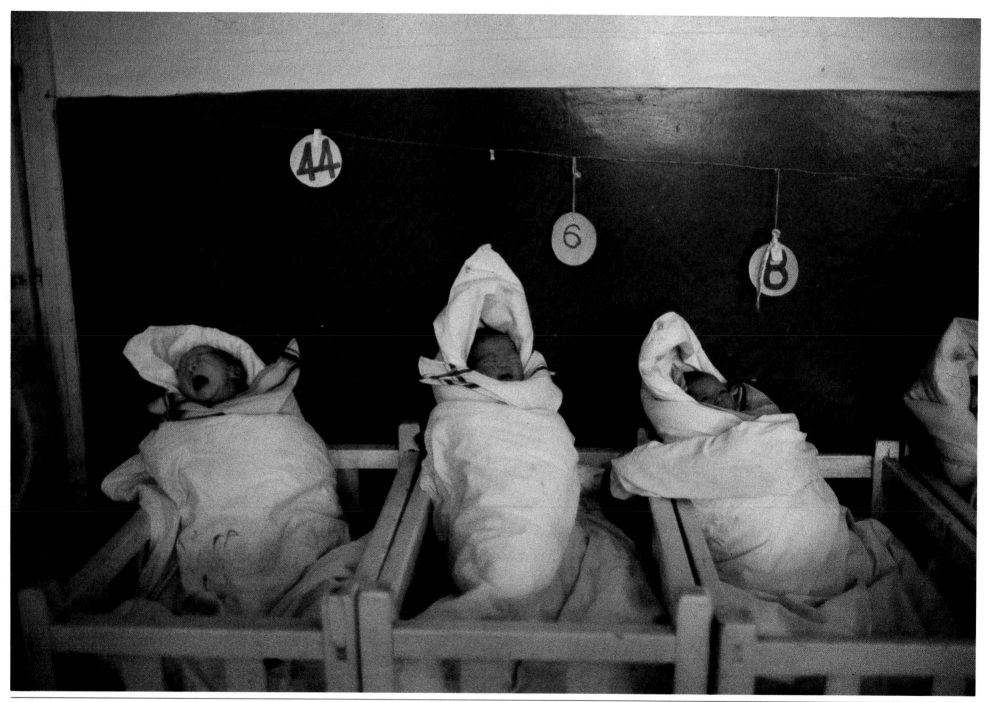

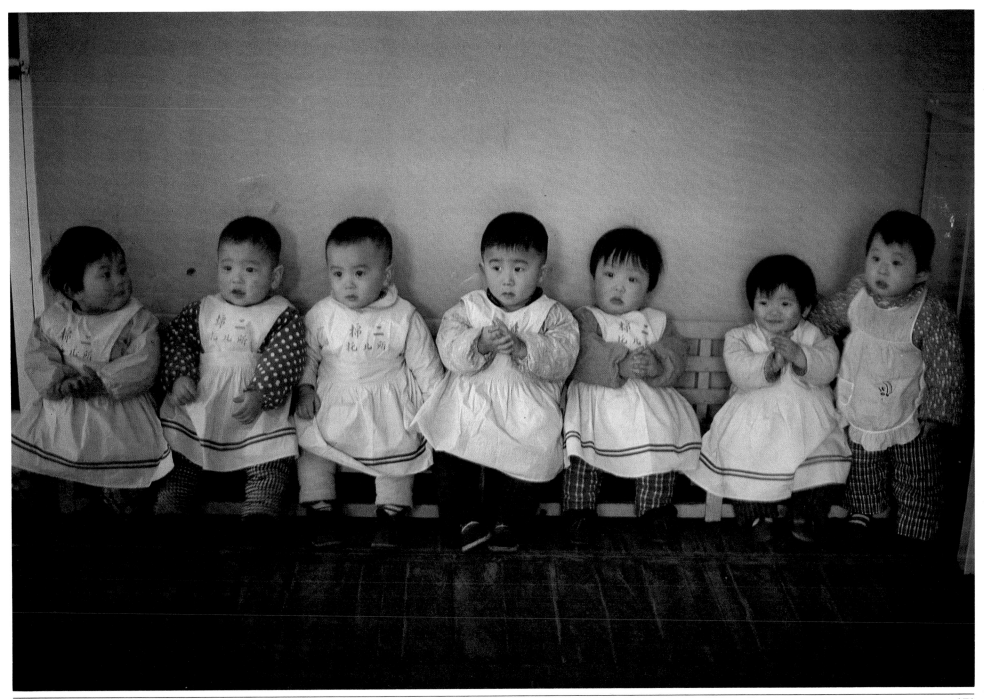

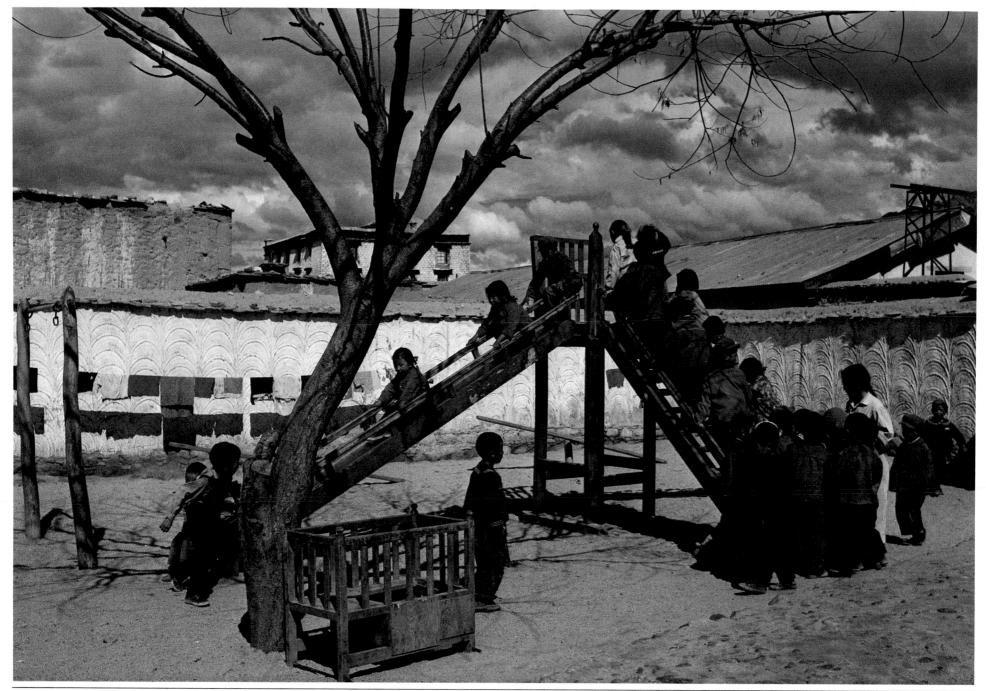

PLAYGROUND OF THE GREAT LEAP FORWARD COMMUNE/*Lhasa, Tibet*

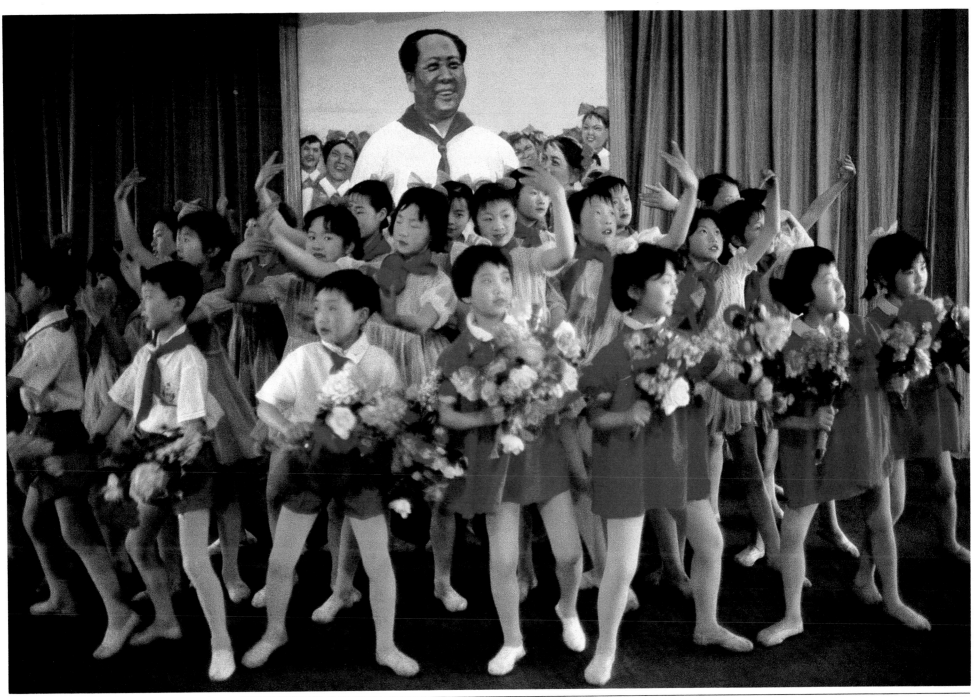

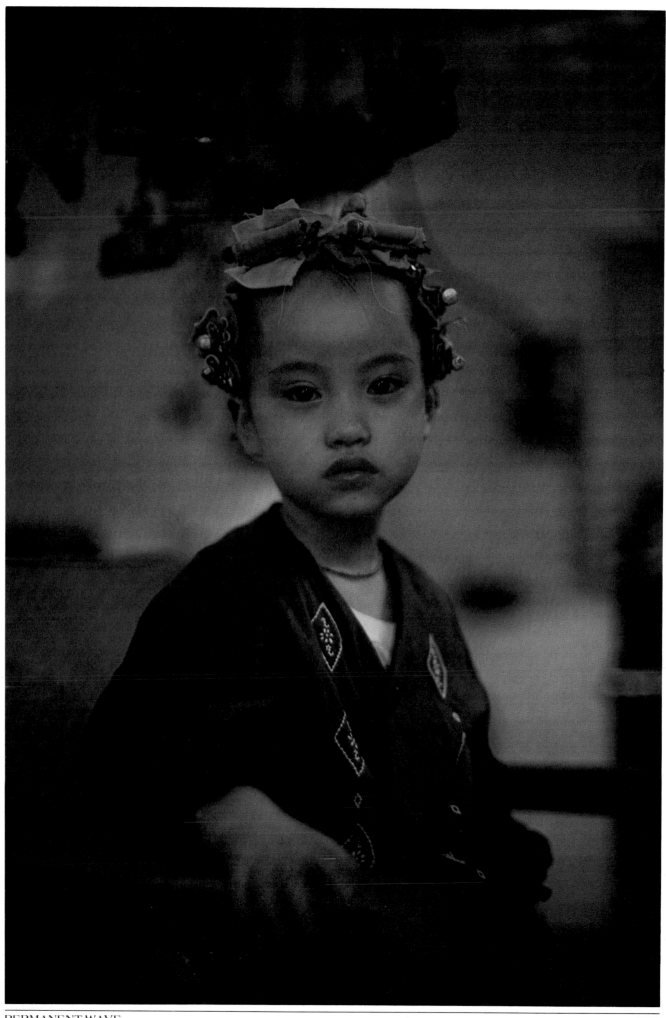

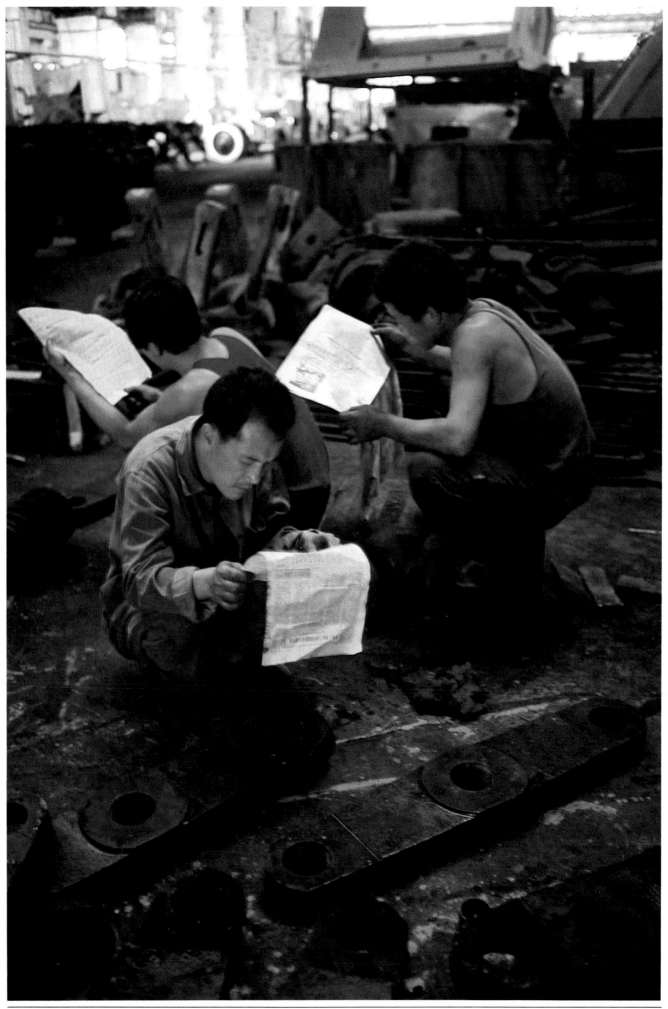

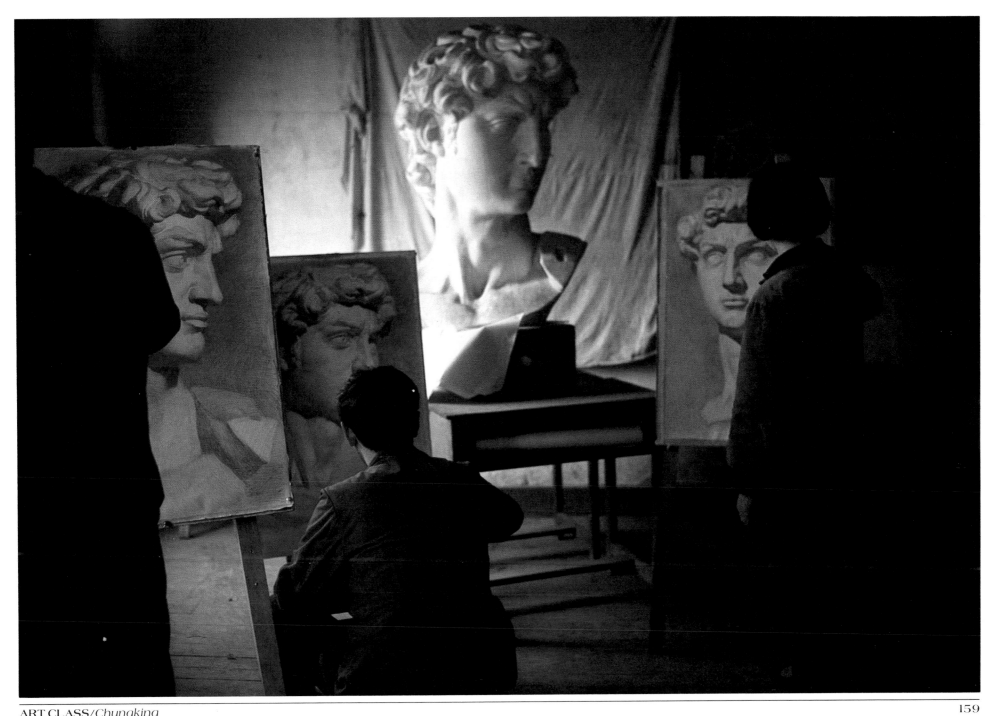

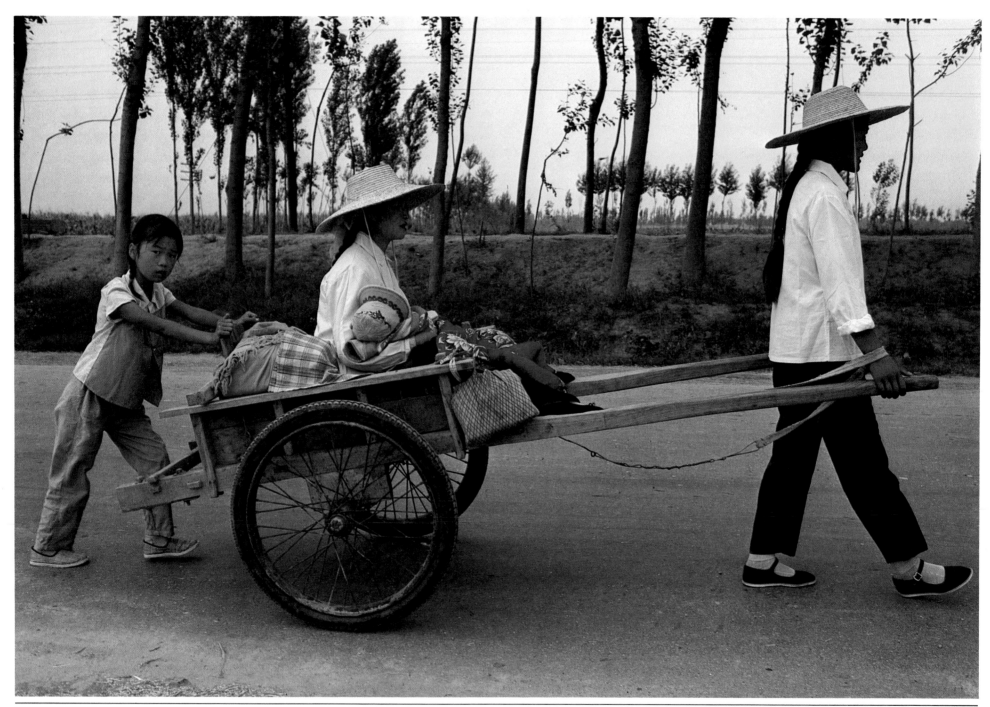

MOTHER BRINGING NEWBORN BABY FROM MATERNITY HOSPITAL/*Sian*

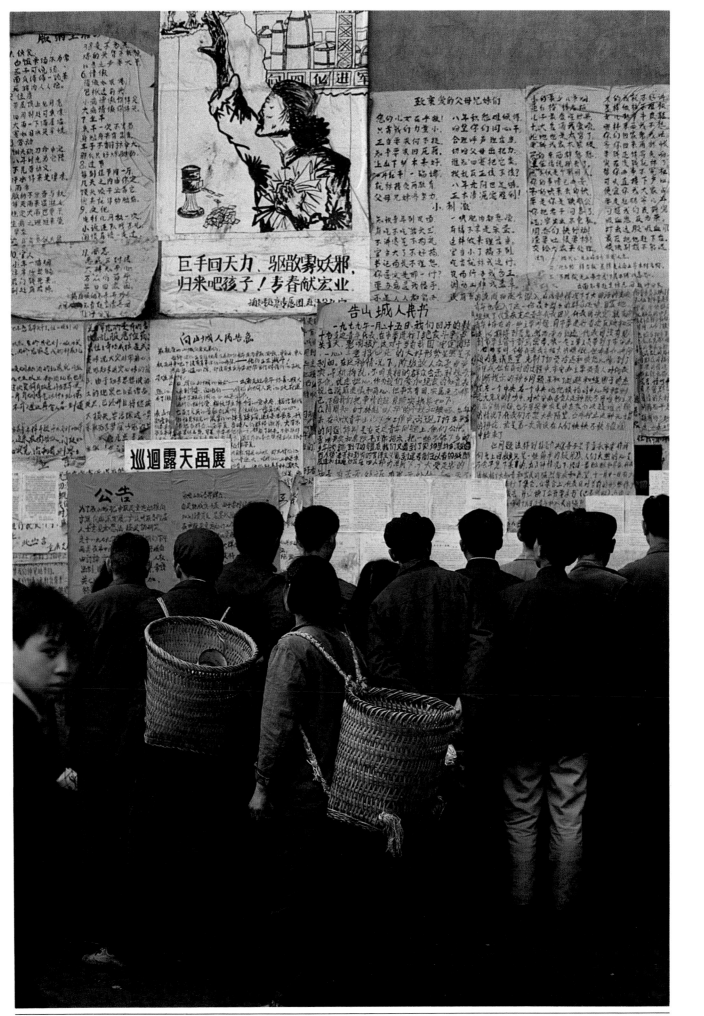

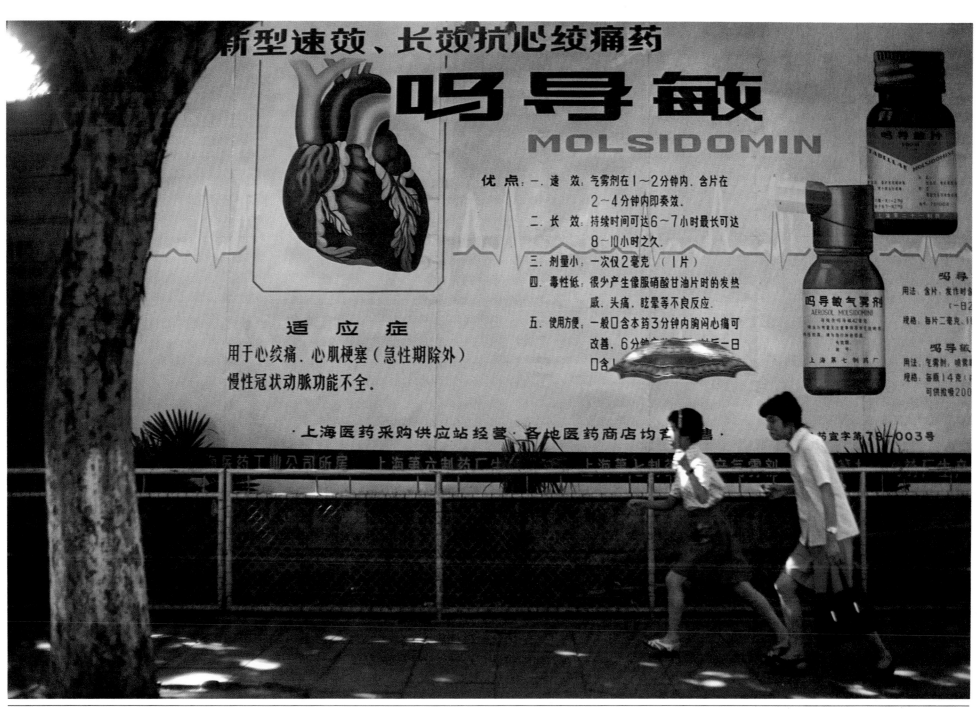

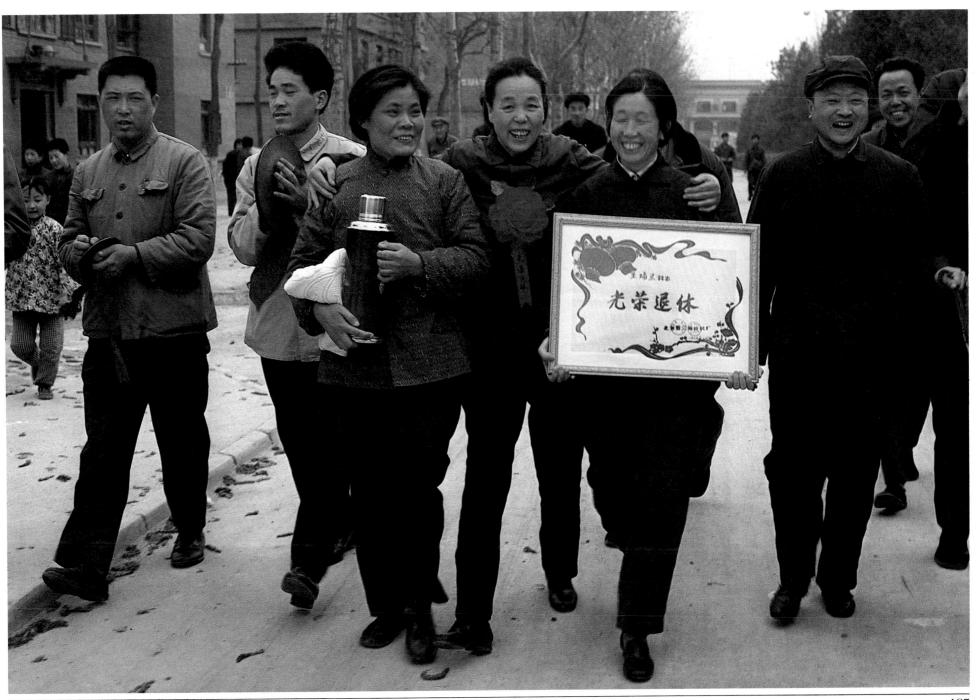

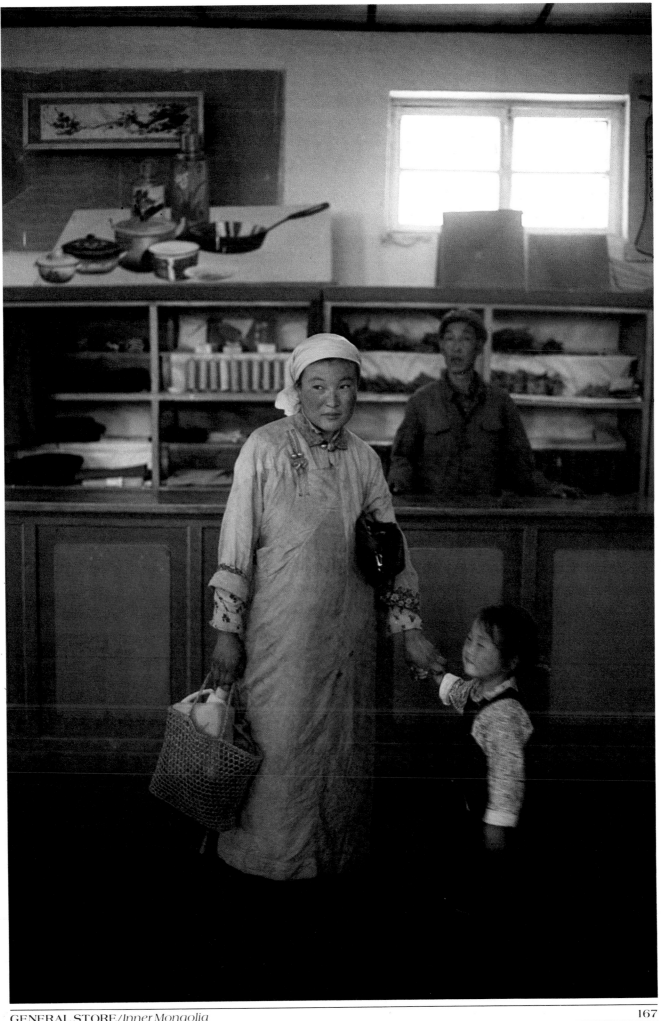

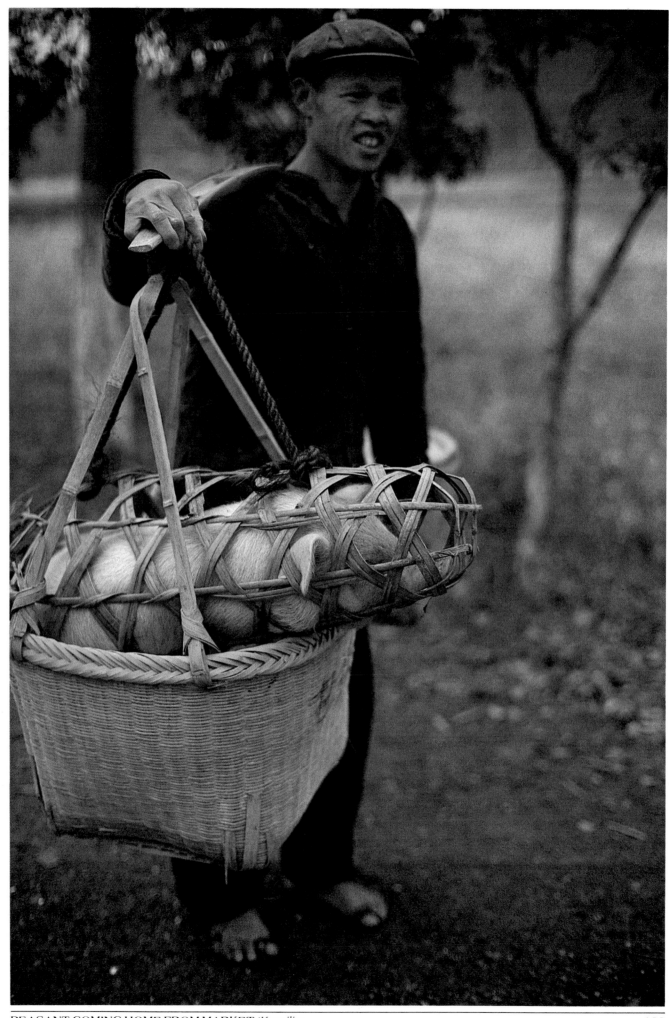

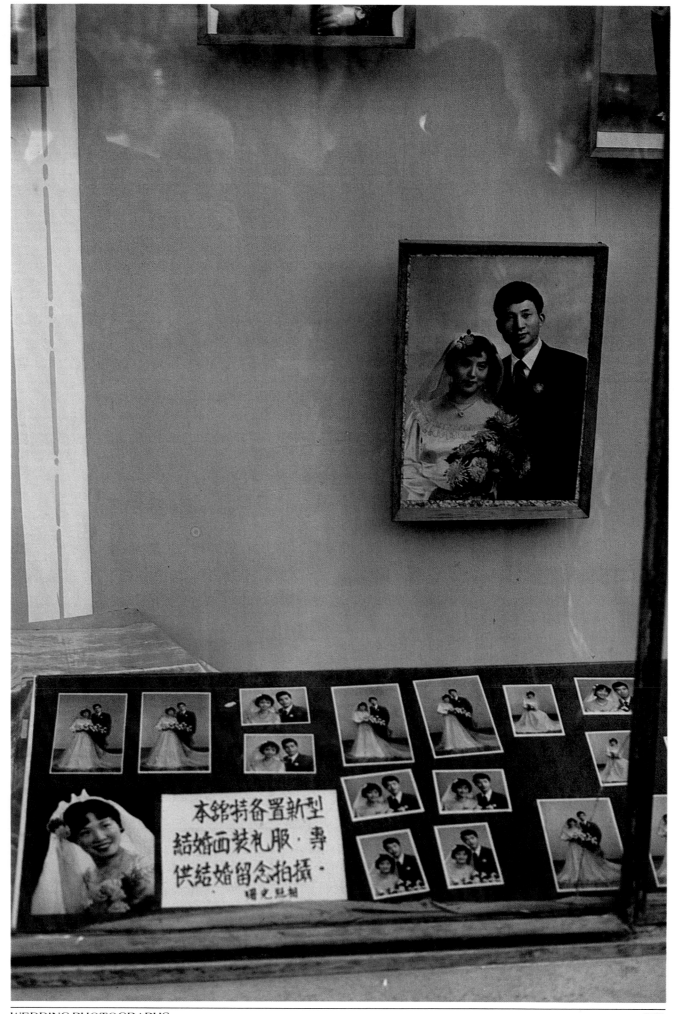

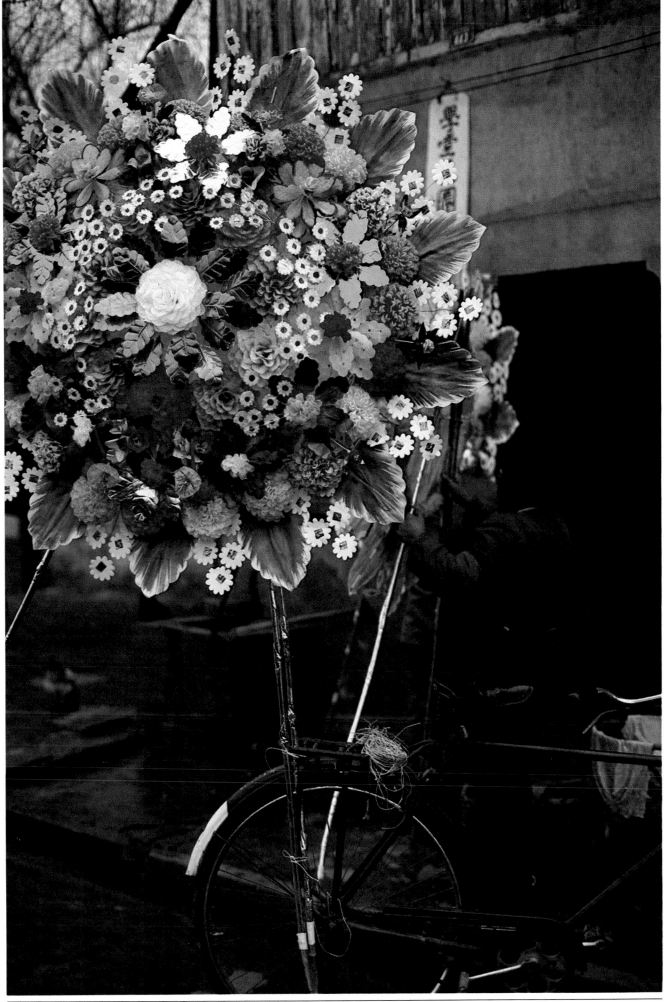

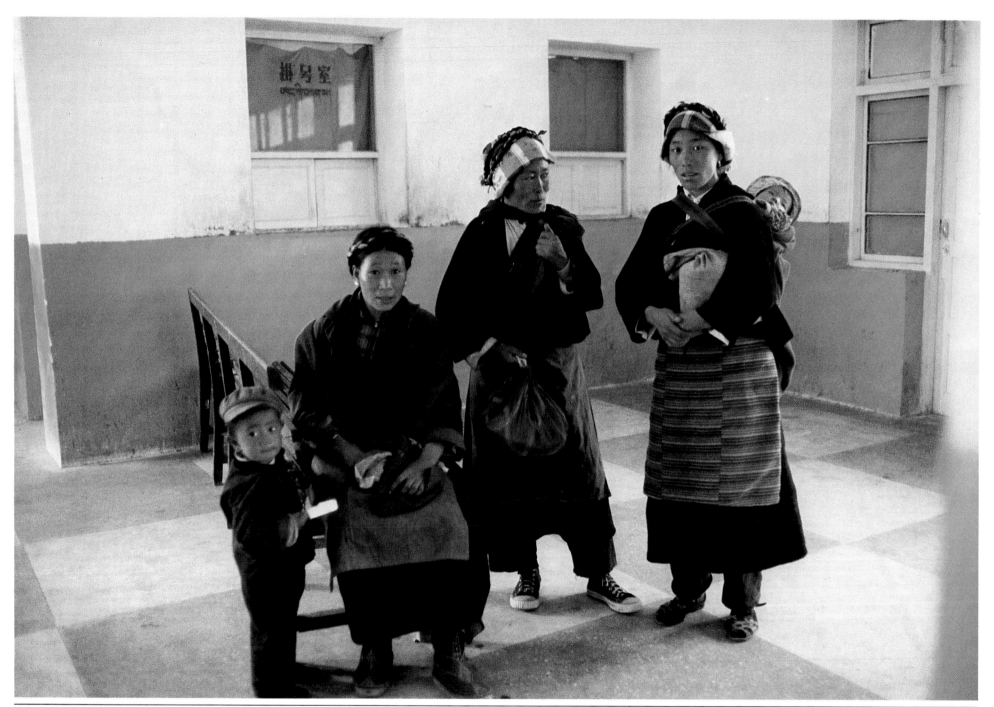

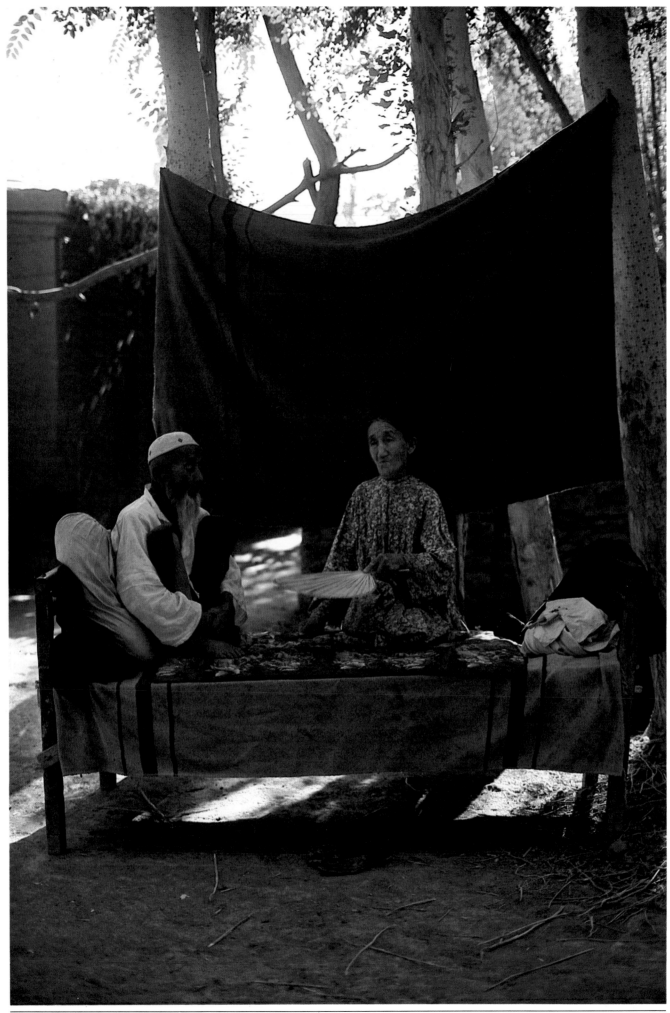

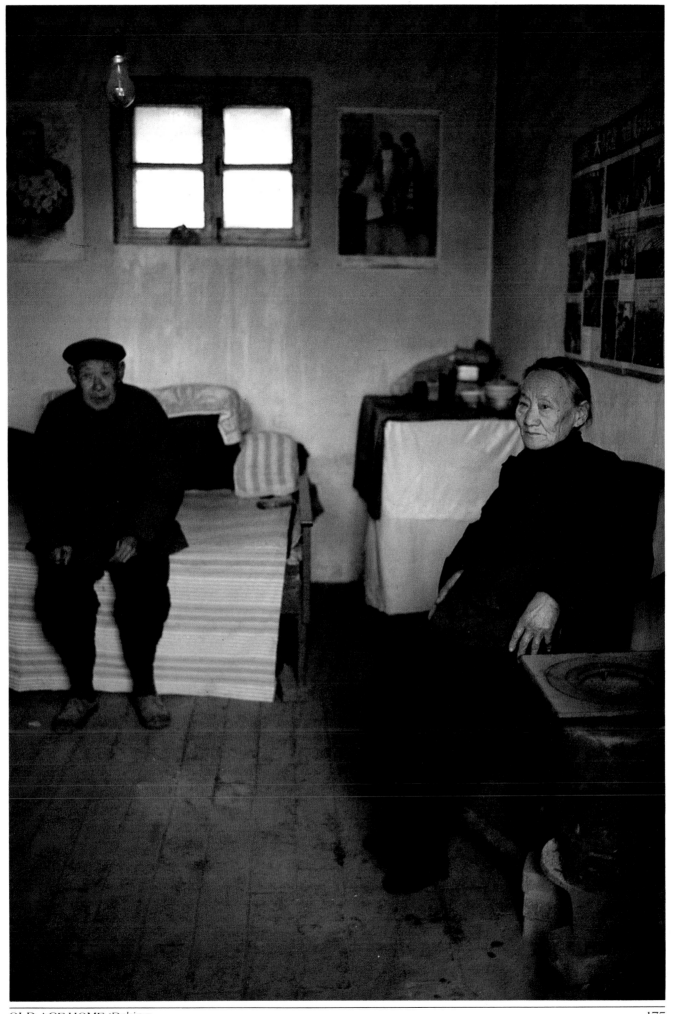

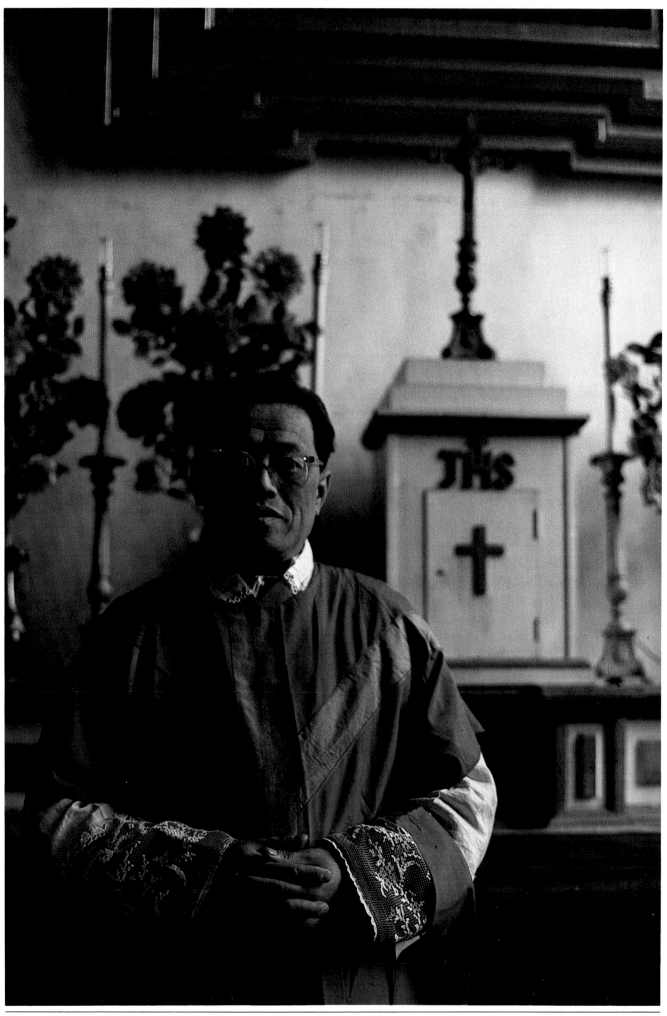

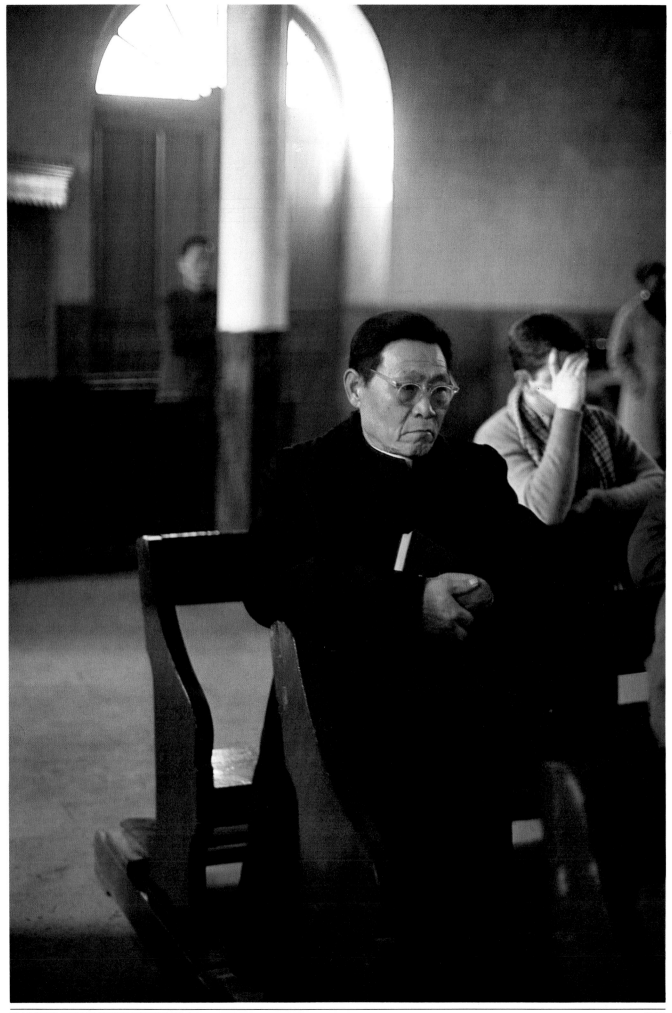

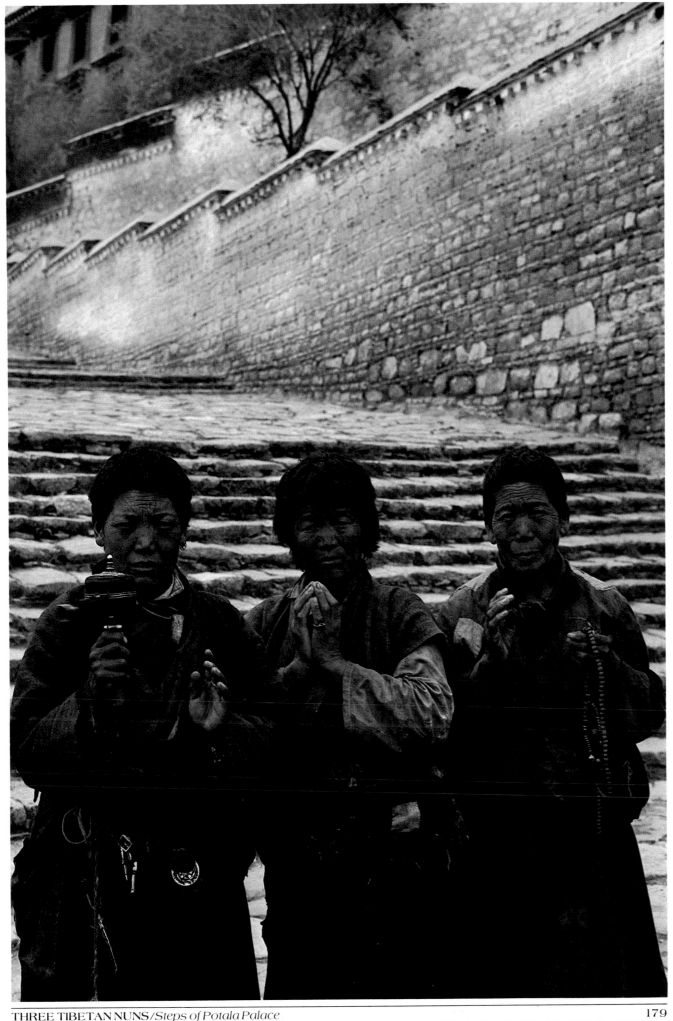

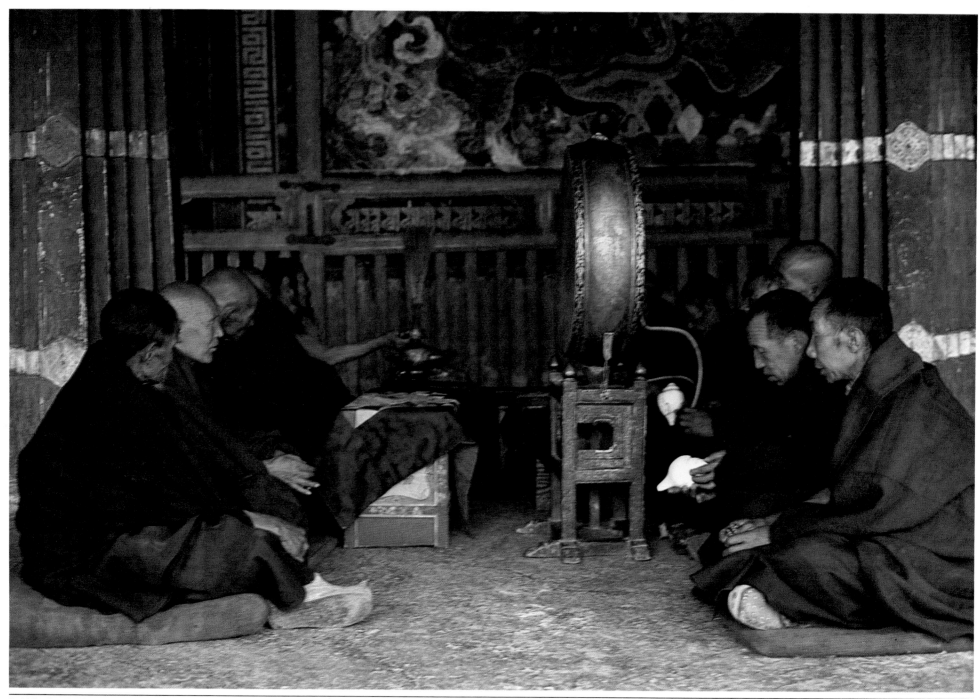

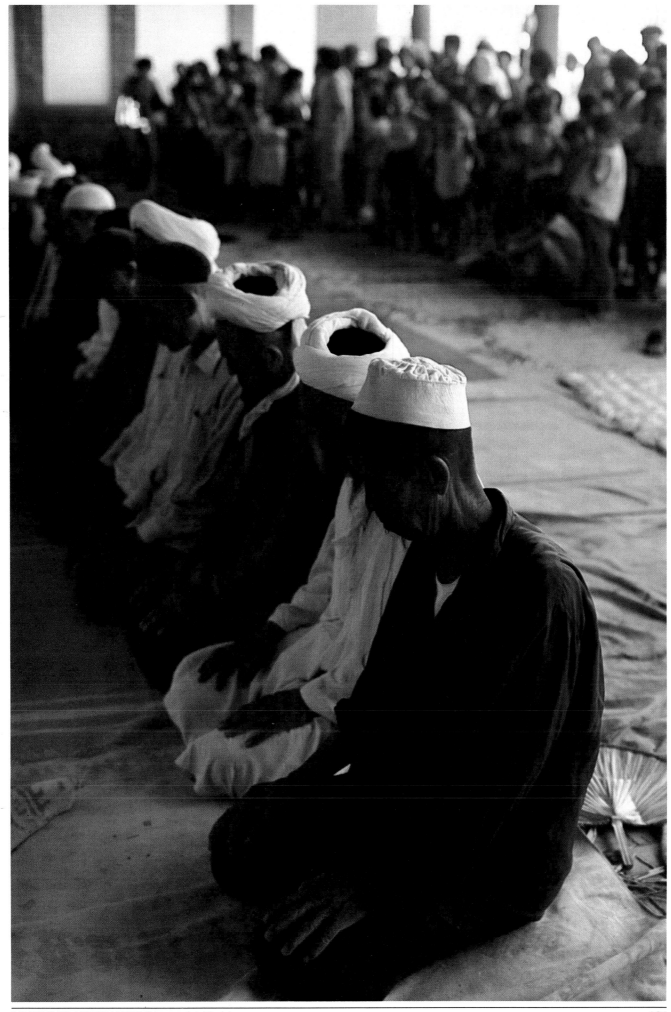

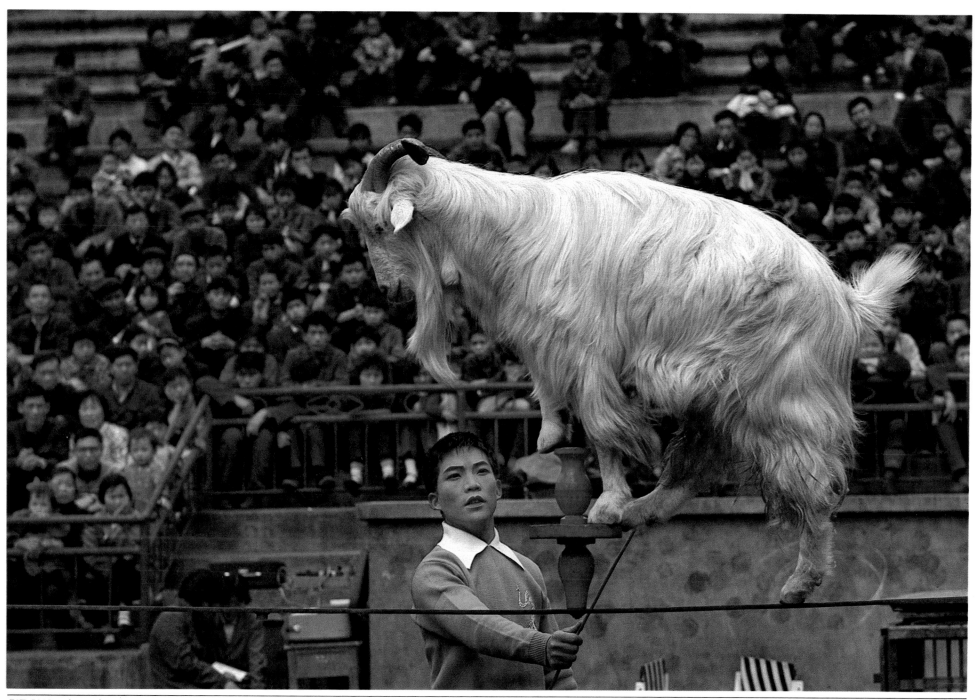

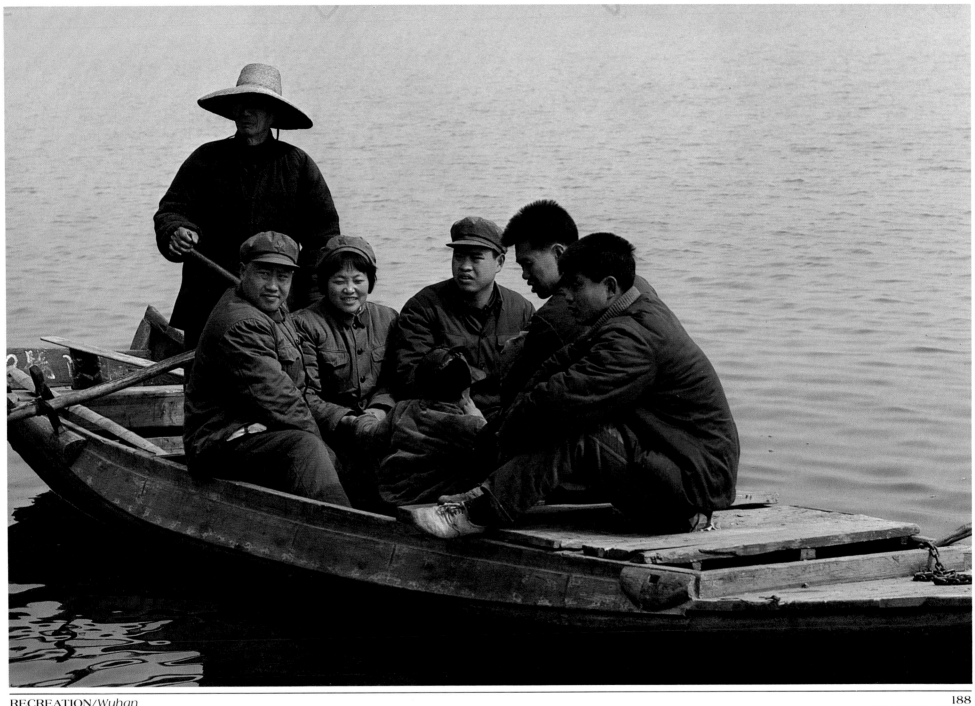

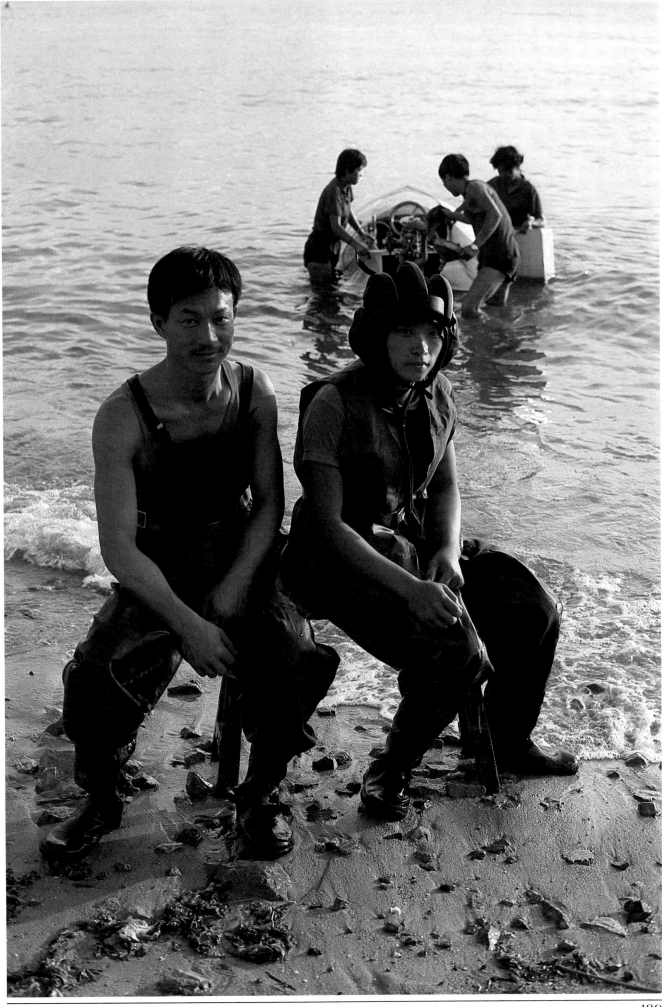

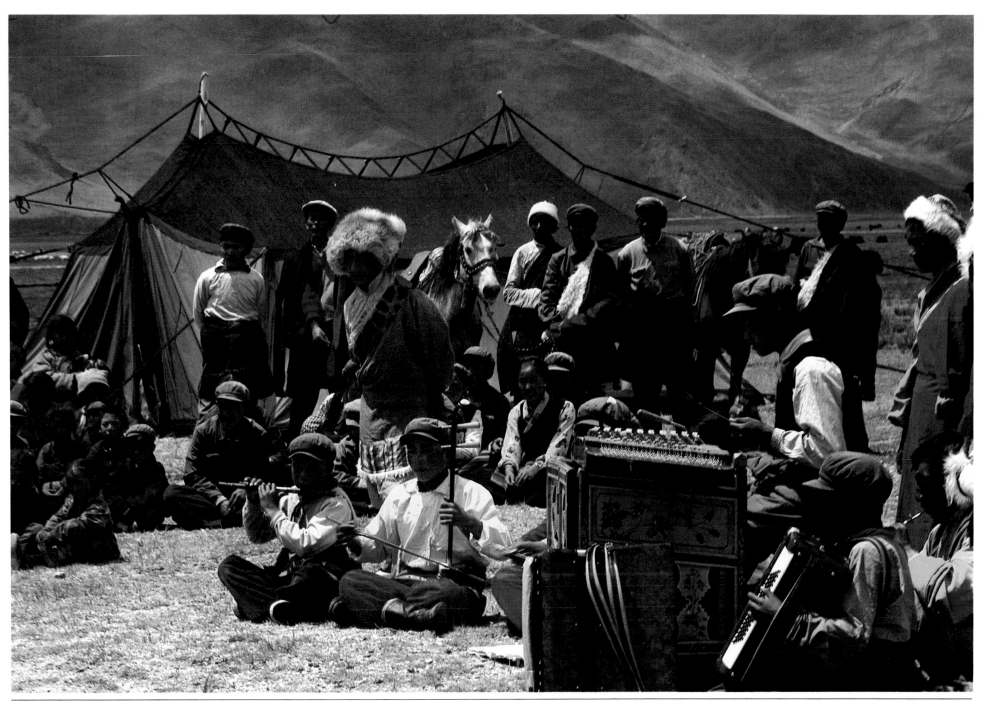

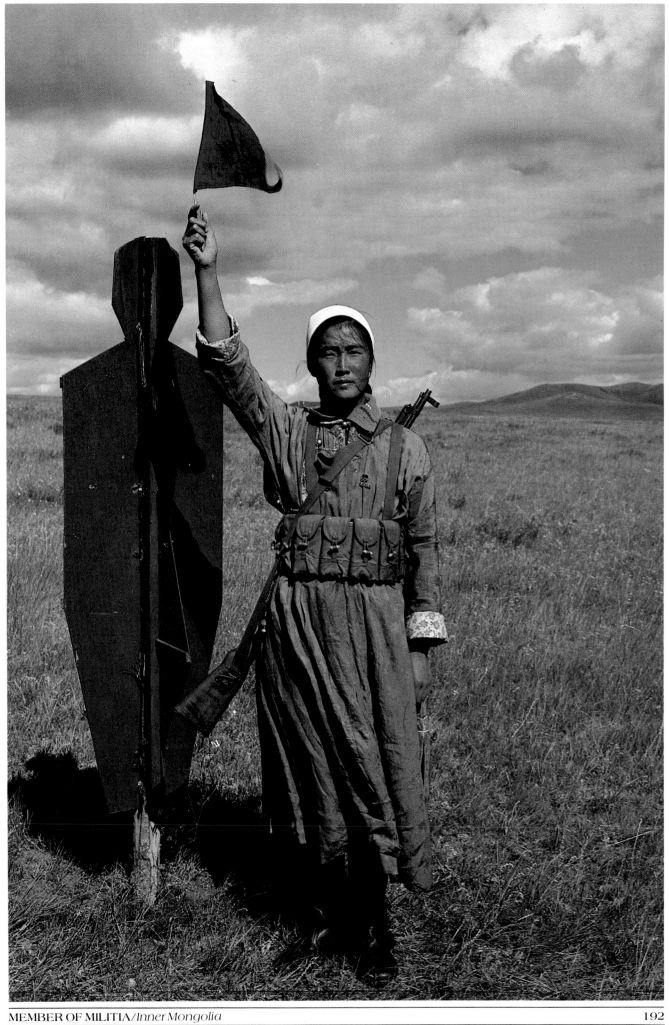

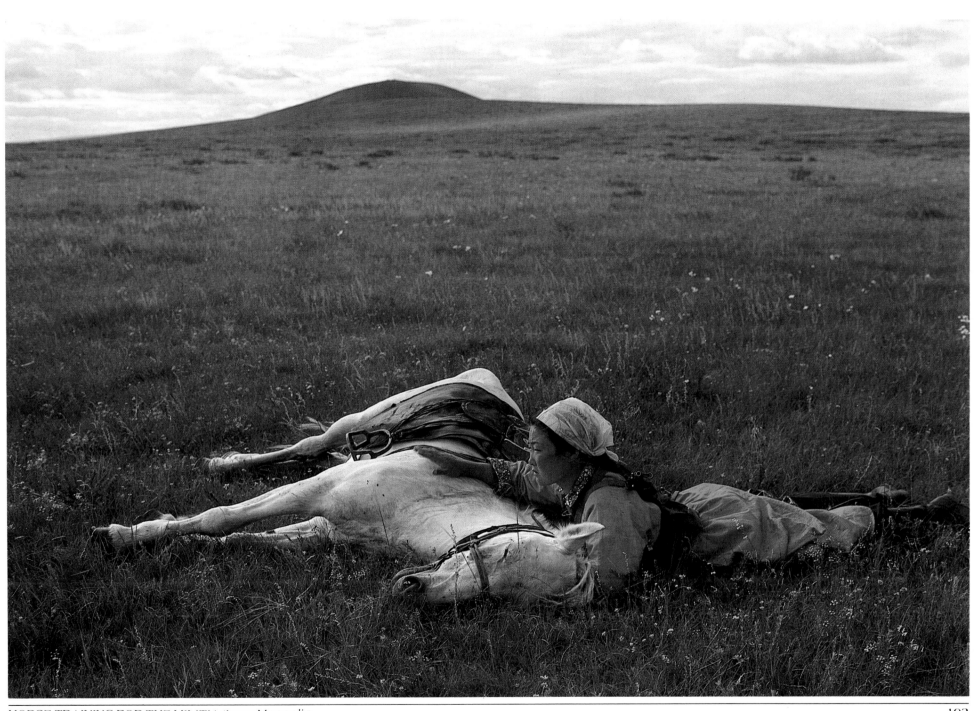

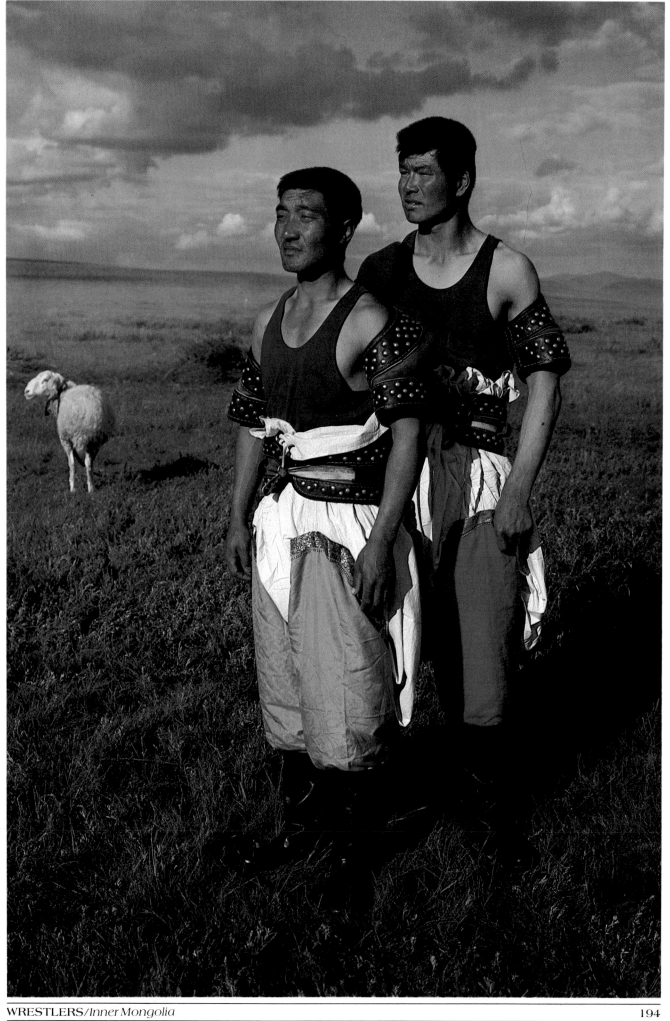

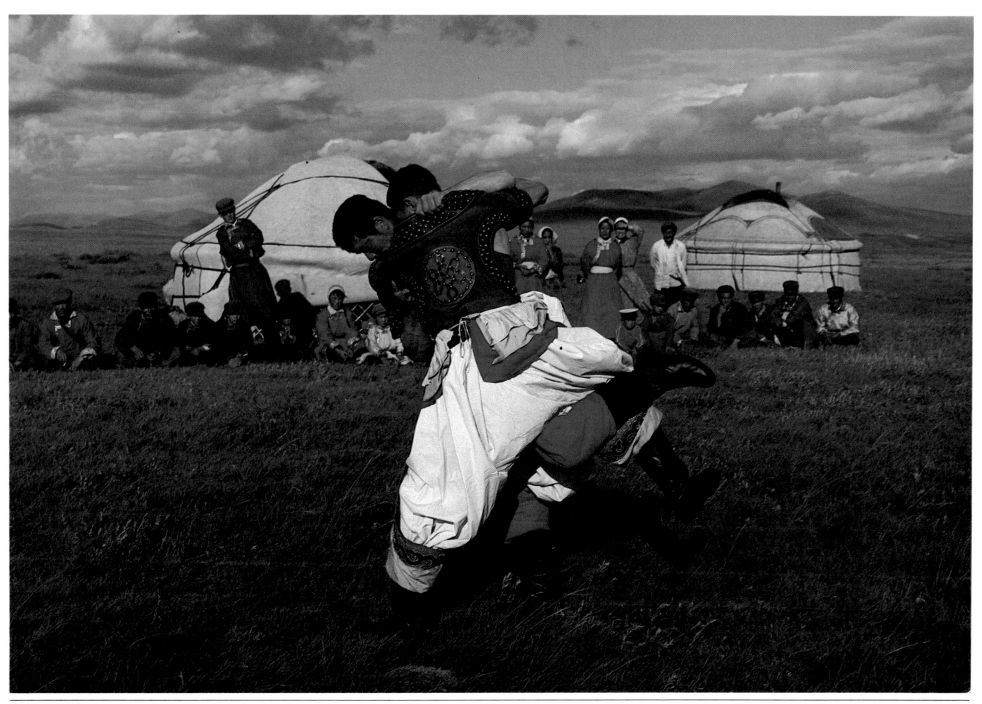

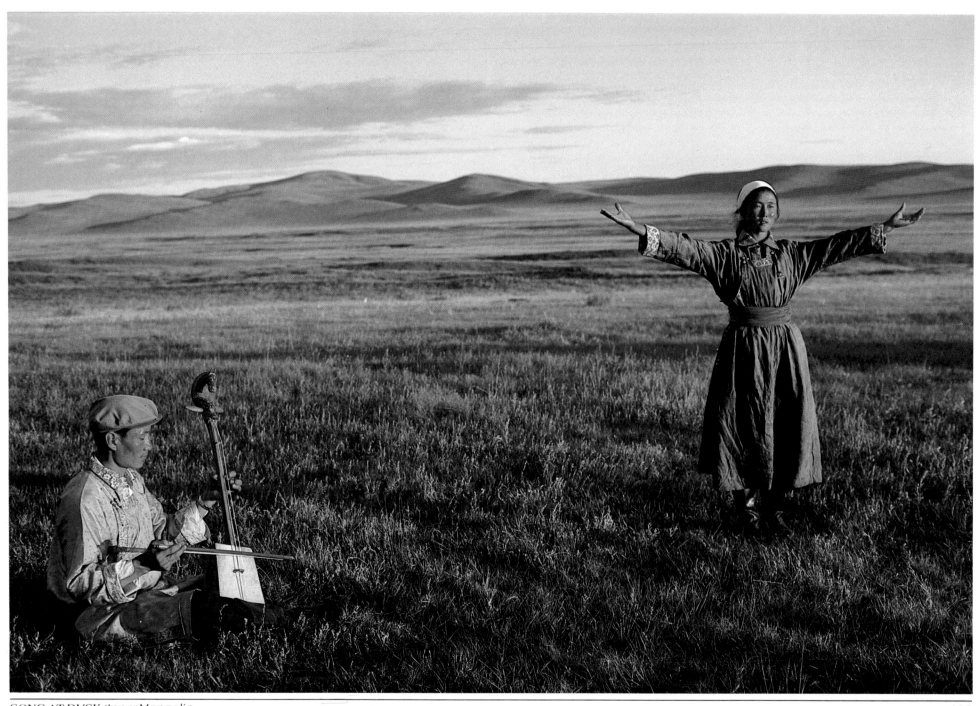

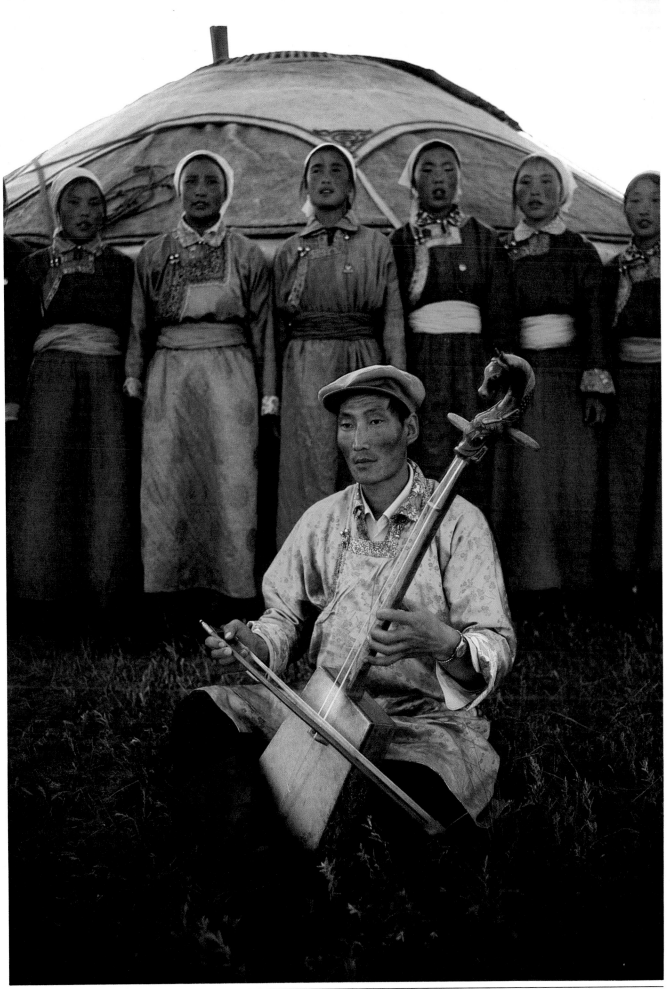

MILITIA OF GOLDEN RIVER WHITE HORSE COMPANY SINGING A FOLK SONG

GRAPHICS

The text of this book was set in the film version of Horizon, a typeface originally named Imprimatur.
Designed by Bauer and Baum, Imprimatur was imported from Germany in 1952 and renamed Horizon.
The caption and display typeface is Americana, a contemporary design by graphic designer Richard Isbell.

This book was photocomposed by The Type Group and TypoGraphics Communications, both of New York City.

The color reproductions were separated by Offset Separations Corp., of New York City and Turin, Italy.
The book was printed by American Printers & Lithographers, Chicago, Illinois, and bound by A. Horowitz
& Sons, Fairfield, New Jersey.

Ellen McNeilly directed the production and manufacturing. Lesley Krauss supervised the copy editing
and proofreading. R. D. Scudellari designed the book and directed the graphics.